ADDICTED to AMERICANA

CHARLES

ADDICTED to

CELEBRATING CLASSIC & KITSCHY

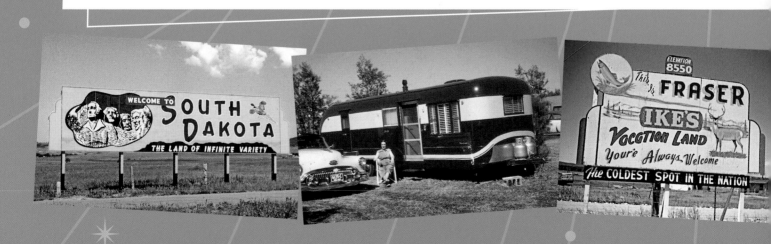

PHOENIX

AMERICANA

AMERICAN LIFE & STYLE

with
KATHY KIKKERT

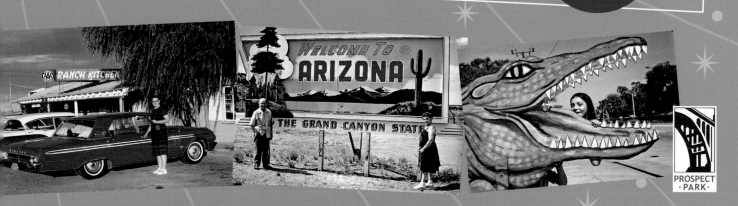

PROSPECT PARK

ADDICTED to AMERICANA 6

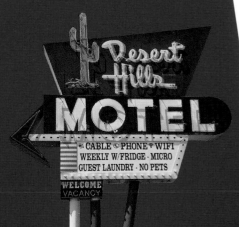

THEMEPARKLAND! 14

Contents!

LET'S EAT! 100

5-4-3-2-1... BLAST-OFF! 144

THE POP CULTURE EXPLOSION that rocked the United States in the 1950s and '60s was second only in scale to the BIG BANG. Never before or since has a society so cleverly fashioned such a high-quality, colorized, progressive-and-proud-of-it supercalifragilisticexpialidocious buffet feast of productivity, prosperity, and national pride. For many Americans, the standard of living skyrocketed into a magically delicious life of leisure, and America was an enchanted land of optimistic opportunity.

I was born to celebrate this classic and kitschy American life and style. The midcentury is my muse. Looking through the layers of time in search of treasures, traditions, and time warps is my life's work. Sharing my delightful discoveries in my retro slide shows, coffee table books, and field-trip tours is the icing on the cake and the cherry on top.

Addicted to AMERICANA!

This book is a kaleidoscope of my vintage Kodachrome slide collection and road trip adventures. Before we travel through time and space, let me take a moment to introduce myself and tell you how I became addicted to Americana.

Born on a Used Car Lot

GROWING UP ON MY DAD'S USED CAR LOT in Southern California in the '60s and '70s was a big part of my childhood education. I might as well have born there, because that's where I came to life. "What kind of car is that?" was the first sentence out of my mouth. Sparkling spinner wheel covers were the first things that caught my infant eyes. By the time I was toddling, I spent countless Saturdays on my dad's lot getting in and out of every car and pretending to drive each one, while making all the appropriate sound effects. The bigger the tail fins, the more I liked the car. This was the genesis of my lifelong obsession with Americana.

I began collecting classic cars when I was 22. My first was a 1959 Plymouth Belvedere convertible (photo above). I saw it parked on the street, and two days later it was mine. From there it began. Over the years, I've owned a couple of hundred classics. One-owner, unrestored factory originals are always my first choice. The fewer the owners, lower the mileage, better the con-dition, and more intact the history of the car, the more I'm interested. The stories that go with them could fill a book of its own. Some cars I kept longer than others, and some I should've never let go. My obsession with American cars of the '50s and '60s has never waned and never will.

My ultimate find was a super-rare pink 1959 Dodge Coronet convertible (photo below). I had eyed it many times in the Sears parking lot in Pomona in the late '70s. A lady who worked there owned it. In the early '80s I went back to find it, only to discover that the Sears had closed and the car was gone. I kicked into detective mode and managed to find out where the lady lived. I went to her house, and although she wasn't home, the garage side door was unlocked, so I opened it. The Coronet was there. When she got home she was startled at first to find me in her garage, but that didn't stop her from saying, "I've been waiting for someone just like you to come along."

From top to bottom: AT MY DAD'S CAR LOT IN ONTARIO IN 1973, WHEN I WAS IN THE 5TH GRADE; MY FIRST CLASSIC CAR WITH FINS, A 1959 PLYMOUTH BELVEDERE CONVERTIBLE, IN 1983; MT BEST VINTAGE CAR FIND, A 1959 DODGE CORONET CONVERTIBLE, IN 1986. EXTRA POINTS BECAUSE IT'S PINK!

Child of Disneyland

THE MOST EAGERLY ANTICIPATED and fondly remembered days of my childhood were spent in the Magic Kingdom. For me, it really was the happiest place on earth. A trip to Disneyland was always an extended family affair. I cherished every moment of togetherness there, and I never, ever took it for granted. Like clockwork, we always arrived the minute the gates opened and didn't leave until closing.

Disneyland was the best playground a kid could ask for. To experience total immersion in a fabricated future and past, and in the Old West, the Old World, and exotic faraway realms all in one day…well, it all mushroomed my mind far beyond just being entertained. For me, Disneyland was a picture-perfect school of architecture, style, and design, and an unmatchable source of local pride. It gave me the eyes to observe everywhere I went and recognize the themes in everything. Without the wonder of it all, I would've grown up to be a different person.

When I'm at Disneyland these days, I feel ageless. I still experience the magic like I'm a kid again. That's a fantastic feeling!

WHEN YOU SHOW UP TO DISNEYLAND WEARING THE SAME THING AS MICKEY… OOPS!

OUR FIRST STOP WAS ALWAYS FOR A MICKEY MOUSE PANCAKE ON MAIN STREET.

ALL DRESSED UP FOR DAPPER DAY, A TWICE-YEARLY EXTRAVAGANZA OF RETRO STYLE.

9

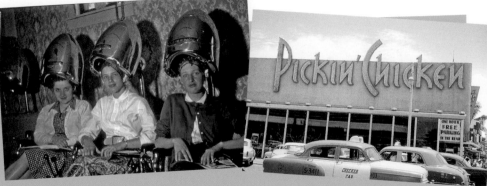

COLLECTING KODACHROME

DISCOVERING OTHER PEOPLE'S ORPHANED KODACHROME SLIDES CHANGED MY LIFE.

It was 1992, and I was in a thrift store in Pasadena when out of nowhere a voice inside me said, "No more thrift shopping!" It stopped me dead in my tracks. I thought, *You're right, Voice Inside, I've done enough thrift shopping, but just give me five more minutes and I'll never thrift shop again.*

As fate would have it, in that five minutes I found a little blue shoebox marked "Trip across the United States 1957." Inside were somebody's old Kodachrome slides. I held a few up to the light and knew immediately that this was a treasure trove with my name on it. To this day, I'm still collecting Kodachrome slides. Going through each collection is a surprise time-travelogue. You never know where they're going to take you, what you're going to see, and who you're going to meet.

My mind nearly exploded the day I discovered thrift shopping. I was 14. It was the late 1970s, and thrift stores were bursting with marvelous midcentury leftovers. This was long before "vintage" became a thing. I was just looking for a cowboy shirt so I could be cast in the local community-theater production of *Oklahoma*. I found a thrift shop, took three steps in, took and two steps back, and thought, *I think I'm gonna like it here.* Not only did I find the cowboy shirt I was looking for, I found a whole new wardrobe, which was much more interesting than anything I'd ever gotten from the Husky Boy department at Sears.

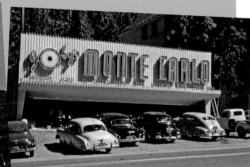

That was the beginning of my 30-year thrift-shopping spree. Eventually, I became a thrift shopaholic and a vintage junkie. Thrift shops were my schools of style and museums of merchandise—the perfect places for me to study the underbelly of our mass-consumerism culture. Little did I know this happy habit would lead to a discovery that would change the course of my life.

I began having little retro slide shows for friends in my living room. I wondered if they'd be as interested in the colorful images from the '50s and '60s as I was. They were. A friend suggested I do a show at a travel store in West Los Angeles, so the very next day I went there and told the owner about my slide collection and how I wanted to do a retro vacation-themed slide show. "Nobody will ever be interested in looking at other people's old vacation slides," she declared sternly. I knew better and went back a week later with a stack of slides. She took one look at them and immediately booked me for a show. That was in 1998, and I've been doing retro slide shows ever since.

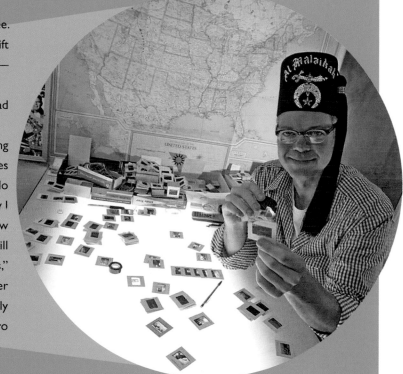

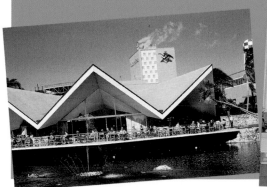

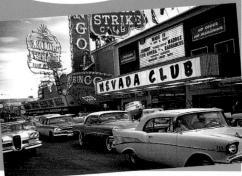

Retro Slide Shows

WHAT BEGAN IN MY LIVING ROOM QUICKLY BLOSSOMED INTO A CAREER. At first, my retro slide-show performances were free, but one night after a show in a coffeehouse, a guy said to me, "People would pay for this." From that moment on, I was in show business: reinventing the traditional living-room slide show into a laugh-out-loud celebration of classic and kitschy American life and style.

My shows all have a theme. No two are ever alike, because I'm always finding new material. As I began to get out-of-state gigs, I customized each show by including vintage slides of the town from my collection. I'd also arrive a few days early to go field tripping and treasure hunting, then work my discoveries into the performance.

I love to learn from the audience. They often share wonderful leads on where to find even more local rarities and curiousities to celebrate in even more shows. Happily, there's no shortage of retro pop culture for show-and-tell, it's infinite. My enthusiasm comes from the heart. Sharing my passion for Americana on stages across the USA is a pleasure and a privilege.

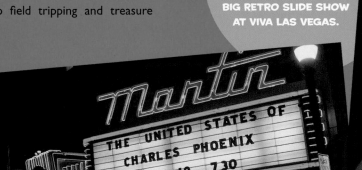

BIG RETRO SLIDE SHOW AT VIVA LAS VEGAS.

THE MARTIN THEATER, PANAMA CITY, FLORIDA.

SOMETIMES I THROW DONUTS AT THE AUDIENCE!

Field Tripping

I'M A TRAVELIN' MAN. Every time I leave my house I consider it a field-trip discovery tour. It doesn't matter if I'm just going across town, road tripping around the USA, or exploring a city I'm playing in. The journey begins when I back out of the driveway. I think of the freeway as a giant Autopia. Boarding a boat, train, or plane always reminds me of getting on a ride at Disneyland. If you're lucky enough to have turbulence, it's a thrill ride.

I love to connect the past with the present. The places and things from decades ago that I see in the slides I collect inspire and inform my travels. I'm fascinated to see how places evolve and what hidden treasures I can track down that have survived against all odds. I've found a giant turtle, a magnificent moai, dreamy dream cars, midcentury monorails, and even a few rocket ships.

Whether it's my own town or somewhere I've never been, I explore every city east, west, north, and south. I start on Main Street and go from there in search of time-honored mom 'n pop businesses, underrated landmarks, hidden treasures, and unexpected oddities. Genuine, authentic heart and soul is what I'm looking for, and I know it when I find it.

So don't be surprised if you run into me basking in the warm glow of a vintage neon sign, or chatting up the owner of a classic diner while chowing down on the specialty of the house, or sitting behind the wheel of a one-of-a-kind show car of the future from the past preparing for blastoff. We live in a wonderland—there's something interesting around every corner, no matter where you go!

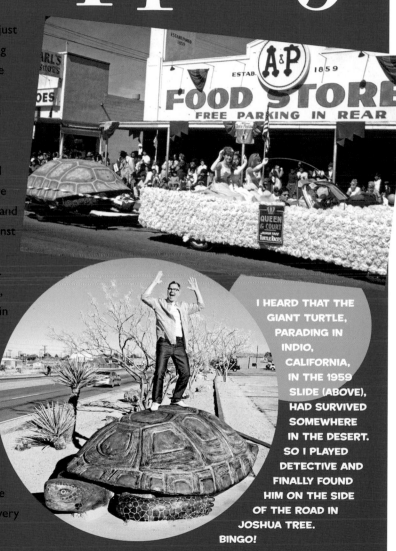

I HEARD THAT THE GIANT TURTLE, PARADING IN INDIO, CALIFORNIA, IN THE 1959 SLIDE (ABOVE), HAD SURVIVED SOMEWHERE IN THE DESERT. SO I PLAYED DETECTIVE AND FINALLY FOUND HIM ON THE SIDE OF THE ROAD IN JOSHUA TREE. BINGO!

I LOVE WHIMSY. If it's playful, colorful, novel, one of a kind, out of this world, over the top, and/or larger than life, I want to know about it. After all, I don't want to just exist—I want to be totally immersed in hyper-stylized places and environmental extravaganzas. I have a theme park sensibility.

The midcentury welcomed an unprecedented array of modes and motifs. There was no fear of shape or color; the brighter and bolder, the better. Dreamers and builders embraced the sky's-the-limit spirit of the day with gusto, transforming cities, inventing suburbia, and creating roadside distractions and picture-perfect playlands. These new destinations were well dressed for success, and consumers showed up in droves and ate it all up with a spoon.

New upscale suburban shopping centers embraced modernism and reinvented the way we

THEMEPARKLAND

shopped. These ultra-mod meccas of merchandise appeared in stark contrast to the turn-of-the-century downtowns they replaced. Also in the suburbs, a new generation of bowling palaces epitomized the glory of Googie, the most whimsical form of modernism. Massive murals and sensational supergraphics decorated drive-in theaters.

The motoring masses hit the road with the pedal to the metal. Eye-popping neon signs in a seemingly infinite array of forms and fun marked mom 'n pop motels.

Giant fiberglass gents and awesome oversized animals became instant landmarks. Quaint fantasy fairytale parks and kiddie lands catered to the boomer babies. Wacky tourist traps and wondrous roadside attractions proved irresistible. The Seattle and New York World's Fairs showcased technology, industry, and culture. The Las Vegas strip came of age in an atomic-bomb blaze of light, showing us how to push neon to the absolute extreme. And, of course, we saw the birth of Disneyland, the gold standard and granddaddy of all theme parks.

At the end of the day, we have Walt Disney to thank for defining the five basic styles of the era: Main Street USA, Adventureland, Frontierland, Fantasyland, and Tomorrowland. Midcentury America is like a great big theme park. You don't need a ticket, and there's no waiting in lines. Enter here!

Hey Yogi!
Where's Boo-Boo?

YOGI BEAR'S JELLYSTONE PARK, QUARRYVILLE, PENNSYLVANIA.

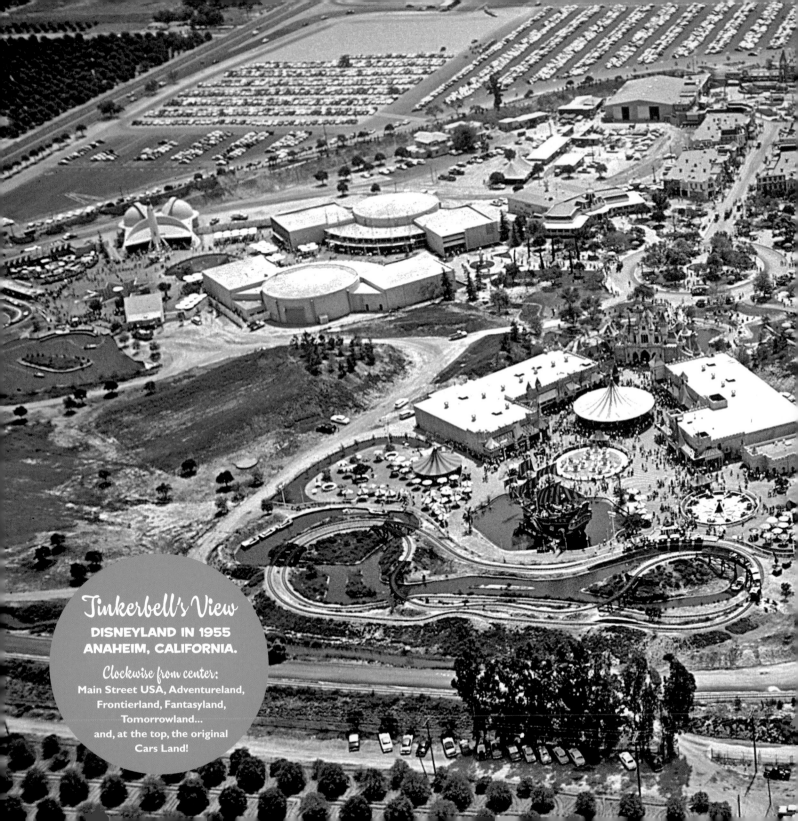

Tinkerbell's View

**DISNEYLAND IN 1955
ANAHEIM, CALIFORNIA.**

Clockwise from center:
Main Street USA, Adventureland,
Frontierland, Fantasyland,
Tomorrowland...
and, at the top, the original
Cars Land!

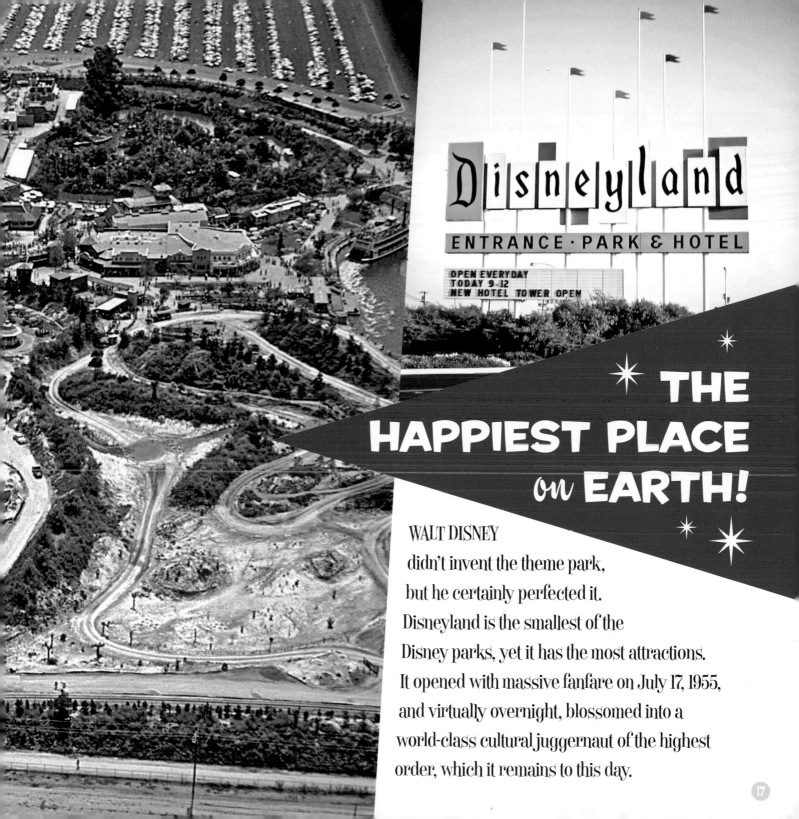

THE HAPPIEST PLACE on EARTH!

WALT DISNEY didn't invent the theme park, but he certainly perfected it. Disneyland is the smallest of the Disney parks, yet it has the most attractions. It opened with massive fanfare on July 17, 1955, and virtually overnight, blossomed into a world-class cultural juggernaut of the highest order, which it remains to this day.

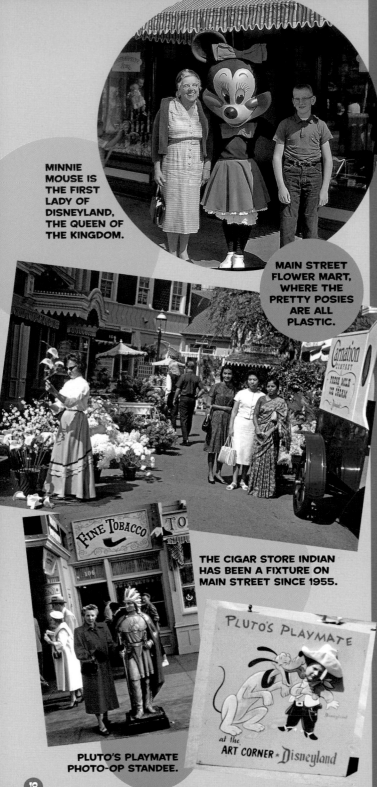

MINNIE MOUSE IS THE FIRST LADY OF DISNEYLAND, THE QUEEN OF THE KINGDOM.

MAIN STREET FLOWER MART, WHERE THE PRETTY POSIES ARE ALL PLASTIC.

THE CIGAR STORE INDIAN HAS BEEN A FIXTURE ON MAIN STREET SINCE 1955.

PLUTO'S PLAYMATE PHOTO-OP STANDEE.

SHOPLIFTING ON MAIN STREET

THE FIRST TIME I ever went to Disneyland with friends, I was 14 years old. There were six of us. At the end of the night, as we were walking down Main Street to leave, my friend Debbie said, "Hey, we didn't get any souvenirs." Turns out none of us had any money left. To that she replied, "That's never stopped me before! Let's spilt up and go into the Emporium and each take something. Meet back here in five minutes."

I'd never shoplifted before. I wasn't raised that way, and the mere thought of thievery felt lousy. We spilt up, and I hemmed and hawed but finally went in the store. Still not felling good about it, I grabbed a 14-inch stuffed Dumbo and walked out the door, straight to our designated meeting spot. I waited and waited for the others, feeling terrible about what I'd just done. I waited a bit more until the guilt was just too much, and then I marched myself right back into the store and put Dumbo back exactly where I found him and returned to our meeting spot.

Still no sign of my friends.

Finally a lady walked over and said, "Are you looking for your friends?" When I said yes, she told me, "They all had to go to Securityland!"

MAIN STREET USA, 1957

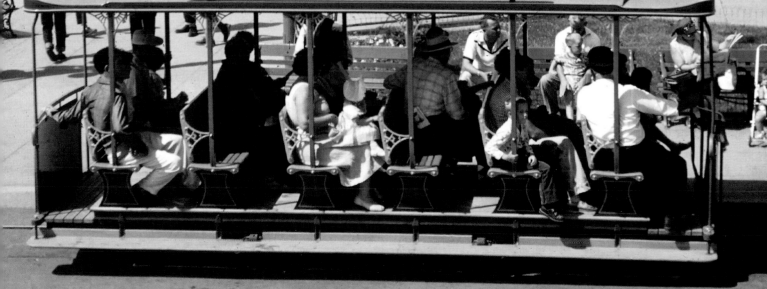

DEPOT MAIN STREET PLAZA

MAIN STREET USA

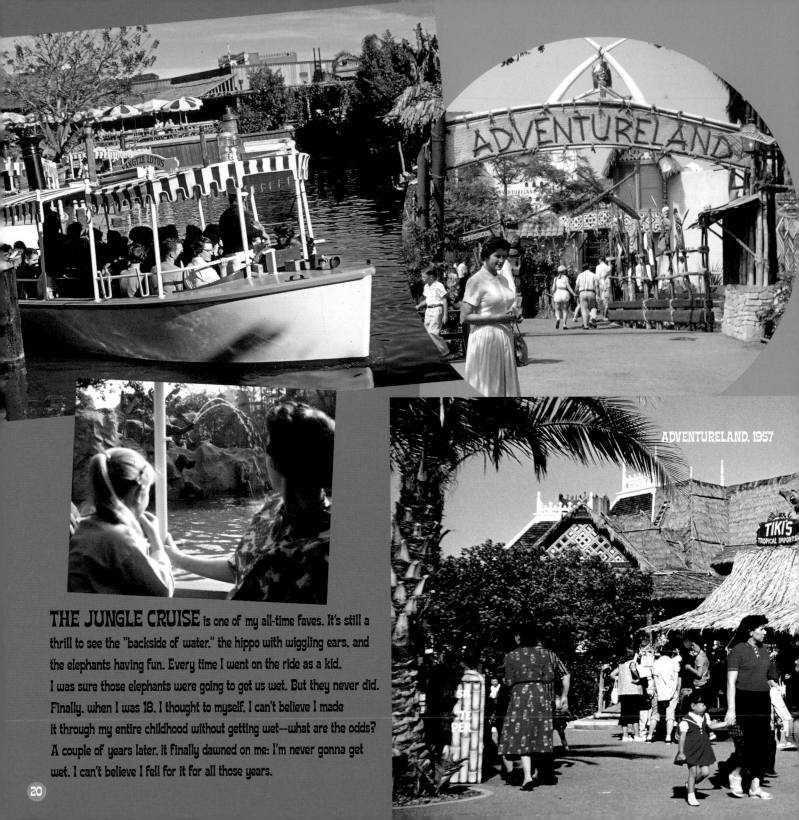

ADVENTURELAND, 1957

TIKI'S TROPICAL IMPORTS

THE JUNGLE CRUISE is one of my all-time faves. It's still a thrill to see the "backside of water," the hippo with wiggling ears, and the elephants having fun. Every time I went on the ride as a kid, I was sure those elephants were going to get us wet. But they never did. Finally, when I was 18, I thought to myself, I can't believe I made it through my entire childhood without getting wet—what are the odds? A couple of years later, it finally dawned on me: I'm never gonna get wet. I can't believe I fell for it for all those years.

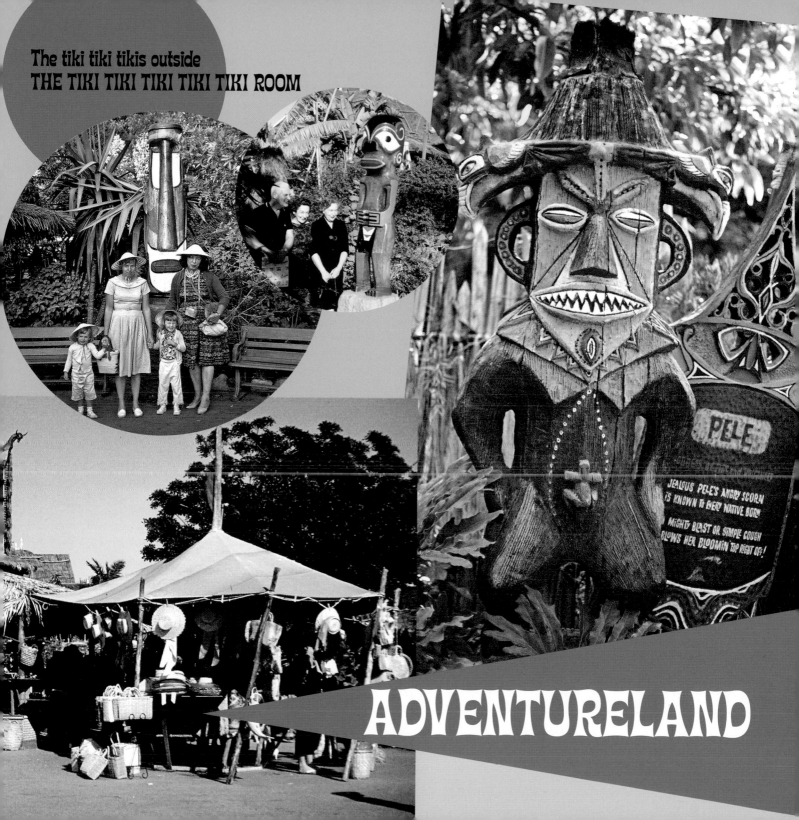

The tiki tiki tikis outside
THE TIKI TIKI TIKI TIKI TIKI ROOM

PELE

JEALOUS PELE'S ANGRY SCORN
IS KNOWN TO 'GET' NATIVE BORN!

A MIGHTY BLAST OR SIMPLE COUGH
BLOWS HER BLOOMIN' TOP RIGHT OFF!

ADVENTURELAND

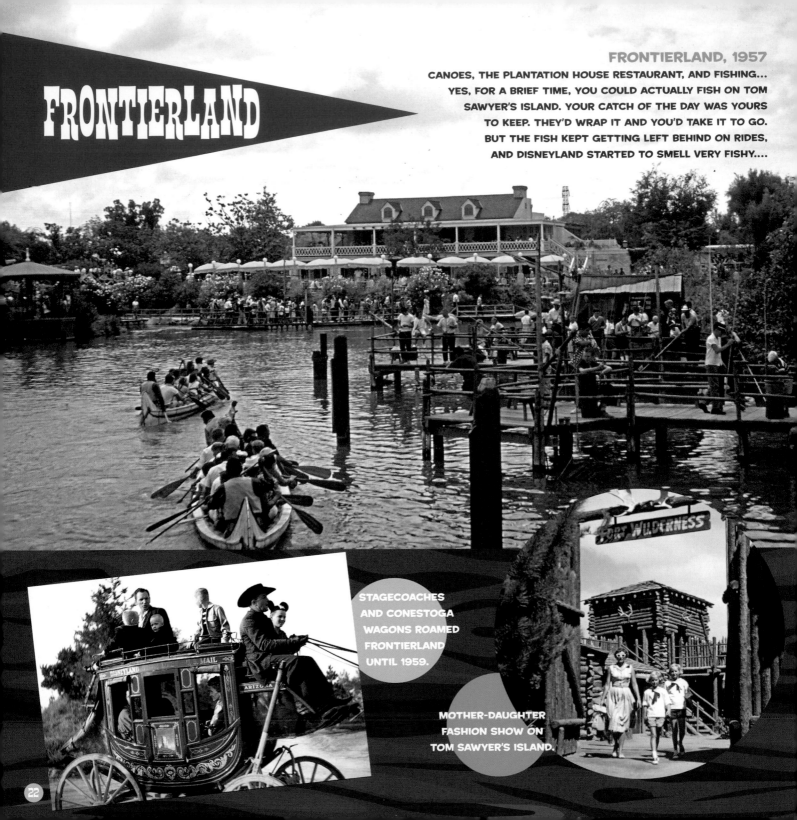

FRONTIERLAND

CANOES, THE PLANTATION HOUSE RESTAURANT, AND FISHING... YES, FOR A BRIEF TIME, YOU COULD ACTUALLY FISH ON TOM SAWYER'S ISLAND. YOUR CATCH OF THE DAY WAS YOURS TO KEEP. THEY'D WRAP IT AND YOU'D TAKE IT TO GO. BUT THE FISH KEPT GETTING LEFT BEHIND ON RIDES, AND DISNEYLAND STARTED TO SMELL VERY FISHY....

STAGECOACHES AND CONESTOGA WAGONS ROAMED FRONTIERLAND UNTIL 1959.

FORT WILDERNESS

MOTHER-DAUGHTER FASHION SHOW ON TOM SAWYER'S ISLAND.

Steering the MARK TWAIN

The *Mark Twain* is the prettiest paddle wheeler on the planet. Divine in every Dixie detail, it's the ultimate old-timey attraction in Frontierland and has been since opening day in 1955. Over the years, I've taken that round-the-island journey enough times to have gone down the entire Mississippi at least once. But when I heard you could "drive" the *Mark Twain* and then get a certificate that says, "I drove the *Mark Twain*," I just had to get my hands on the wheel. The day finally came. I boarded with five friends and politely asked the captain if we could steer the ship. He hesitated before agreeing. He ushered my group up the stairs, but as I stepped up at the end of the line, he stopped me and said, "I'm sorry, only five are allowed." I begged and pleaded and finally got an okay, but he said I'd to have to duck down the entire time I was up there. I agreed and went up the stairs, ducking the whole way. Everyone got their chance to steer and blow the whistle. Then it was my turn. I stood up to take the wheel, but he said, "Hey, duck back down."

"But I can't see where I'm going!"

"Haven't you ridden the *Mark Twain* before?" I told him I had. "Then you know where you're going!" The ride ended, and everyone got a souvenir certificate—except me. "I'm sorry," the captain said, "I just ran out." I have nothing to show for it, but I finally did get to steer the *Mark Twain*. Without even looking!

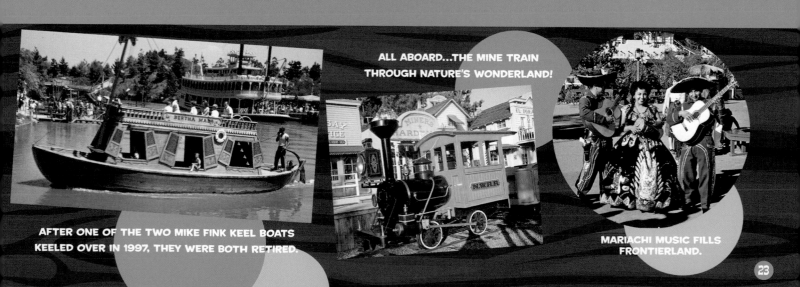

AFTER ONE OF THE TWO MIKE FINK KEEL BOATS KEELED OVER IN 1997, THEY WERE BOTH RETIRED.

ALL ABOARD...THE MINE TRAIN THROUGH NATURE'S WONDERLAND!

MARIACHI MUSIC FILLS FRONTIERLAND.

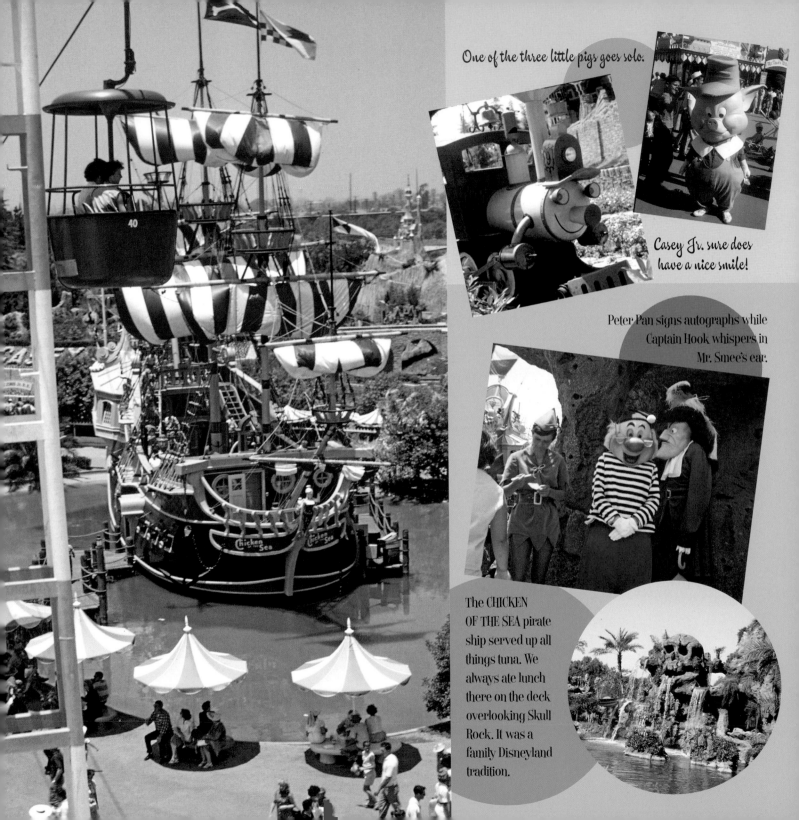

One of the three little pigs goes solo.

Casey Jr. sure does have a nice smile!

Peter Pan signs autographs while Captain Hook whispers in Mr. Smee's ear.

The CHICKEN OF THE SEA pirate ship served up all things tuna. We always ate lunch there on the deck overlooking Skull Rock. It was a family Disneyland tradition.

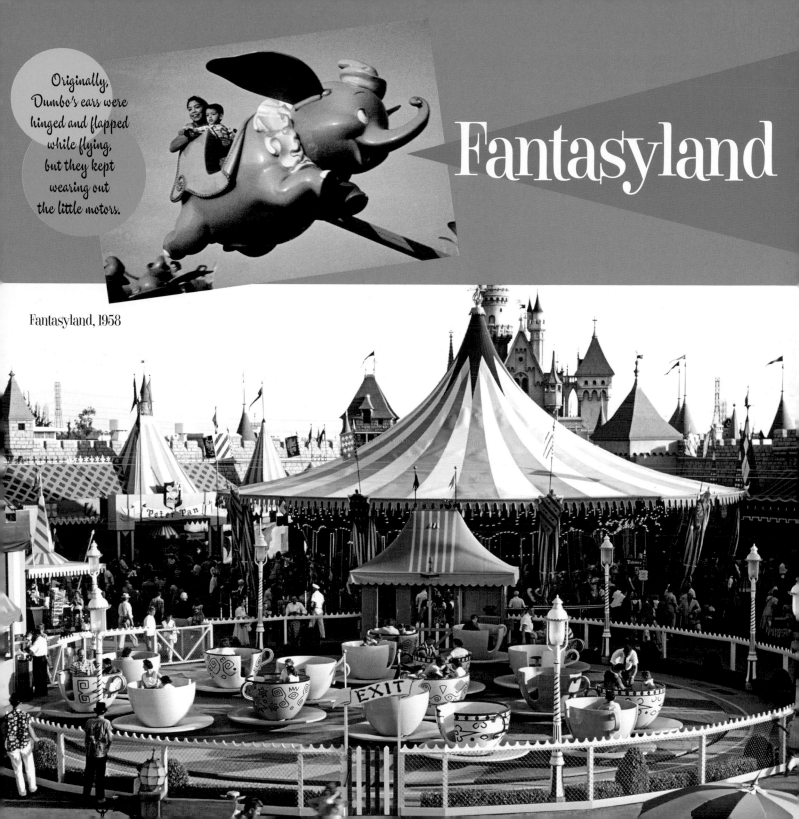

Originally, Dumbo's ears were hinged and flapped while flying, but they kept wearing out the little motors.

Fantasyland

Fantasyland, 1958

Skyway

IT WAS A RARE MOMENT IN TIME WHEN THE SKYWAY'S ORIGINAL 1956 TWO-PASSENGER GONDOLAS WERE REPLACED IN 1965 WITH UPDATED FOUR-PASSENGER GONDOLAS. SKYWAY CLOSED IN 1994.

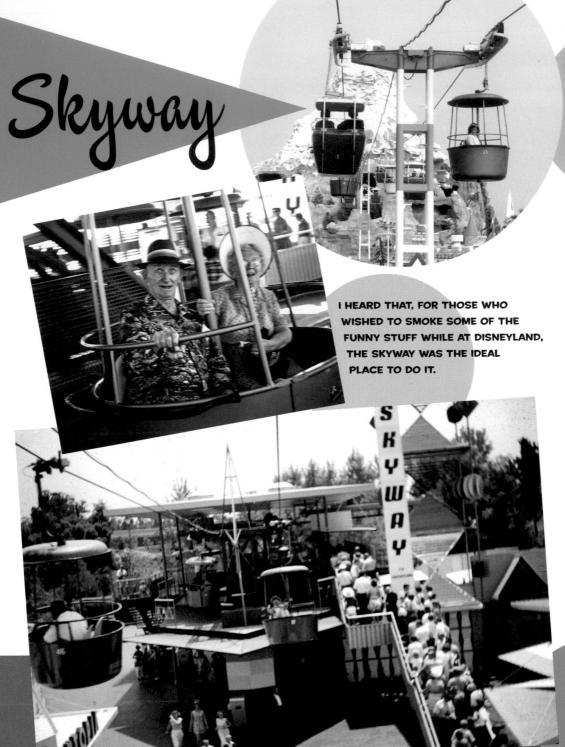

I HEARD THAT, FOR THOSE WHO WISHED TO SMOKE SOME OF THE FUNNY STUFF WHILE AT DISNEYLAND, THE SKYWAY WAS THE IDEAL PLACE TO DO IT.

THE YACHT BAR

TOMORROWLAND SKYWAY STATION, 1961.

26

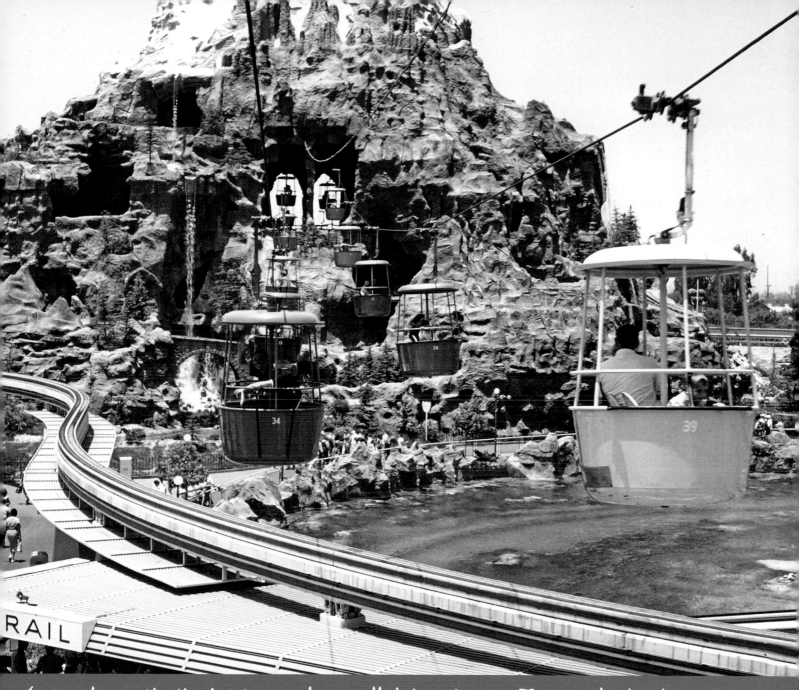

RAIL

I miss riding in the "buckets," as we always called them, between Tomorrowland and Fantasyland. The bird's-eye view of Disneyland was intoxicating. The highlight was going through the Matterhorn with all the bobsleds whooshing by.

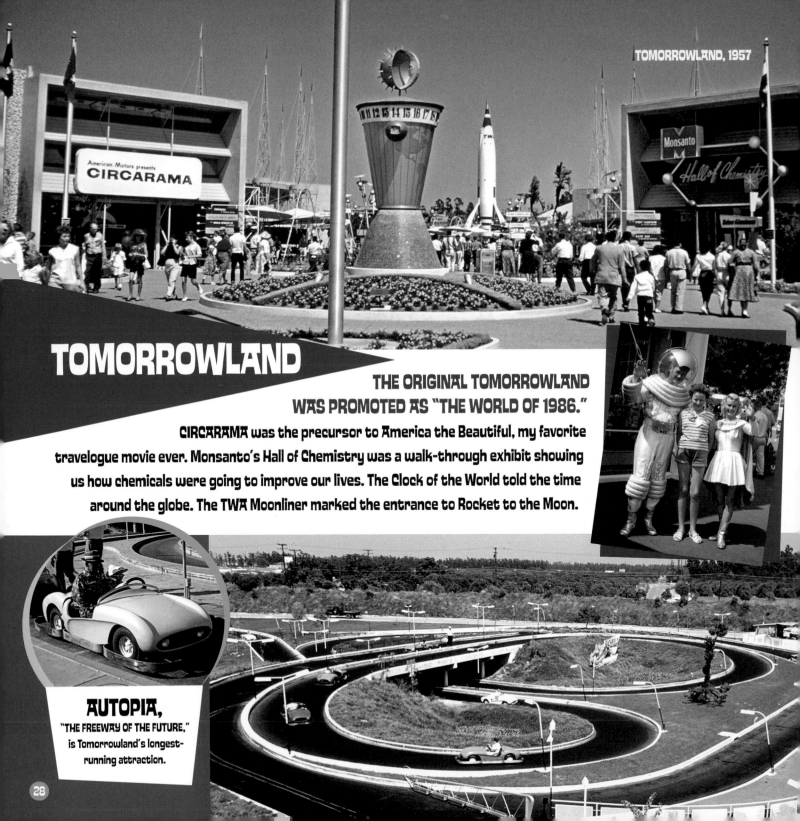

American Motors presents
CIRCARAMA

Monsanto
Hall of Chemistry

TOMORROWLAND

THE ORIGINAL TOMORROWLAND WAS PROMOTED AS "THE WORLD OF 1986."

CIRCARAMA was the precursor to America the Beautiful, my favorite travelogue movie ever. Monsanto's Hall of Chemistry was a walk-through exhibit showing us how chemicals were going to improve our lives. The Clock of the World told the time around the globe. The TWA Moonliner marked the entrance to Rocket to the Moon.

AUTOPIA,
"THE FREEWAY OF THE FUTURE,"
is Tomorrowland's longest-running attraction.

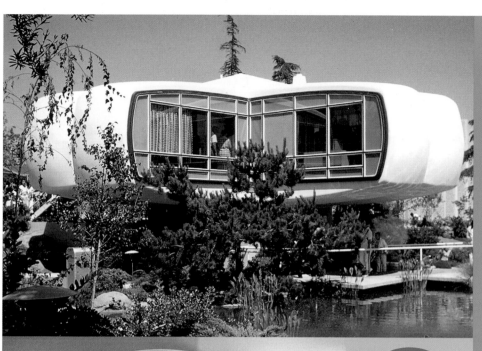

The Monsanto-sponsored three-bedroom, two-bathroom exhibit was where most visitors saw a big-screen TV, microwave cooking, electric toothbrushes, and pushbutton telephones for the first time. Ironically, this dream house still looks futuristic, but apparently it wasn't modern enough for the new Tomorrowland that was built in 1967, so it was demolished. They tried a wrecking ball, but it bounced right off the plastic, so they had to cut it up in pieces.

After one of my early slide shows, a guy came up and said, "My family's been in the garbage business for years, and my grandpa was contracted to haul the House of the Future away." Years later, we met again by chance and he said, "I never told you the end of the story. My grandfather dumped it in the Orinda landfill in Brea." That means the House of the Future is still there, since the whole thing was made of plastic. I say we all get out our shovels and dig the ol' dream home up.

HOUSE OF THE FUTURE

Lost & Sort-of Found

Very few images exist of the interior of the House of the Future.

MONSANTO CHEMICAL CO.
HOME OF THE FUTURE
← ENTRANCE
THIS WAY

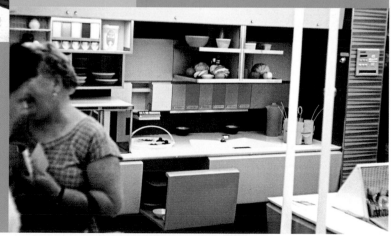

29

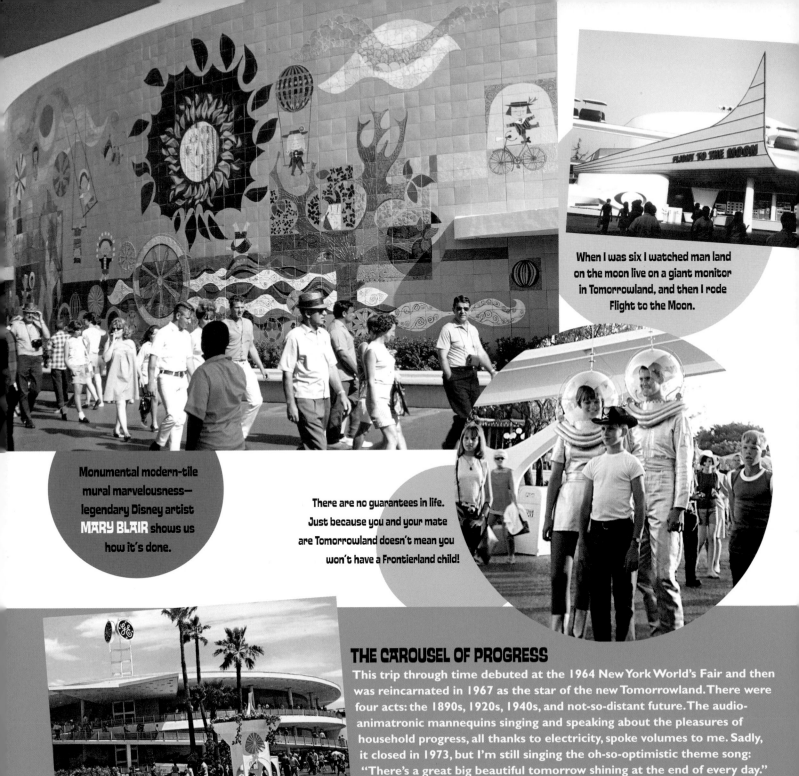

When I was six I watched man land on the moon live on a giant monitor in Tomorrowland, and then I rode Flight to the Moon.

Monumental modern-tile mural marvelousness— legendary Disney artist **MARY BLAIR** shows us how it's done.

There are no guarantees in life. Just because you and your mate are Tomorrowland doesn't mean you won't have a Frontierland child!

THE CAROUSEL OF PROGRESS

This trip through time debuted at the 1964 New York World's Fair and then was reincarnated in 1967 as the star of the new Tomorrowland. There were four acts: the 1890s, 1920s, 1940s, and not-so-distant future. The audio-animatronic mannequins singing and speaking about the pleasures of household progress, all thanks to electricity, spoke volumes to me. Sadly, it closed in 1973, but I'm still singing the oh-so-optimistic theme song: "There's a great big beautiful tomorrow shining at the end of every day."

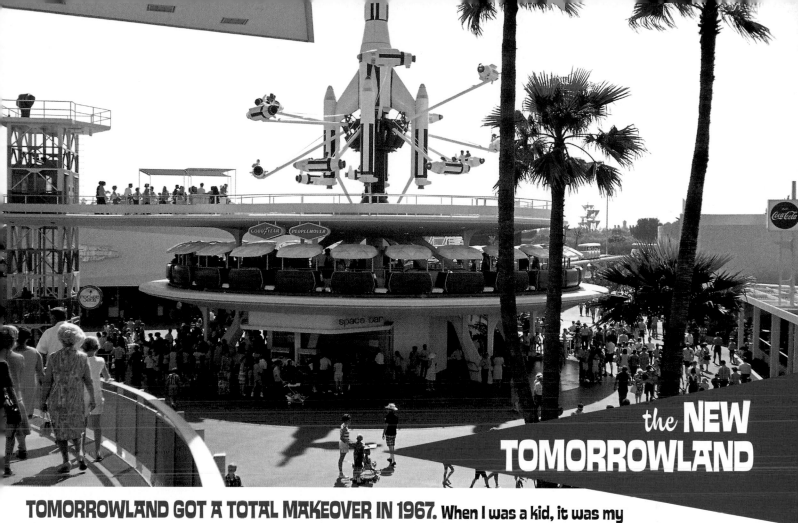

the NEW TOMORROWLAND

TOMORROWLAND GOT A TOTAL MAKEOVER IN 1967. When I was a kid, it was my favorite place in the world to be. The futuristic ambience was spectacular. The high-rise rocket jets were a bit scary but thrilling, and while the people mover was slow, I loved it anyway. And then there was the Carousel of Progress, my absolute favorite Disneyland attraction of all time.

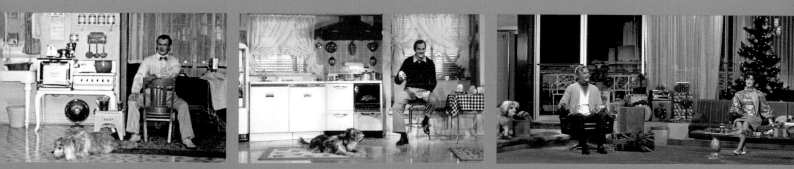

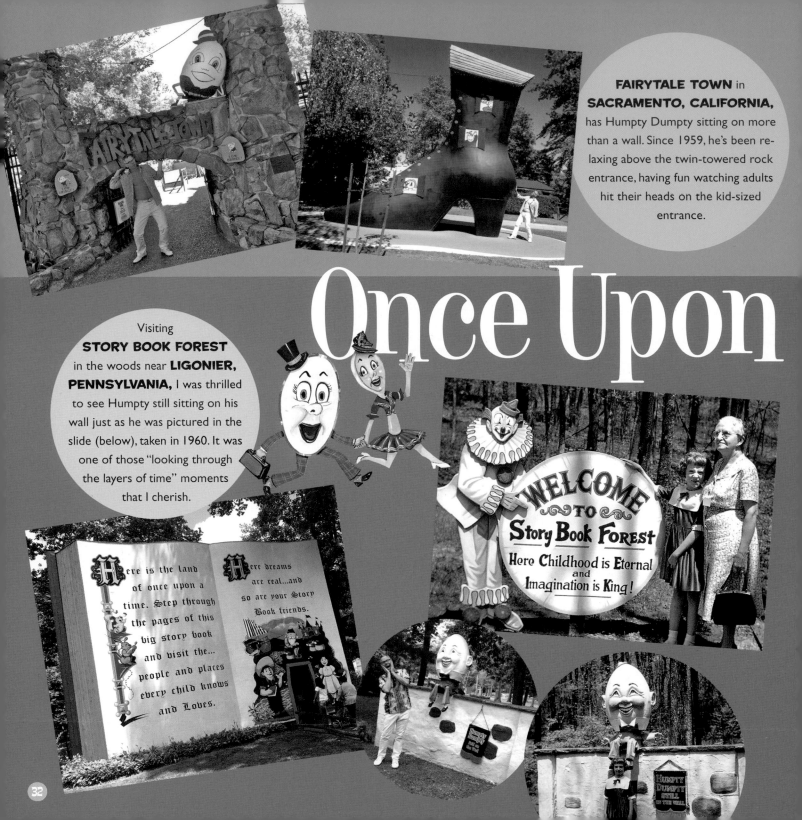

FAIRYTALE TOWN in **SACRAMENTO, CALIFORNIA,** has Humpty Dumpty sitting on more than a wall. Since 1959, he's been relaxing above the twin-towered rock entrance, having fun watching adults hit their heads on the kid-sized entrance.

Once Upon

Visiting **STORY BOOK FOREST** in the woods near **LIGONIER, PENNSYLVANIA,** I was thrilled to see Humpty still sitting on his wall just as he was pictured in the slide (below), taken in 1960. It was one of those "looking through the layers of time" moments that I cherish.

Here is the land of once upon a time. Step through the pages of this big story book and visit the... people and places every child knows and Loves.

Here dreams are real...and so are your Story Book friends.

WELCOME TO Story Book Forest
Here Childhood is Eternal and Imagination is King!

HUMPTY DUMPTY STILL ON THE WALL

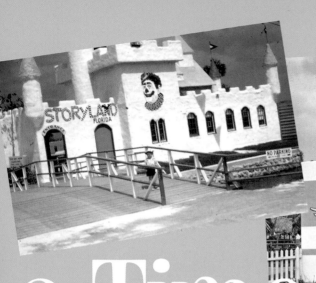

THIS IS ...

Storyland

FLORIDA

ADMISSION
Children 25¢
Adults 88¢

At **STORYLAND** in **POMPANO BEACH, FLORIDA,** visitors crossed over a moat and through this stucco castle to enter a nine-acre island of nursery rhymes.

YOU ARE NOW LEAVING... THE LAND OF REALITY

a Time...

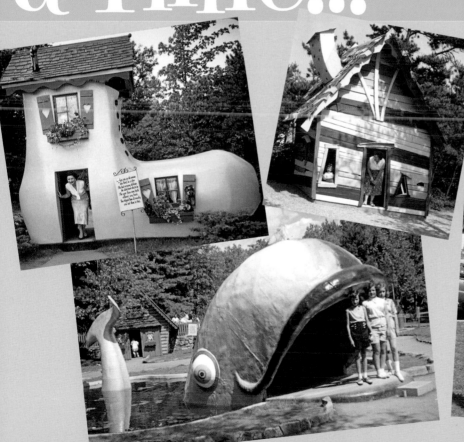

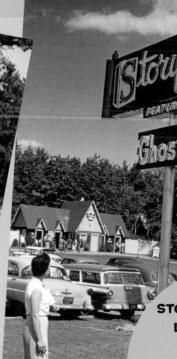

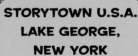

STORYTOWN U.S.A. LAKE GEORGE, NEW YORK

When it opened in 1954, Storytown was billed as the Never-Never Land of the Adirondacks.

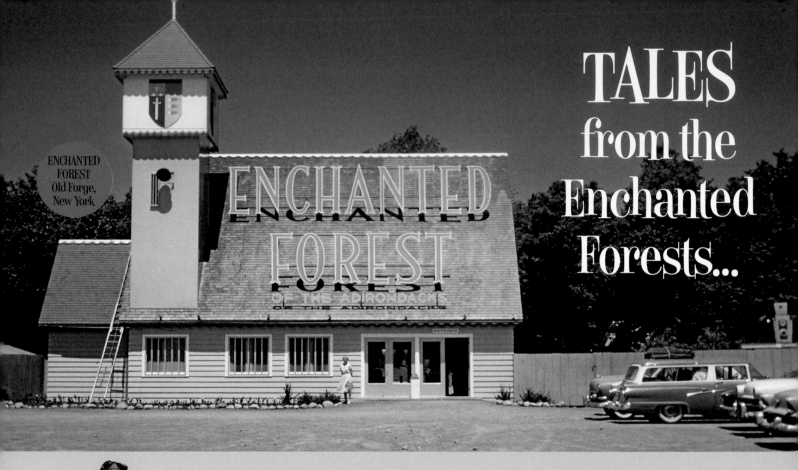

TALES from the Enchanted Forests...

Once Upon a Time...
PAUL "PEE-WEE HERMAN" REUBENS AND I were among a small group invited by a mutual friend to visit her family's historic mountain cabin in the Adirondacks. As fate would have it, we were five miles from the Enchanted Forest, a children's storybook theme park built in Old Forge, New York, in 1956. There was no way I was going to leave the Adirondacks without seeing if the Enchanted Forest was still enchanted.

So midway through the week, while taking a break between camp activities, I suggested that we all go on a field trip to Old Forge. Everyone said no but Paul. Off we went, him disguised in a hat and sunglasses and me thinking to myself over and over, *I can't believe I'm going to the Enchanted Forest with Pee-wee Herman!*

Once beyond the vintage turnstile, we were both charmed by the storybook wonderland. Everything was original, just a bit thicker from so many coats of paint. After we'd seen it all and had had several encounters with his fans (even with his hat and sunglasses, they still recognized him), it was time to go.

While he was driving us back to camp, he started to talk about his TV show, *Pee-wee's Playhouse*. I hesitated and finally had to confess that I'd never seen it. Without skipping a beat, he veered to a screeching halt on the side of the road, reached across me, threw my door open, and said, "Get out!" I refused, and we drove on. Then the conversation turned to guacamole. I said, "Oh, I love guacamole!" He said, "Then why don't you marry it?" THE END

Once Upon a Time...HUMPTY DUMPTY TOOK A GREAT FALL. Humpty had been perched on his wall for nearly five and a half decades when two boys behaving badly climbed up to take a selfie with him. This was all was too much for the beloved egg man, who ended up scrambled on the ground. Owner Roger Tofte came to his rescue, putting Humpty Dumpty back together again and setting him on the wall where he belongs. The story had a fairytale ending—it went viral, bringing new visitors and becoming the best thing had that happened to the Enchanted Forest in years. Everyone lived happily ever after. THE END

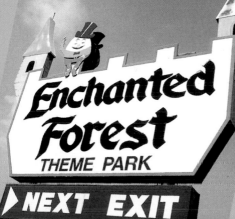

ENCHANTED FOREST
Turner, Oregon

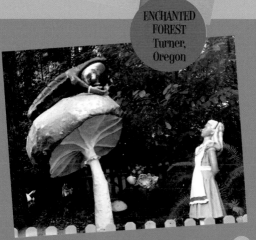

Once Upon a Time...ROGER TOFTE, the king, mastermind, builder, and chief engineer of Oregon's Enchanted Forest, began constructing his magical land in 1964. Carving out a forest and crafting a kingdom took a bit longer than he thought—the grand opening didn't happen until 1971. The first time I did a slide show in Portland, of course I included the Enchanted Forest. When I said, "This place didn't build itself" and clicked to a picture of Mr. Tofte, the audience cheered, having no idea he was sitting in the front row. I introduced him, he stood, and the crowd jumped up and nearly blew the roof off the place. After the performance, his ten-year-old grandson came up to me with tears in his eyes and said, "This is the nicest thing that's ever happened to my grandfather." THE END

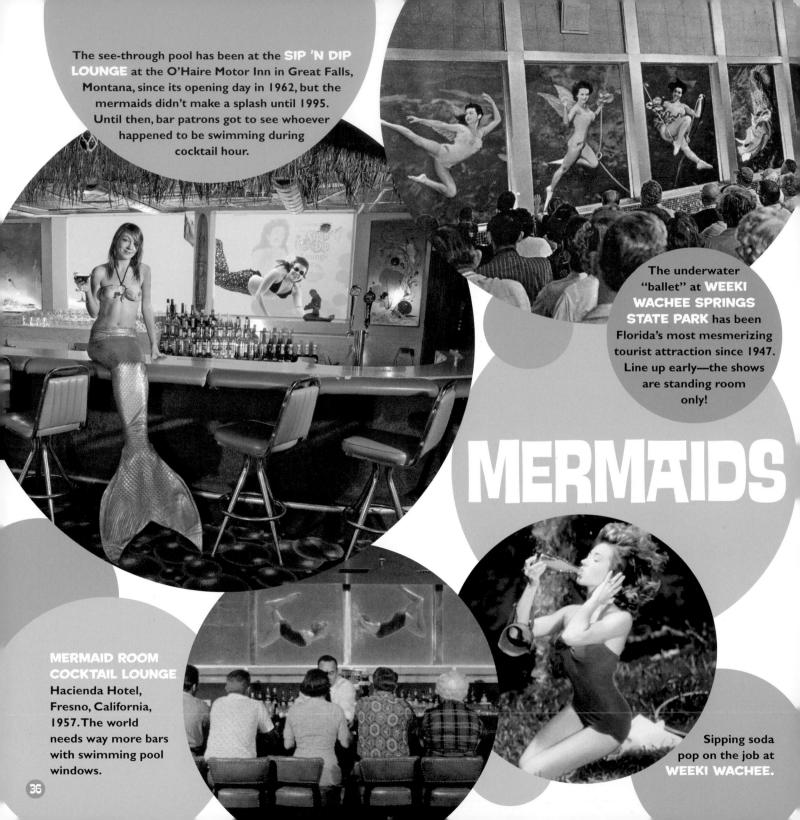

The see-through pool has been at the **SIP 'N DIP LOUNGE** at the O'Haire Motor Inn in Great Falls, Montana, since its opening day in 1962, but the mermaids didn't make a splash until 1995. Until then, bar patrons got to see whoever happened to be swimming during cocktail hour.

The underwater "ballet" at **WEEKI WACHEE SPRINGS STATE PARK** has been Florida's most mesmerizing tourist attraction since 1947. Line up early—the shows are standing room only!

MERMAIDS

MERMAID ROOM COCKTAIL LOUNGE Hacienda Hotel, Fresno, California, 1957. The world needs way more bars with swimming pool windows.

Sipping soda pop on the job at **WEEKI WACHEE.**

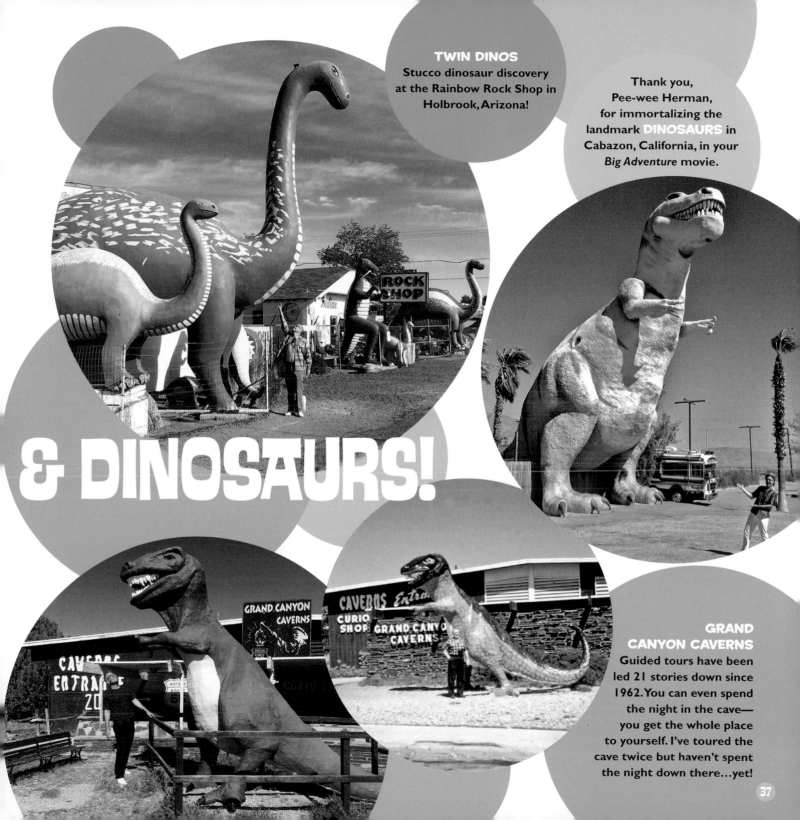

TWIN DINOS
Stucco dinosaur discovery at the Rainbow Rock Shop in Holbrook, Arizona!

Thank you, Pee-wee Herman, for immortalizing the landmark **DINOSAURS** in Cabazon, California, in your *Big Adventure* movie.

& DINOSAURS!

GRAND CANYON CAVERNS
Guided tours have been led 21 stories down since 1962. You can even spend the night in the cave—you get the whole place to yourself. I've toured the cave twice but haven't spent the night down there...yet!

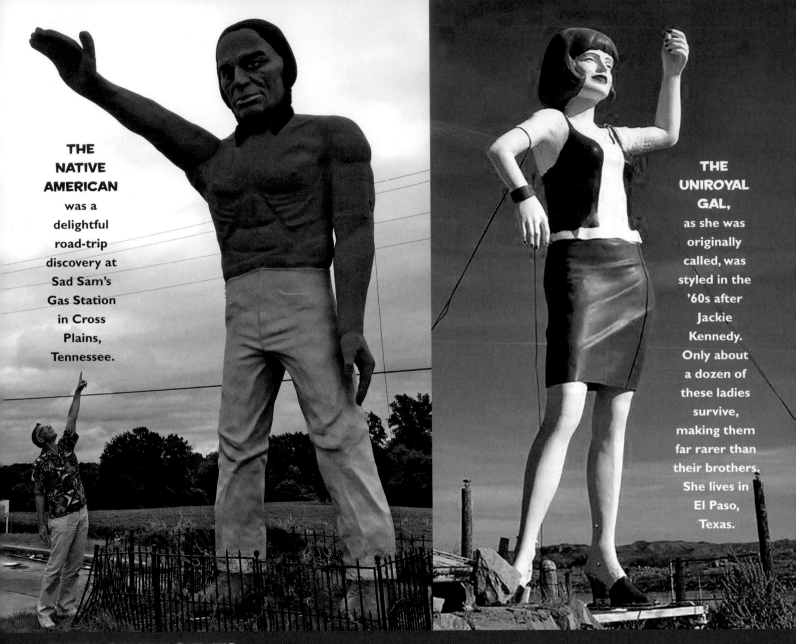

THE NATIVE AMERICAN was a delightful road-trip discovery at Sad Sam's Gas Station in Cross Plains, Tennessee.

THE UNIROYAL GAL, as she was originally called, was styled in the '60s after Jackie Kennedy. Only about a dozen of these ladies survive, making them far rarer than their brothers. She lives in El Paso, Texas.

THESE GENTLE GIANTS were the successful products of the International Fiberglass Company in Venice, California.
Thousands of them were cloned and migrated all over the United States. The origin of the species was a Paul Bunyan figure made in 1962 for a café on Route 66 in Flagstaff, Arizona. Sales were slow at first, but after a photo of one of the company's big guys standing in front of a gas station in Las Vegas appeared in a national advertising magazine, orders began flooding in, and giant-fiberglass-man production was in full swing. The family expanded to include golfers, cowboys, spacemen, Native Americans, and, most famously, muffler men, all offspring of the original mold. Buyers could dress their giant-man dolls up with a long list of accessories. The survivors are highly prized, the grandest of all collectible figures.

LAND
OF THE
GIANTS

I slammed on the brakes the instant I encountered **PAUL BUNYAN** at Don's Hot Rod Shop in Tucson, Arizona. I was spellbound and starstruck. I bopped into the shop and started asking questions. Turns out the shop owner bought Paul brand new in 1964 for a mere $1,275, and he's been standing in the same spot since. At Christmastime they hand him a candy cane, put a beard on him, and suit him up as Santa. He's even been known to sport a tutu a time or two.

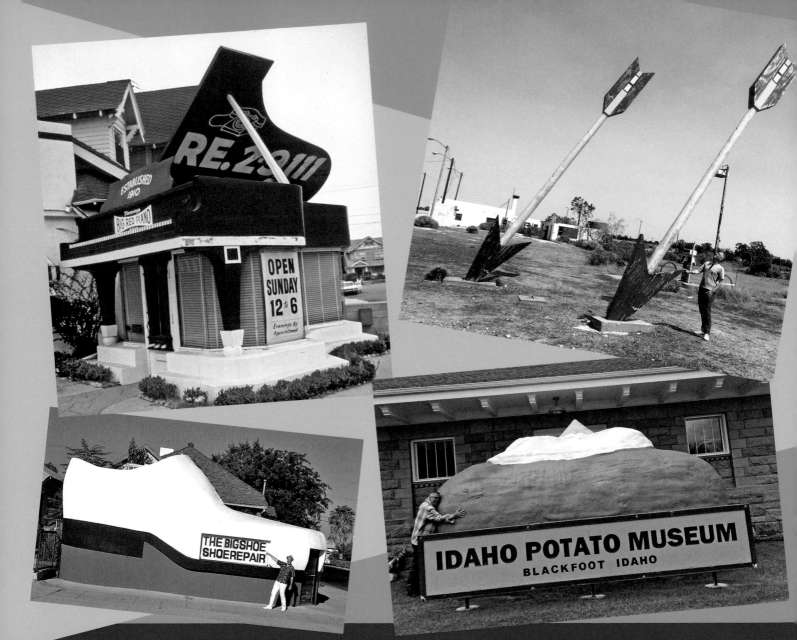

THE BIG RED PIANO in Los Angeles began duty in 1930 as the entrance to a showroom selling, yep, pianos. In 1972, the store burned, and the fire department doomed the grand grand piano by deeming it unsafe. Preservationists came to the rescue, but while they were unloading it at its new location, they dropped it and it splintered into smithereens.

THE BIG SHOE SHOE REPAIR, located in Bakersfield, California, since 1947, gives heart and soul a whole new meaning.

Yes to extra butter and sour cream on the **GIANT BAKED POTATO,** which is found (of course) at the Idaho Potato Museum in Blackfoot, Idaho.

THE TWIN ARROWS, just east of Flagstaff, Arizona, are legendary Route 66 landmarks.

Dating to 1952, **THE BOOTS** of Seattle's legendary hat-and-boots duo were originally restrooms for a gas station.

THE RADIO FLYER WAGON sits in front of company headquarters in Chicago, Illinois, where they began manufacturing wagons since 1917.

This is what happens when a playground designer watches the movie *Franken-stein* one too many times on the late late show. The screws are a dead giveaway. **GIGANTA,** a 1970s Southern California creation, is a cross between a giant toy robot and a birdcage. He's part observation deck, part thrill ride, part jungle gym, and part park pop art.

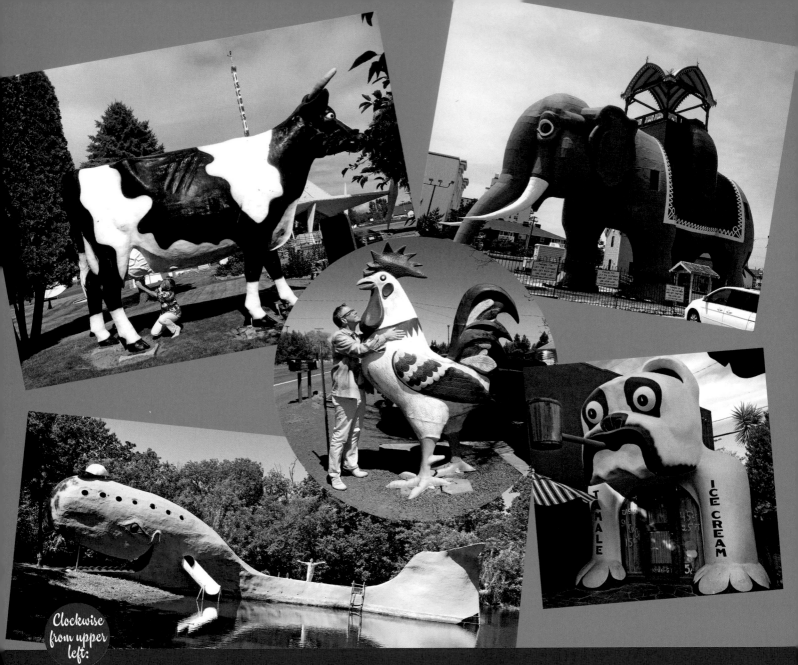

Clockwise from upper left:

In Neillsville, Wisconsin, put a quarter in the slot of **CHATTY BELLE, THE TALKING COW,** and she talks to you about cheese.

LUCY, THE LEGEND-ARY ELEPHANT, is the most famous landmark on the New Jersey Shore and has been since 1881.

BULLDOG CAFE, a 1980s re-creation of the L.A. original from the 1930s, is now displayed at the Idle Hour Bar in North Hollywood, California.

THE BLUE WHALE of Catoosa, Oklahoma, is one of the most popular attractions on Route 66.

A GIANT CHICKEN sighting is always a special thrill. This one landed in front of a nursery in Bend, Oregon.

GATORLAND, ORLANDO, FLA.

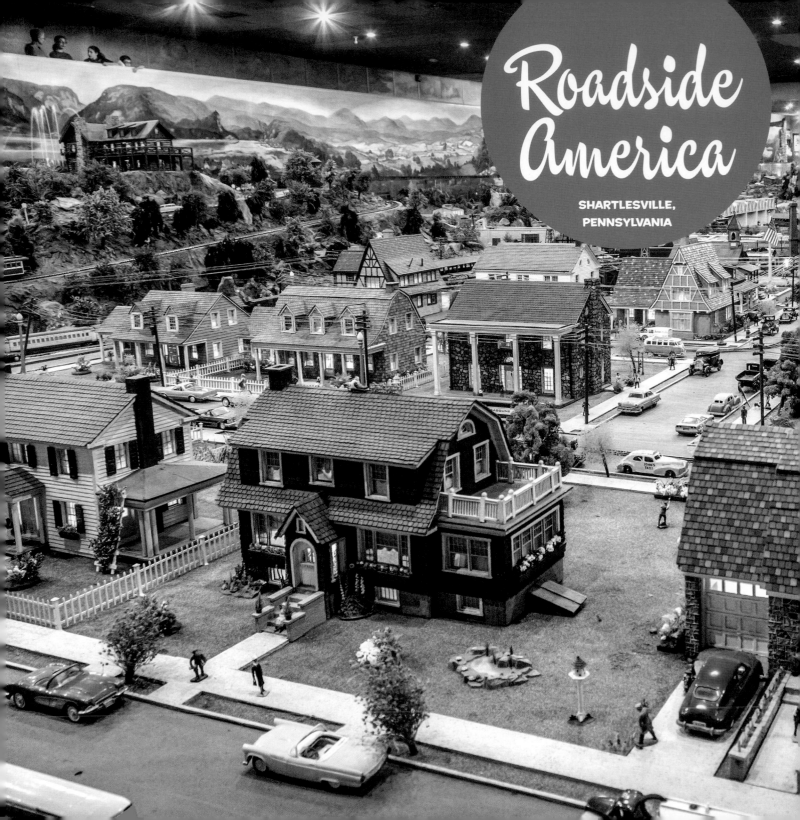

Roadside America

SHARTLESVILLE, PENNSYLVANIA

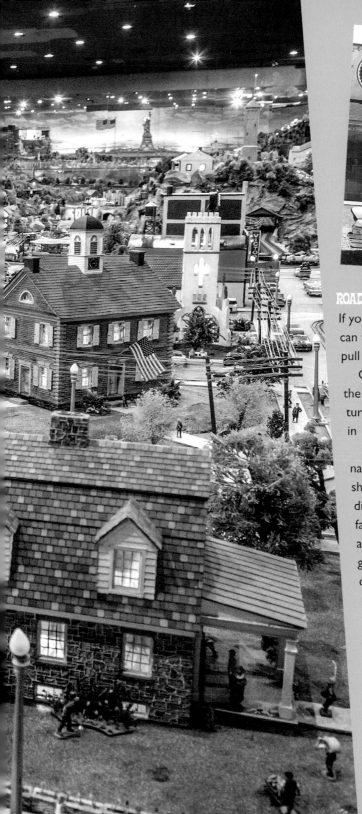

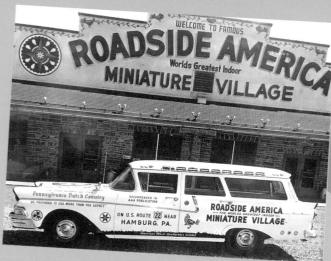

ROADSIDE AMERICA IS THE WORLD'S GREATEST INDOOR MINIATURE VILLAGE.

If you're looking for genuine, homespun, family-run Americana, this is it. You can feel the heart and soul of this time-honored attraction the minute you pull into the parking lot.

Covering some 7,450 square feet, this massive made-with-love display is the life's work of one man, Laurence T. Gieringer, who began building miniatures in 1899 when he was five years old and didn't stop until his dying day in 1963.

Photos simply cannot capture the imaginative detail and crazy-great craftsmanship that went into creating this epic display of villages, streams, trees, farmland, and even a circus parade and working Ford factory. You get the feeling that very little has changed since it opened to the public in 1953, because it hasn't.

Mr. Gieringer's granddaughter, who dutifully runs the place, can tell you all about it. She's been there her entire life.

The grand finale of the experience is when night falls over the miniature world and Kate Smith sings "God Bless America." If that's not Americana, I don't know what is! This was on the top of my must-see list for a long, long time. When I left I wept a little.

Master miniature maker Laurence T. Gieringer keeping house.

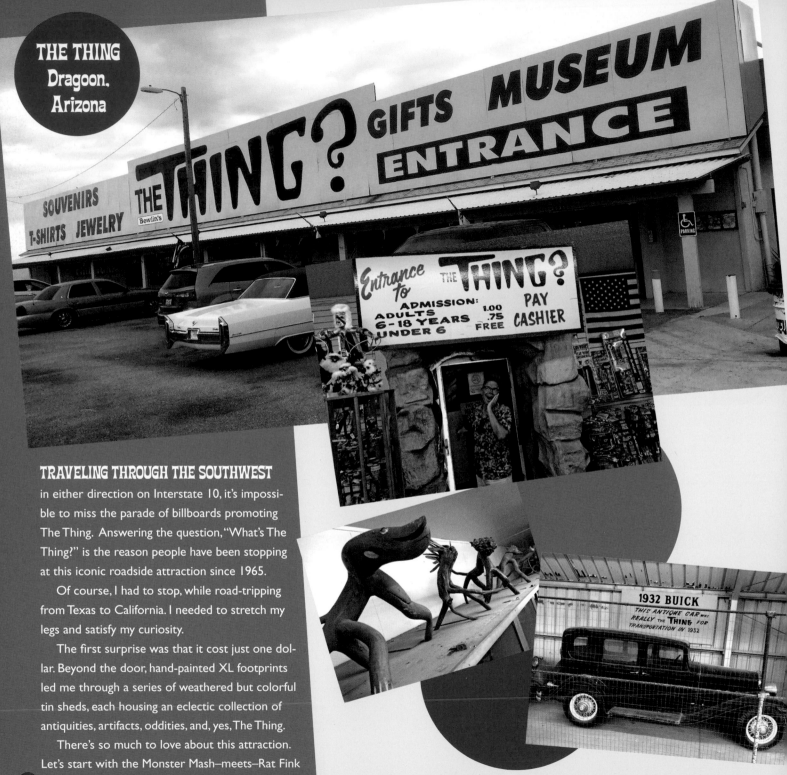

THE THING
Dragoon, Arizona

TRAVELING THROUGH THE SOUTHWEST

in either direction on Interstate 10, it's impossible to miss the parade of billboards promoting The Thing. Answering the question, "What's The Thing?" is the reason people have been stopping at this iconic roadside attraction since 1965.

Of course, I had to stop, while road-tripping from Texas to California. I needed to stretch my legs and satisfy my curiosity.

The first surprise was that it cost just one dollar. Beyond the door, hand-painted XL footprints led me through a series of weathered but colorful tin sheds, each housing an eclectic collection of antiquities, artifacts, oddities, and, yes, The Thing.

There's so much to love about this attraction. Let's start with the Monster Mash–meets–Rat Fink

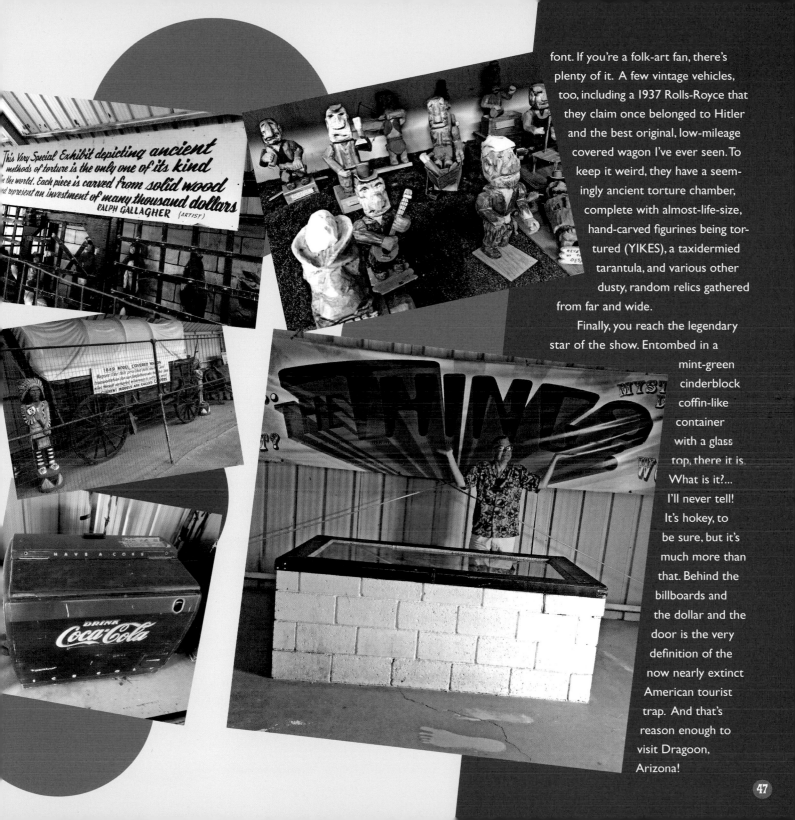

This Very Special Exhibit depicting *ancient methods of torture* is the only one of *its kind* in the world. Each piece is carved from *solid wood* and represent an investment of *many thousand dollars*
RALPH GALLAGHER (ARTIST)

font. If you're a folk-art fan, there's plenty of it. A few vintage vehicles, too, including a 1937 Rolls-Royce that they claim once belonged to Hitler and the best original, low-mileage covered wagon I've ever seen. To keep it weird, they have a seemingly ancient torture chamber, complete with almost-life-size, hand-carved figurines being tortured (YIKES), a taxidermied tarantula, and various other dusty, random relics gathered from far and wide.

Finally, you reach the legendary star of the show. Entombed in a mint-green cinderblock coffin-like container with a glass top, there it is. What is it?... I'll never tell! It's hokey, to be sure, but it's much more than that. Behind the billboards and the dollar and the door is the very definition of the now nearly extinct American tourist trap. And that's reason enough to visit Dragoon, Arizona!

AMISH COUNTRY

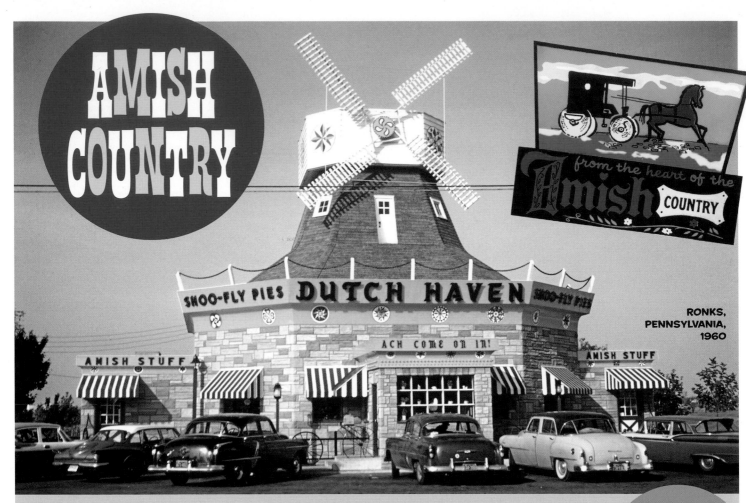

SHOO-FLY PIES DUTCH HAVEN SHOO-FLY PIES

ACH COME ON IN!

AMISH STUFF AMISH STUFF

from the heart of the Amish COUNTRY

RONKS, PENNSYLVANIA, 1960

I'm always hungry for local foods wherever I go, so there was no way I was going to road-trip through Pennsylvania without stopping at DUTCH HAVEN for a free sample of shoo-fly pie. This taste-treat sensation is an Amish-country tradition that's been made the old-fashioned way since 1946.

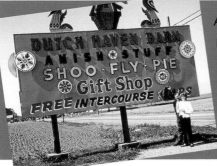

DUTCH HAVEN BARN AMISH STUFF SHOO·FLY·PIE Gift Shop FREE INTERCOURSE MAPS

A man half-hides behind a redheaded woman posing before a rural roadside billboard for the **DUTCH HAVEN BARN GIFT SHOP.** The colorful, multi-font display promotes Amish stuff, shoo-fly-pie, and free intercourse. Everybody loves a bargain, but it's always better when you can get it for free!

Shoo-fly pie makes a perfect hostess gift for my friend Mod Betty.

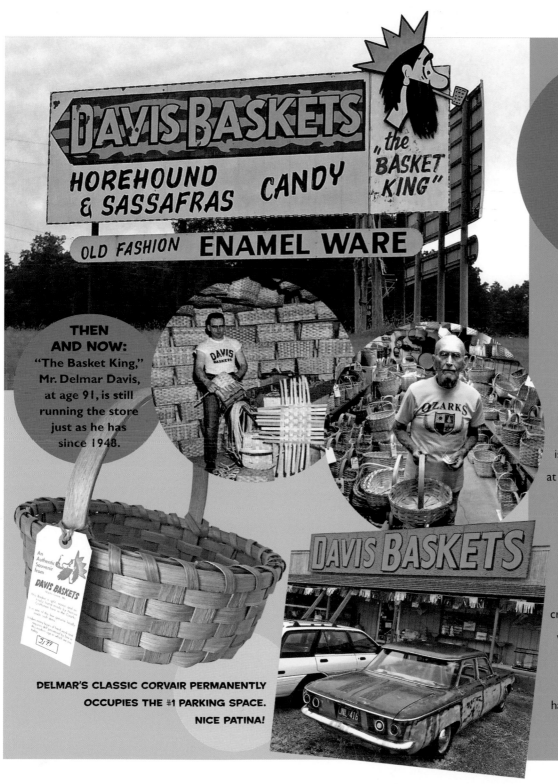

DAVIS BASKETS

← HOREHOUND & SASSAFRAS CANDY "the BASKET KING"

OLD FASHION **ENAMEL WARE**

THEN AND NOW: "The Basket King," Mr. Delmar Davis, at age 91, is still running the store just as he has since 1948.

An Authentic Souvenir from **DAVIS BASKETS**

DELMAR'S CLASSIC CORVAIR PERMANENTLY OCCUPIES THE #1 PARKING SPACE. NICE PATINA!

LAKE of the OZARKS

"Charles"

A VISIT TO THE OZARKS

isn't complete without a stop at the area's most time-honored and precious roadside attraction, Davis Baskets, where you'll find a dizzying display of beautiful baskets handwoven by local craftspeople. There's an infinite variety of styles and sizes to choose from. Of course, I had to have one. Got a hand-painted hillbilly mug with my name on it, too!

No VACANCY

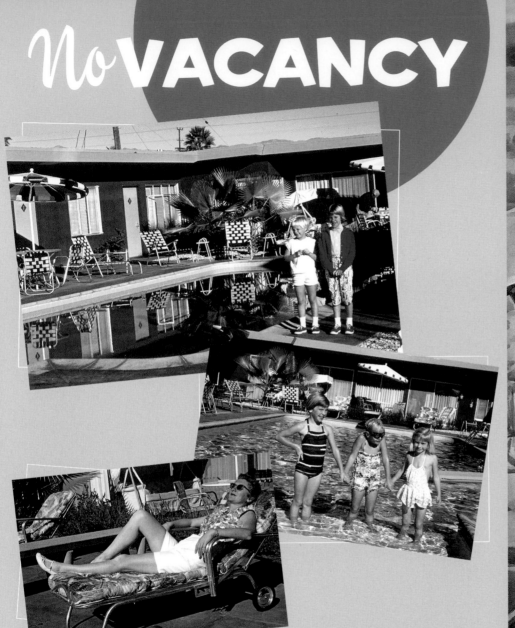

GAY'S MAR-ROY MANOR
Palm Springs

WHILE MEANDERING AROUND THE PALM SPRINGS MODERNISM SHOW a few years ago, I spotted this watercolor rendering of Gay's Mar-Roy Manor, signed F. Romley, 1960. Most likely it was painted for and hung beside the check-in desk. Everything about the motel in the painting sang to me: the white-rock roof, the pink-and-aqua trim, the patio furniture, the palm trees, the parking lot, even the swimmers in the pool. Plus, it's Palm Springs, the ultimate land of leisure. And just look at the pastel watercolor palette and its hon- est, amateur, folk-artsy style! I just had to have it. Home it went, where I promptly and proudly hung it on the

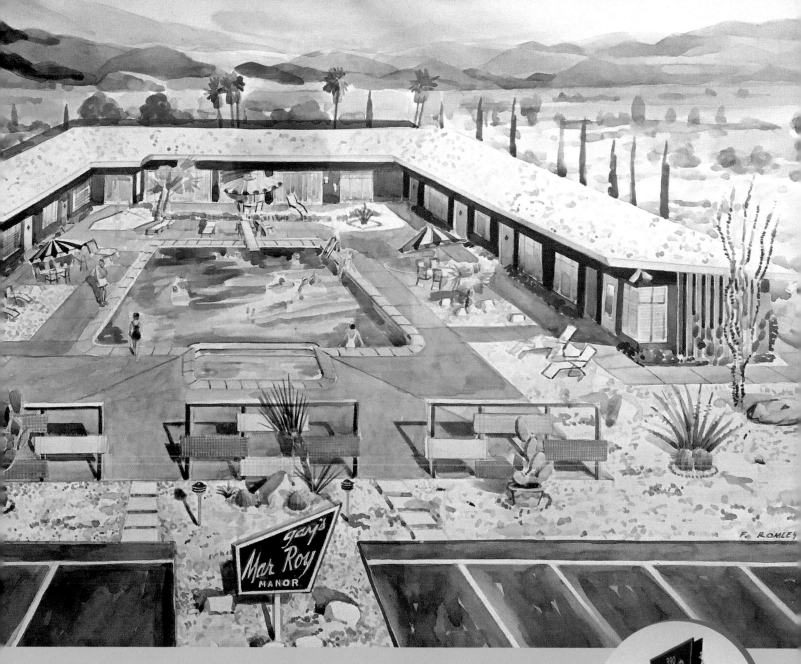

wall above my desk, where it's been ever since. I admire it several times a day at least. (BTW, "Mar" is short for Marcia—her husband's name was Roy, and Gay was their last name.)

A few years went by. I was going through a new-to-me collection of Kodachrome slides and came across several images of a motel that looked familiar. Could this be Gay's Mar-Roy Manor? I looked at the painting on the wall, looked back at the slides a couple of times, and sure enough, that was it. It's always a thrill when paths cross across the layers of time. I love putting the puzzle pieces of history together.

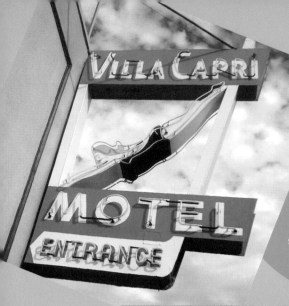

VILLA CAPRI
Coronado, California

Other than the superb sign at the Starlite, this is the only other diving-girl sign left in the wild. Long may she dive, just as she's been doing since 1956.

WORLD'S GREATEST DIVING GIRL SIGN
Starlite Motel, Mesa, Arizona

The people of Mesa showed us how to treat an electrifying national treasure. In 2010, their EPIC landmark animated neon diving-girl sign blew over in a terrible windstorm. The community was so fond of the iconic midcentury diver that they came together and raised the money to restore, rebuild, and relight her. That's the spirit!

THE MARK MOTEL 1958, Location unknown

A 1961 Ford Country Squire station wagon does the backstroke!

MOTEL MOTEL MOTEL MOTEL

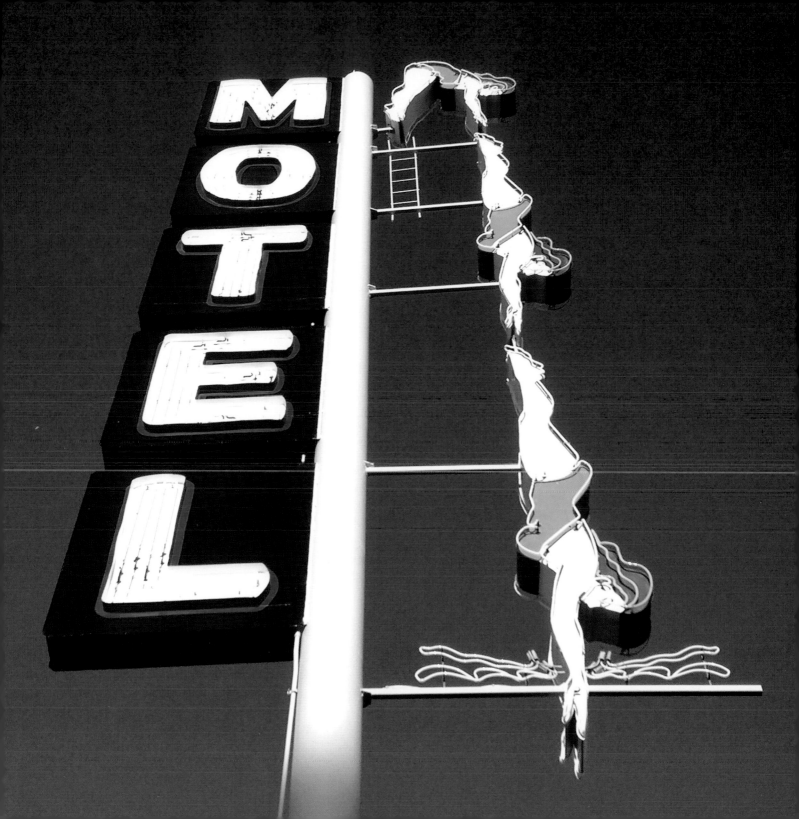

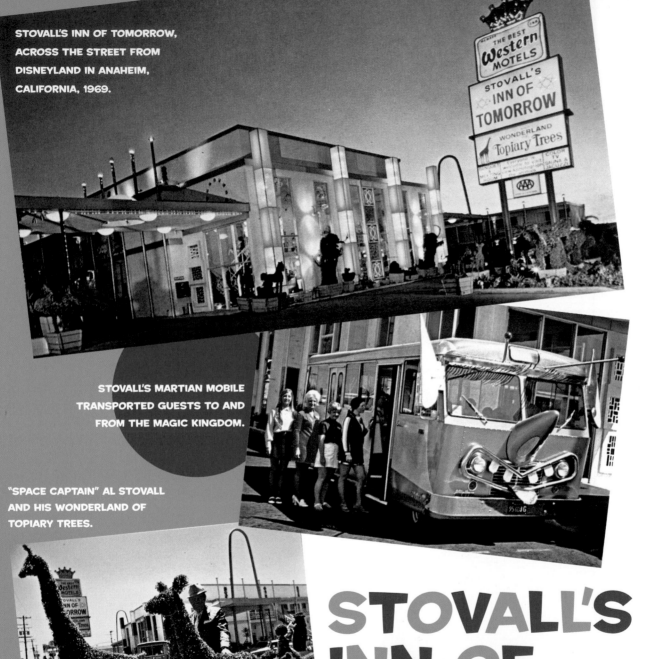

STOVALL'S INN OF TOMORROW, ACROSS THE STREET FROM DISNEYLAND IN ANAHEIM, CALIFORNIA, 1969.

STOVALL'S MARTIAN MOBILE TRANSPORTED GUESTS TO AND FROM THE MAGIC KINGDOM.

"SPACE CAPTAIN" AL STOVALL AND HIS WONDERLAND OF TOPIARY TREES.

STOVALL'S INN OF TOMORROW!

"MOON-LEVEL LUXURY AT DOWN-TO-EARTH RATES"

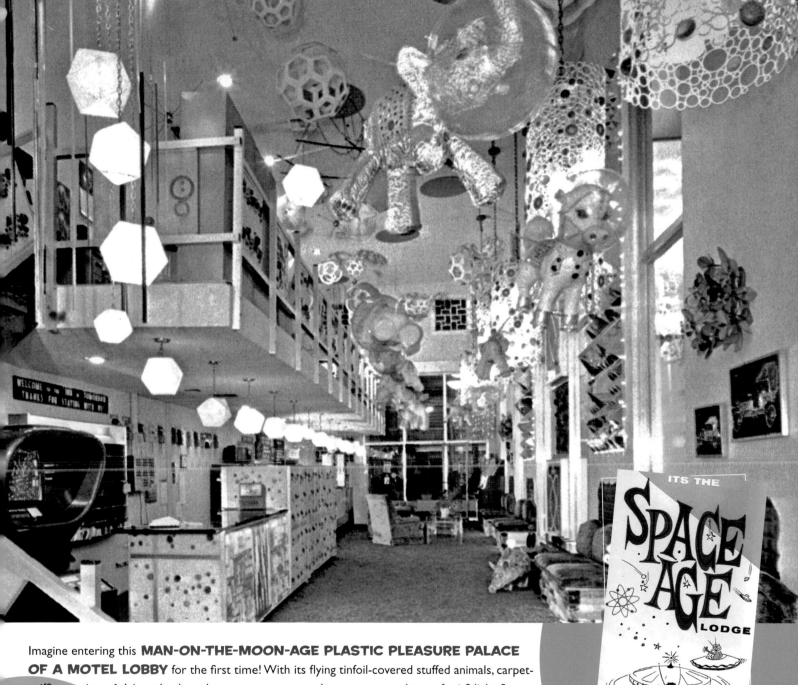

Imagine entering this **MAN-ON-THE-MOON-AGE PLASTIC PLEASURE PALACE OF A MOTEL LOBBY** for the first time! With its flying tinfoil-covered stuffed animals, carpet-sniffing papier-mâché aardvark, early computer game, and space-age symphony of sci-fi light fixtures and décor, it's Tomorrowland–meets–It's a Small World gone mad. When it comes to the future, more is more.

Today, Stovall's is still a hotel, but only the Wonderland of Topiary Trees remains intact. The once-wacky lobby has been totally "updated" and stripped of all its otherworldly delights.

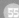

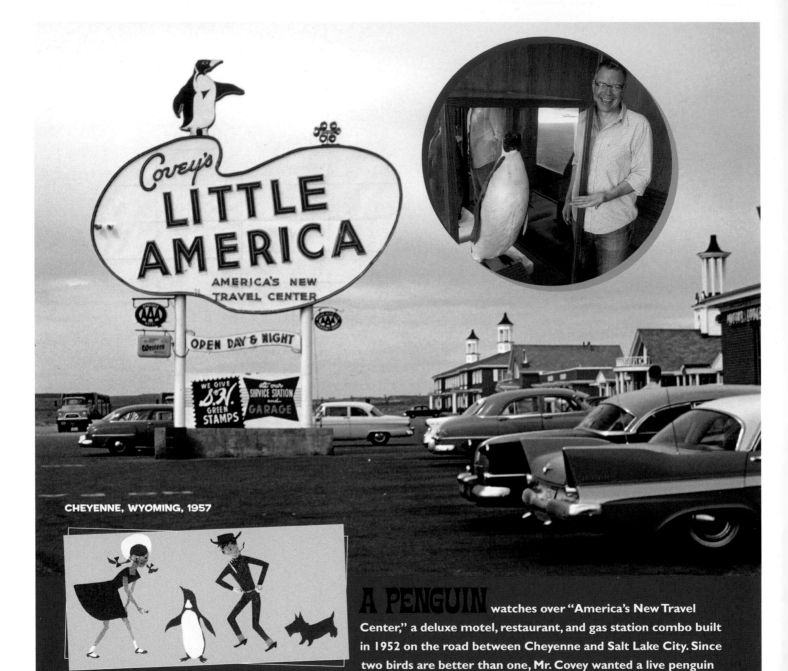

CHEYENNE, WYOMING, 1957

A PENGUIN watches over "America's New Travel Center," a deluxe motel, restaurant, and gas station combo built in 1952 on the road between Cheyenne and Salt Lake City. Since two birds are better than one, Mr. Covey wanted a live penguin in a cage on display for his customers. So he ordered one from a penguin dealer in the Antarctic. But when the bird arrived it was dead. So Mr. Covey called a taxidermist and had the poor thing stuffed. To this day the dead penguin remains mounted on a fake block of ice in the hotel for us all to enjoy.

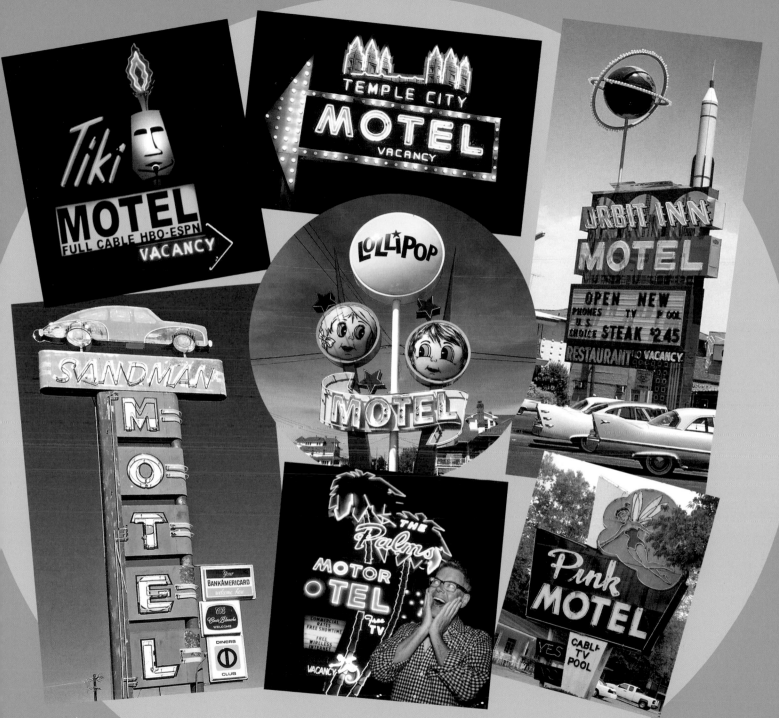

Clockwise from upper left: TIKI MOTEL, Tucson, Arizona; TEMPLE CITY MOTEL, Salt Lake City, Utah; ORBIT INN MOTEL, Las Vegas, Nevada;
PINK MOTEL, Cherokee, North Carolina; PALMS MOTOR HOTEL, Portland, Oregon; SANDMAN MOTEL, Reno, Nevada; LOLLIPOP MOTEL, Wildwood, New Jersey.
Miraculously, these classic motel signs are still standing, with the exception of the Orbit Inn.

THE VINTAGE WIGWAM NEON SIGN GLOWS NIGHTLY IN CAVE CREEK, KENTUCKY.

EVER SLEPT IN A WIGWAM?

Spending the night in a cement wigwam is the ultimate vintage-motel experience. A developer named Frank Redford built the first of his nine Wigwam Motels in Horse Cave, Kentucky, in 1933. Miraculously, three locations are still standing, open for business and waiting for you: in Cave City, Kentucky, on historic Route 66 in Holbrook, Arizona, and also on Route 66, in San Bernardino, California. I'm proud to say I've had the privilege of staying at all three.

I can remember driving past the San Bernardino Wigwam Motel in the '70s, when the slogan

the W I G W A M

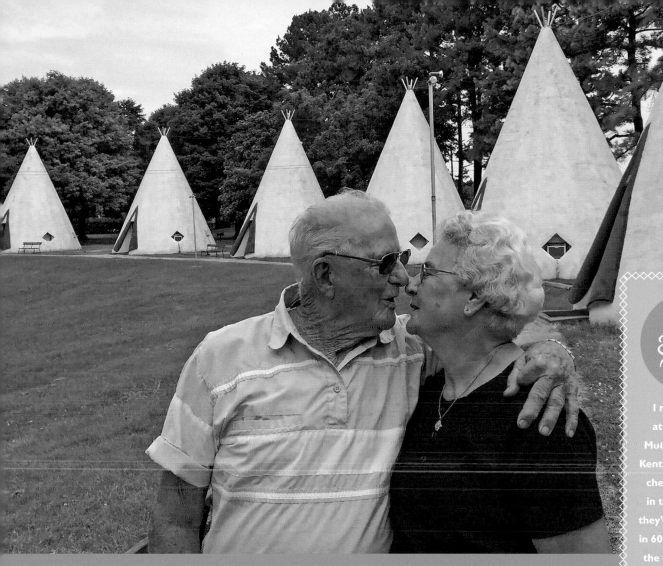

Meet James & Martha

I ran into them at the Wigwam Motel in Cave City, Kentucky. They'd just checked in to stay in the same room they'd honeymooned in 60 years before, to the day. They asked me if I'd take their picture. Just as I said, "Say cheese," they turned and gave each other a big kiss. **HAPPY ANNIVERSARY!**

beneath the sign said "Do It in a Teepee!" The first time I ever spent the night in a Wigwam was at the Arizona location. I walked into my room—um, wigwam—and immediately felt an unexplainable mystical magical forcefield of pure Americana energy unlike any I'd experienced before or since. (And no, I hadn't been smokin' anything!) There's something very powerful about standing, sitting, showering, and sleeping inside one of these icons of the great American roadside. Thanks in part to the Disney movie *Cars,* they're enjoying a well-deserved revival in popularity. You haven't really road-tripped until you've spent a night in a wigwam. Whatever you "do" in a teepee, do something!

VILLAGE

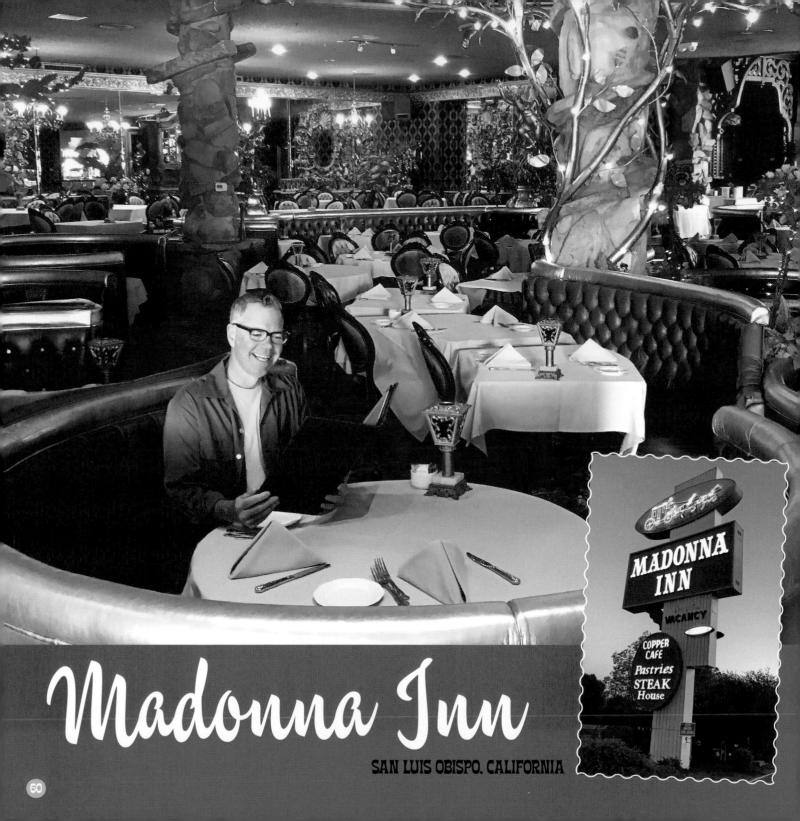

Madonna Inn

SAN LUIS OBISPO, CALIFORNIA

THINK PINK!

Mrs. Madonna

No trip up or down the California coast is fathomable without a stop at the legendary Madonna Inn. It's mecca for those who love first-class kitsch. If there was a hotel in Fantasyland at Disneyland, this would be it.

The Madonna Inn opened on Christmas Eve, 1958, with 12 individually themed rooms. There are now 109. I've had the pleasure of staying in several of them, including two of the famous rock rooms, which, BTW, are guaranteed to bring out your inner caveman.

The over-the-top, fairytale-storybook motif is a mad mashup of the Flintstones, California Arts & Crafts, Old World and Victorian styles, all cleverly handcrafted with love. At its core the Madonna Inn reflects Mr. and Mrs. Madonna's inspired Candyland sensibility, oozing with creativity and integrity, plus heart and soul to spare. From those sky-high pink cakes, to the must-see waterfall in the men's room, to the one-of-a-kind themed guest rooms, the Madonna Inn knows no stylistic rival. While you're there, look for Mrs. Madonna, who's usually holding court in her corner booth in the coffee shop.

Surprise roommate in the "Irish Hills" room

Round counter seating at the Copper Café.

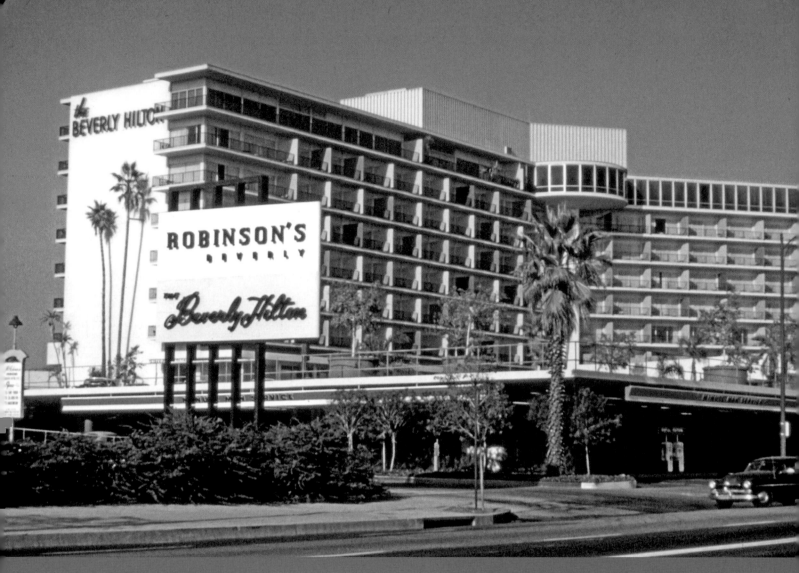

the BEVERLY HILTON

MULTICOLORED TERRACE DIVIDERS give this midcentury-modern masterpiece, built in Beverly Hills in 1955, a grand-scale pop art effect. The giant half-a-cat-food can that's stylishly sticking out from the top floor is in fact a semi-circular cocktail lounge. Street-level orange stripes mark the 76 station at the hotel's entrance. This spectacular photo was taken just months after the grand-opening ceremony, during which pink-painted elephants, escorted by bathing-suit-clad models, circled the main entrance. During its construction, Conrad Hilton buried a stainless-steel time capsule beneath the lobby. The most exciting artifact it holds is a 1954 Sears catalogue. Care to join me when they unearth it in 2054?

THE PICASSO-MEETS-MIRO MURAL

the STATLER HILTON DALLAS

discovered during a remodel after decades of being covered over at Dallas's most stylish midcentury hotel piqued my modern-art-loving curiosity when I read about it online. I just happened to be on my way to Dallas and, of course, I had to see it. When I arrived at the hotel—expecting a beehive of hardhat activity—I was surprised to find nobody there. The lights weren't even on. Pressing my nose up to the glass, I finally spotted a security guard. I knocked on the glass wall to get his attention, but though he opened the door, he refused to let me enter. After a few minutes of begging and pleading, I was scampering about the original terrazzo floors and up and down the curvy staircases looking for the mural. Finally, I turned a corner and there it was, signed Jack Lubin, '56. Glad you're back, Jack!

Trader Vic's at the Beverly Hilton, 1955.

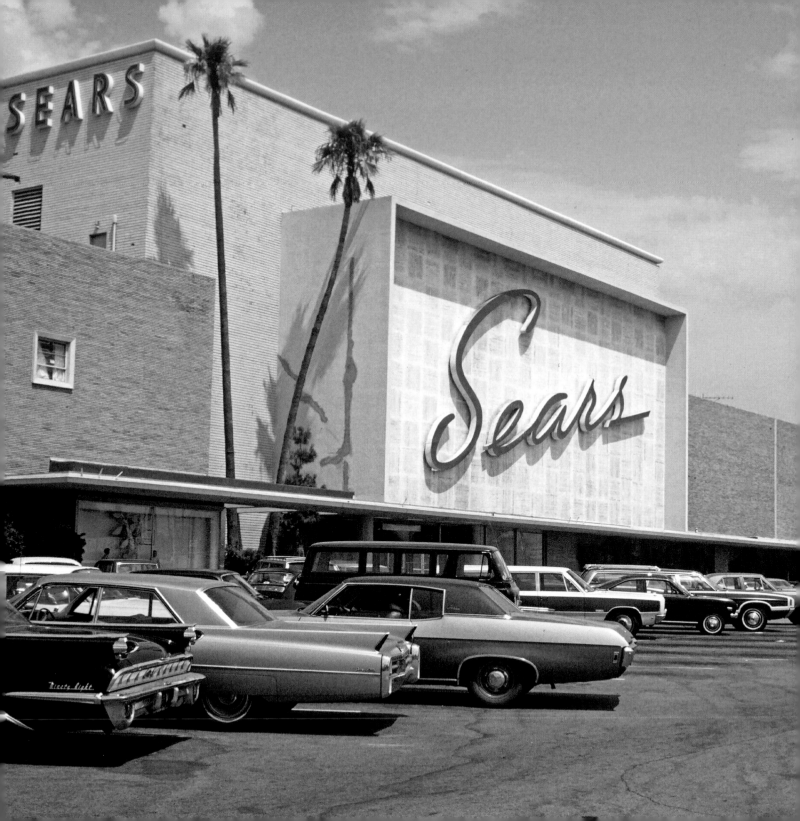

Let's Go Shopping!

LIKE A TITLE ON A GIANT MOVIE SCREEN, THE SEARS LOGO IS SUPER-SIZED AND SPELLED OUT IN THE FONT OF OPTIMISM.

An American classic more than any other department store, Sears began in Chicago in 1886 as a jewelry and watch catalog, which grew to include everything from clothing to kits for building houses. The first Sears department store opened in Chicago in 1925. No other chain in American history has provided so many goods and services in as many places for so many people. This colossal "California casual" store opened in 1954. Most of my school clothes came from the Husky Boy department at "our" Sears in Pomona, California. If I was a "good boy," I'd get some citrus slices from the candy counter on the way out.

Fast forward nearly three decades to the mid-'90s. I was driving by the Sears Service Center in San Gabriel and saw that a sign company had just finished removing the old sign from the building. It was one of the last remaining examples of the Sears sign in that classic script, "handwritten" in neon. I stopped and asked if I could have it. He said he couldn't let me have the sign, but I could have all of the neon. He hadn't broken even one tube taking the sign down. Carefully, we put all the neon in the car, and I kept begging for the enormous steel letters. I thought "no" was his final answer—but there was hope! He said, "I'm going to the Santa Ana dump, and if you 'just happen' to be there when I unload it, you can take it." So I got a truck, hurried to the dump, watched him unload the letters, and started loading them into my truck. They were huge—the "S" was taller than me.

Just as I got it loaded in the truck, here came the security guard, yelling, "Hey, you can't take that! This place is for dumping, not taking." I begged him for at least 45 minutes until I realized he wasn't going to budge.

As a last resort, I did what Lucy would do: cry. That did the trick. Five minutes later I left the dump with the Sears sign. Now what to do with it? Donate it!

Rescued sign is restored and on display at MONA, the Museum of Neon Art, in Glendale, California.

Valley Plaza, North Hollywood, California, 1971.

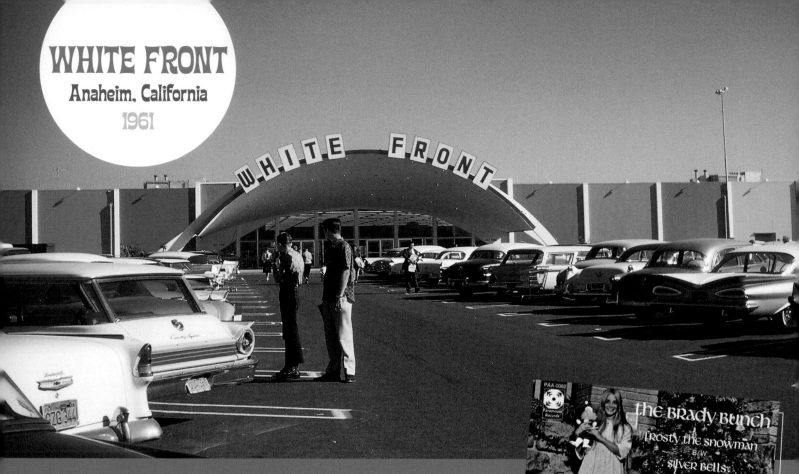

WHITE FRONT
Anaheim, California
1961

WHITE FRONT

GIANT COLOR BLOCKS AND A GRAND ARCHED ENTRANCE

glorify SoCal's first suburban big-box retail chain, founded in Los Angeles in 1955. It was an odd name for such a colorful store.

When I was growing up, my family shopped at the White Front in my hometown of Ontario. One visit stands out. It was a Saturday morning in December of 1970. My mother woke me up and said, "Get ready, we're going to White Front to meet the Brady Bunch!" Before I could say "What?!" I was dressed and in the car. We got there, bought their Christmas album, and stood in line for hours to meet Greg, Marsha, Peter, Jan, Bobby, and Cindy and have them sign the LP. I was on cloud nine. The moment we got home, I played it on the stereo console. We all decided that we didn't care for the way the Brady Bunch sang, and we never played it again.

Decades went by. One day when I was home visiting my mom, I looked for it in the record closet. The records were gone! Turns out my mom had donated them all to the Goodwill. Somewhere out there is a very happy record collector with a Brady Bunch record signed to me. I hope he or she at least likes the way the Brady Bunch sings.

SOUTHGATE CENTER LAKELAND, FLORIDA
I'm feeling very small beside the most extravagant space-age shopping center sign on the planet, standing just as it has since 1957.

PICTURE-PERFECT PORTRAIT
of the "Value" family at a strip mall in Pennsylvania, 1957.

LAKEWOOD, CALIFORNIA
I've admired this midcentury sign totem my whole life. Miraculously, it's still standing in all of its majestic multi-colored glory.

THE WORLD'S FAIR
gave great globe in Anaheim, California, in 1963. Fun fake flags and steel starbursts, too.

Eastland Shopping Center

WEST COVINA, CALIFORNIA, 1959

An Erector Set–style stained glass tower marked America's first freeway-side suburban shopping center: an island of retail surrounded by an ocean of asphalt thoughtfully divided into 12,000 parking spaces. In the event of a nuclear attack, no problem—the tunnels underneath, used for deliveries, doubled as fallout shelters equipped to handle thousands of civilians for up to a week. The future of retail had arrived!

Eastland was the first mall I ever went to. Other than Tomorrowland at Disneyland, it was by far the most out-of-this-world place my family visited. I witnessed my mother and grandmother on many a shopping spree at the May Company, where my grandma always seemed to buy a girdle. That was embarrassing. Afterwards we'd eat at Clifton's Cafeteria, the up-to-date offspring of the original in downtown L.A. I always got the child's tray, which came with a chocolate coin wrapped in gold foil and a toy from the treasure chest. But the real treat for me was the brightest-red fruit punch I'd ever seen.

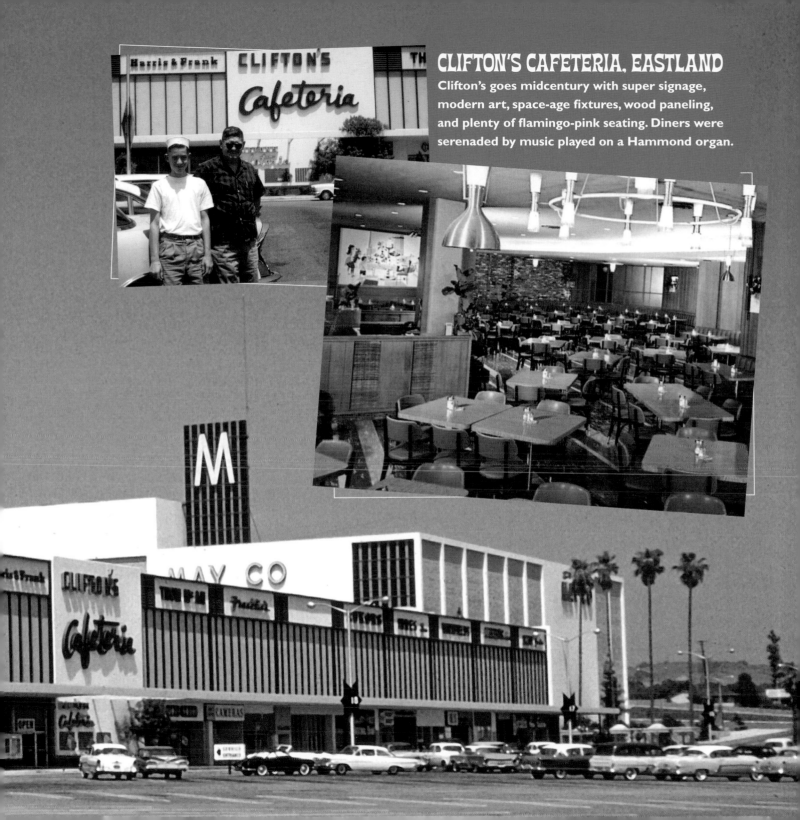

CLIFTON'S CAFETERIA, EASTLAND

Clifton's goes midcentury with super signage, modern art, space-age fixtures, wood paneling, and plenty of flamingo-pink seating. Diners were serenaded by music played on a Hammond organ.

The carnival's in town at the SOUTH TOWN PLAZA, in Rochester, New York, 1957.

Court of the Birds

**CHRIS-TOWN MALL
PHOENIX, ARIZONA, 1960s**

Disneyland's Enchanted Tiki Room–meets–It's a Small World with live birds. The best view is from the little bridge over the bird-of-paradise garden. Do they talk, too?

THE CENTRAL CITY MALL IN SAN BERNARDINO, CALIFORNIA, is dead, and the carousel is no longer going round and round, but that didn't stop me from taking a ride on the sea serpent.

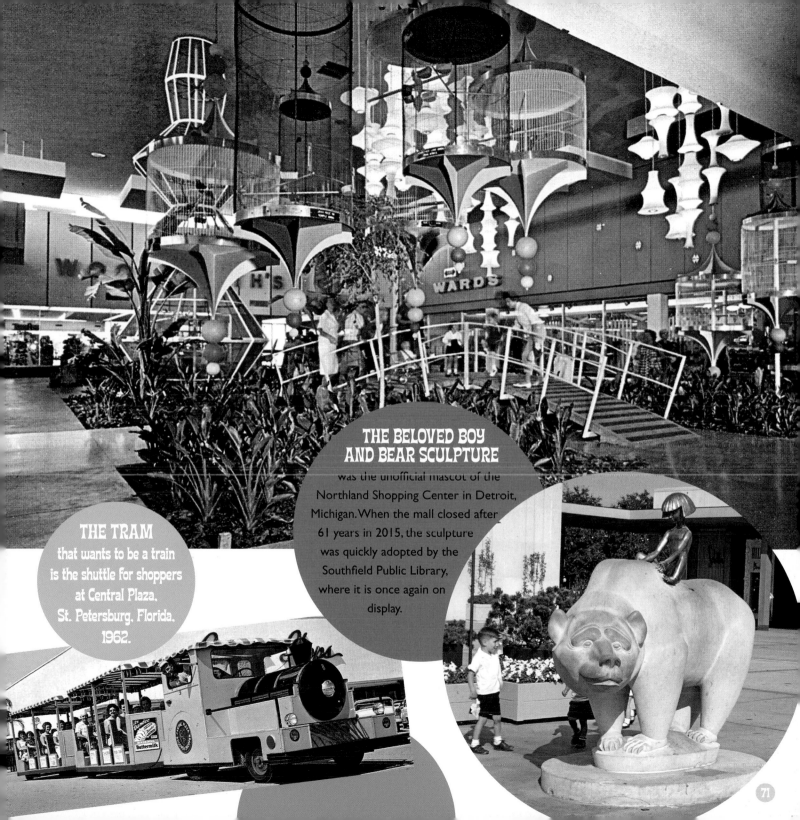

THE BELOVED BOY AND BEAR SCULPTURE

was the unofficial mascot of the Northland Shopping Center in Detroit, Michigan. When the mall closed after 61 years in 2015, the sculpture was quickly adopted by the Southfield Public Library, where it is once again on display.

THE TRAM

that wants to be a train is the shuttle for shoppers at Central Plaza, St. Petersburg, Florida, 1962.

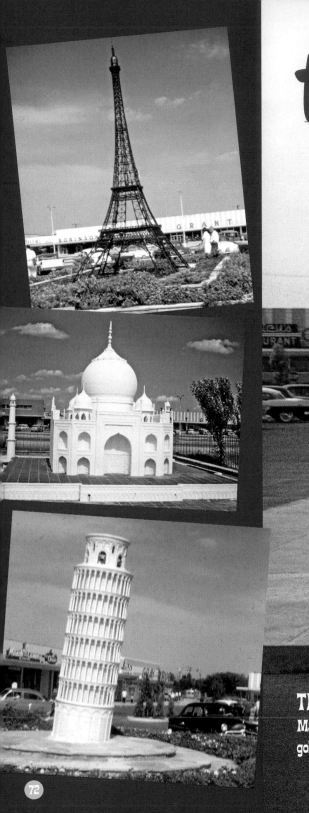

the WALK-

THE SPHINX AND PYRAMIDS, Eiffel Tower, Parthenon, Niagara Falls, Taj Mahal, Grand Canyon, Leaning Tower of Pisa, and Carlsbad Caverns were recreated in miniature golf course scale in the middle of a shopping center parking lot.

In between buying a pound of poultry, picking up the dry cleaning, trying on a pair of shoes,

O-WONDERS

buying a can of paint, or downing a couple of cocktails, shoppers could travel the world without leaving the parking lot.

In the late 1960s, after years of exposure to the elements and the need for more parking spaces, the wee wonders were demolished. Only the Eiffel Tower survived. I heard that the property owner's son saved it and has it in his back-yard. Finding it is at the top of my list next time I'm in Ohio. When I find it, I'll be sure to let you know!

Great Western Shoppers Mart, Columbus, Ohio, 1958.

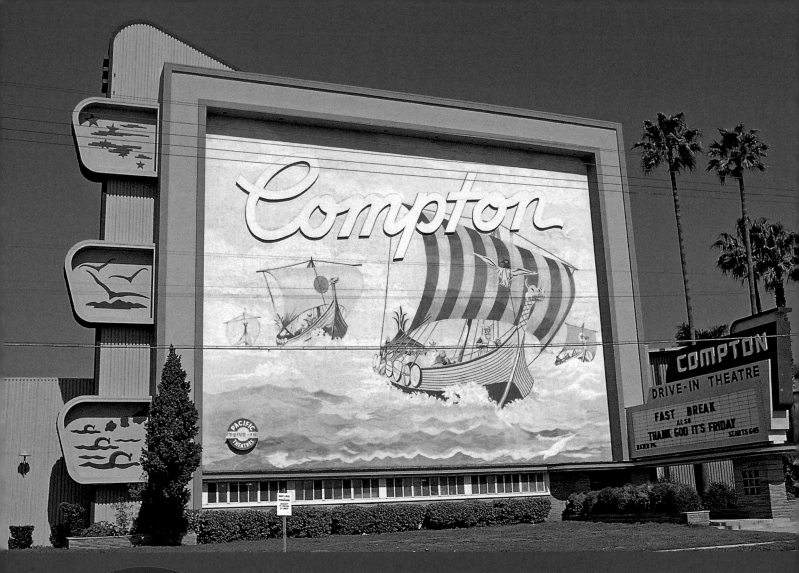

the SHOW STARTS at DUSK!

MY GRANDPARENTS LIVED IN COMPTON, RIGHT DOWN THE STREET FROM THIS DRIVE-IN. The gigantic mural of Viking ships sailing on a choppy sea, generously labeled with the handwritten name of the city, made a big impression on little me. In the early '90s, decades after my grandparents had moved away, I decided to take a ride to Compton to see if the old drive-in was still there. I did and it was, a bit faded but still with the Viking ships and all. For the next couple of weeks, I bragged all over town about my vintage drive-in "discovery." Not quite believing what I'd seen, I decided I needed to go back to take a closer look and make sure I wasn't dreaming. So I did—but my dream drive-in had turned into a nightmare. They had just bulldozed it. The screen tower was just lying there, broken to bits and waiting to be taken to the scrap heap. At least I got to see it one last time before **THE END.**

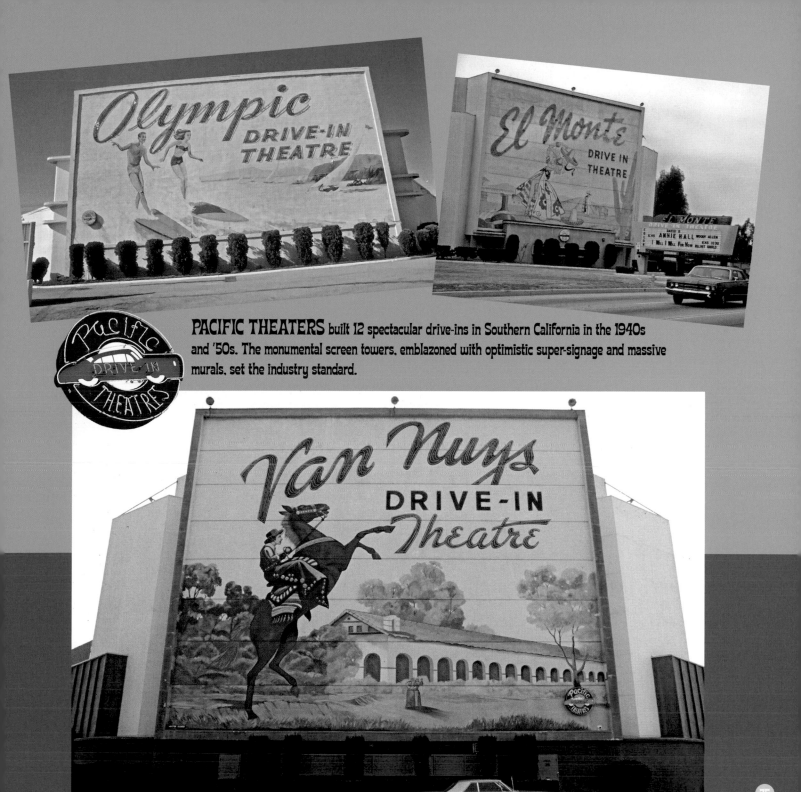

PACIFIC THEATERS built 12 spectacular drive-ins in Southern California in the 1940s and '50s. The monumental screen towers, emblazoned with optimistic super-signage and massive murals, set the industry standard.

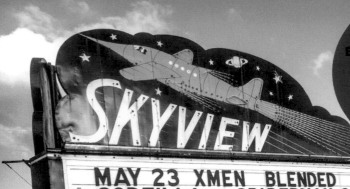

SKYVIEW

MAY 23 XMEN BLENDED
1 GODZILLA SPIDERMAN 2
2 NEIGHBORS RIDE ALONG

OPEN FRI SAT SUN

SKYVIEW DRIVE-IN BELLEVILLE, ILLINOIS
The spectacular neon rocket ship has been flying on the marquee since 1950.

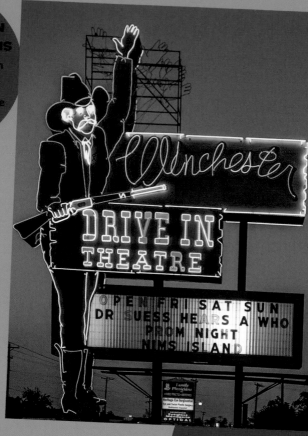

Winchester DRIVE IN THEATRE

OPEN FRI SAT SUN
DR SUESS HEARS A WHO
PROM NIGHT
NIMS ISLAND

WINCHESTER DRIVE-IN THEATER OKLAHOMA CITY, OKLAHOMA
Since 1968, that great big neon cowboy has held his shotgun in one hand while waving to motorists with the other.

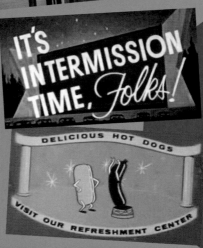

IT'S INTERMISSION TIME, Folks!

DELICIOUS HOT DOGS

VISIT OUR REFRESHMENT CENTER

"LET'S ALL GO TO THE LOBBY"
The colorful intermission film shorts made by Filmack Studios of Chicago in the 1950s, often starring dancing and singing hot dogs, popcorn, and candy, ironically became more famous than most of the movies they accompanied.

ENTRANCE

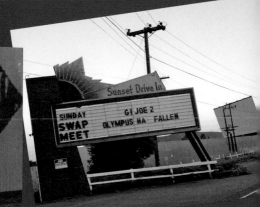

Sunset Drive In

SUNDAY SWAP MEET
GI JOE 2
OLYMPUS HA FALLEN

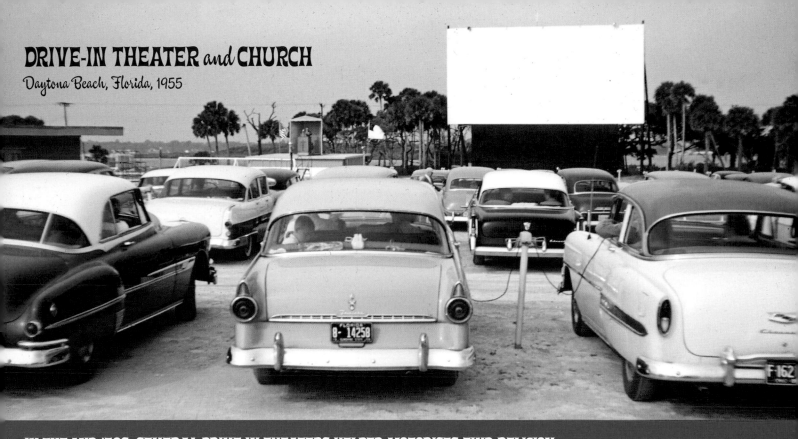

DRIVE-IN THEATER and CHURCH
Daytona Beach, Florida, 1955

IN THE MID-'50S, SEVERAL DRIVE-IN THEATERS HELPED MOTORISTS FIND RELIGION. Just as drive-ins began getting a reputation as teenage passion pits, some started holding Sunday-morning church services to help provide moral balance. As the congregations on wheels developed, so did the slogans: "Stay and pray," "Worship as you are in the family car," and "Honk to say amen!" The preachers' sermons were heard from the same pole-mounted speakers that had played B movies just a few hours earlier. Miraculously, this drive-in church, which has been part of the Daytona Beach religious scene since 1953, still exists. It no longer does double duty as a theater, and the screen is gone, but the preacher still personally greets each car as it drives away at the end of the service. Honk honk honk!

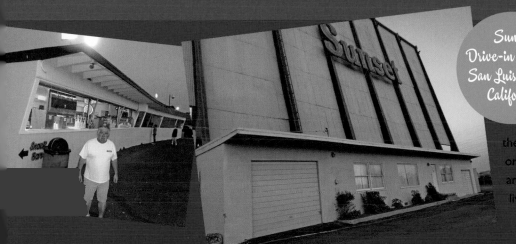

Sunset Drive-in Theater San Luis Obispo, California

THIS SCREEN TOWER DOUBLES AS A HOUSE. The original owner, who built the drive-in in 1950, lived for decades in the home he built at the base of the screen tower. Larry Rodkey, the son of the original theater manager, now proudly owns and operates the theater, although he doesn't live in the house.

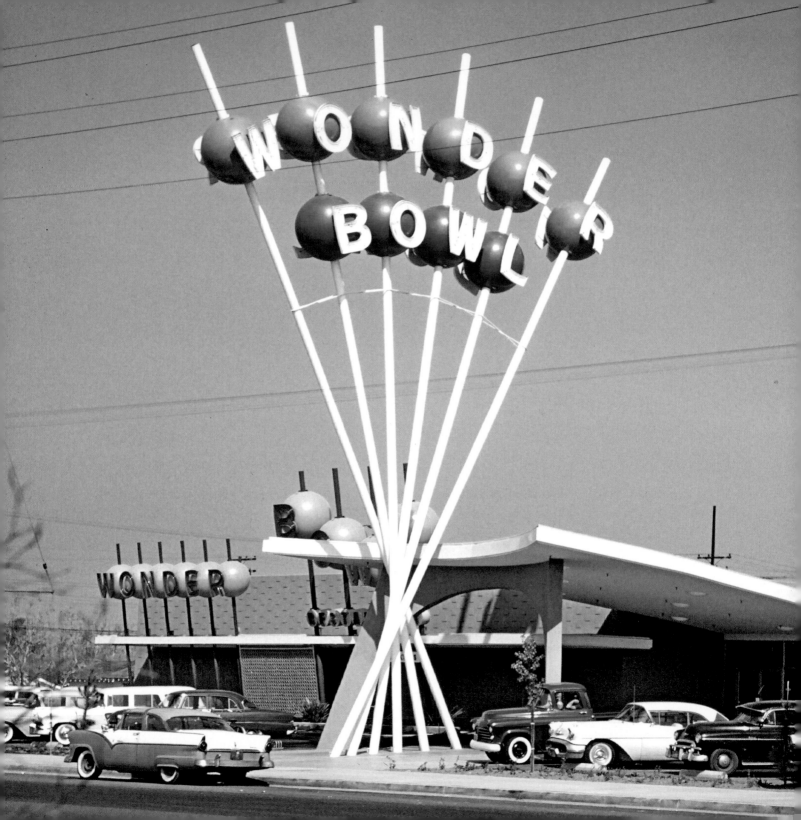

BOWL-A-RAMA!

WONDER BOWL
ANAHEIM, CALIFORNIA, 1959

The Wonder Bowl really bowls me over! That towering splay of signposts skewering giant bowling balls was one of the great wonders of the midcentury-modern world. Who knew a space-age suburban sign could have the poise and grace of a prima ballerina? The Wonder Bowl totally lived up to its name. Even more wonderful was that it was next door to Disneyland.

BOWLIUM
MONTCLAIR, CALIFORNIA

The freestanding arched awnings are over the top and out of this world! The dynamic duo creates the illusion that you've arrived at a space station, but no, it's just a *Jetsons* worthy bowling alley from 1957, and it's still going strong.

OPEN BOWLING : 24 HRS
FREE INSTRUCTIONS DAILY
HELEN TERRY AT PIANO BAR
ROAST SIRLOIN OF BEEF DINNER 1.65
COFFEE SHOP .95 LUNCHEON

BOWLIUM
32 LANES

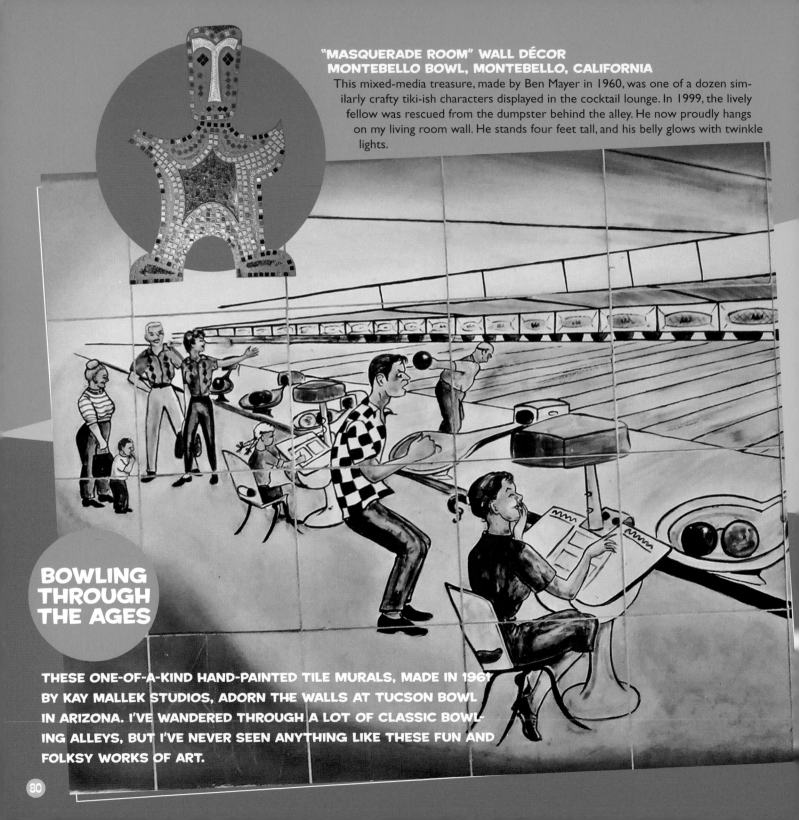

"MASQUERADE ROOM" WALL DÉCOR
MONTEBELLO BOWL, MONTEBELLO, CALIFORNIA

This mixed-media treasure, made by Ben Mayer in 1960, was one of a dozen similarly crafty tiki-ish characters displayed in the cocktail lounge. In 1999, the lively fellow was rescued from the dumpster behind the alley. He now proudly hangs on my living room wall. He stands four feet tall, and his belly glows with twinkle lights.

BOWLING THROUGH THE AGES

THESE ONE-OF-A-KIND HAND-PAINTED TILE MURALS, MADE IN 1961 BY KAY MALLEK STUDIOS, ADORN THE WALLS AT TUCSON BOWL IN ARIZONA. I'VE WANDERED THROUGH A LOT OF CLASSIC BOWLING ALLEYS, BUT I'VE NEVER SEEN ANYTHING LIKE THESE FUN AND FOLKSY WORKS OF ART.

80

The invention of the automatic pin setter, along with glorious Googie architecture, revolutionized BOWLING in the 1950s, turning it into America's favorite suburban sport.

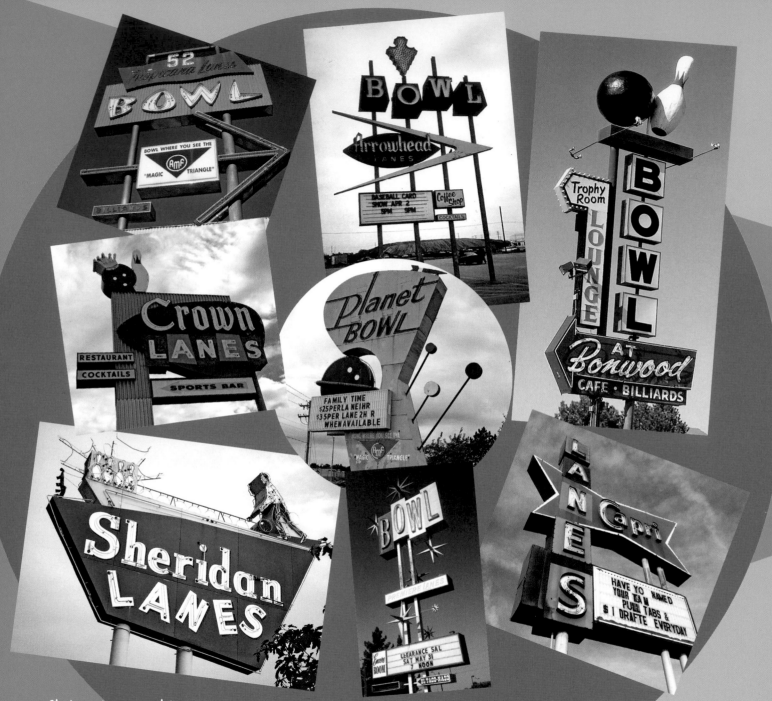

Clockwise from upper left: TROPICANA LANES, St. Louis, Missouri; ARROWHEAD LANES, San Bernardino, California; BONWOOD BOWL, Salt Lake City, Utah; CAPRI LANES, Dayton, Ohio; PREMIER LANES, Sante Fe Springs, California; SHERIDAN LANES, Tulsa, Oklahoma; CROWN LANES, Denver, Colorado; PLANET BOWL, Midwest City, Oklahoma.
Miraculously, several of these classic signs still stand, with the exception of Arrowhead Lanes, Premier Lanes, and Sheridan Lanes.

World's Largest
BOWLING PIN
SALT LAKE CITY, UTAH

To stand beside the World's Largest Bowling Pin is to be in awe of grandeur and feel very small. I spotted it on my first trip to Salt Lake. I thought I was seeing things, but no, I'd just stumbled upon the biggest bowling pin in the known universe. Jackpot! I lept out of the car and raced inside to get the story. The lady at the desk said, "That's not the original big bowling pin—the first one blew over right after they built it in 1958, and it crashed onto the car lot next door." "Are there pictures?" I asked. She had no idea. So I got on the phone with the Utah Heritage Foundation and asked if they had any. A few days later the photo below appeared in my inbox. This big, beautiful bowling beacon would be a superstar stand-out anywhere.

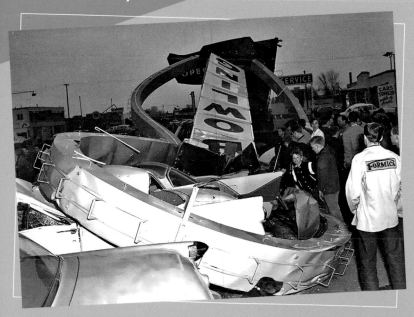

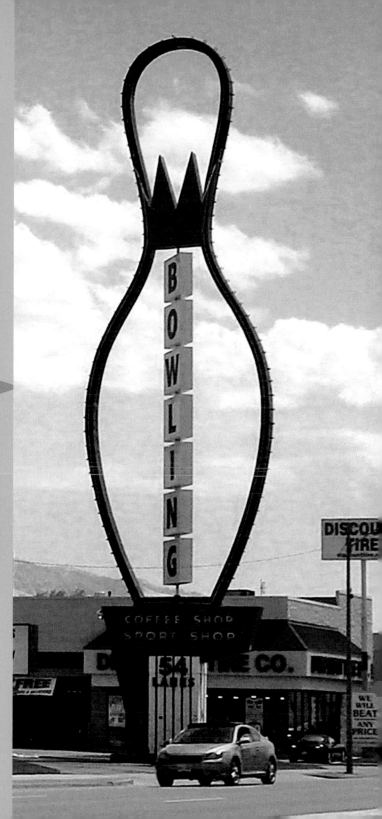

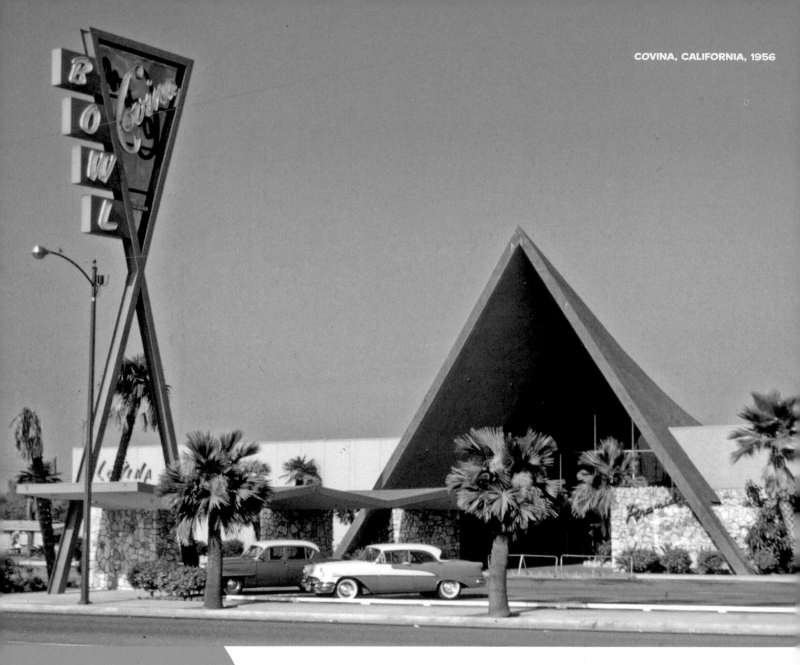

COVINA BOWL

THE TOWERING CRISSCROSS SIGN leads to the grand pyramid entrance to Southern California's first and most deluxe Googie-style bowling palace. Come for the bowling, stay for the beauty parlor, barber shop, billiard room, cocktail lounge, coffee shop, restaurant, and banquet hall. Got kids? No problem—there are registered nurses to babysit the little ones while the mothers play in housewife leagues. In 2017, I hosted a "Last Strike Party" just before it closed after 61 years. From grand-opening day until the last pin fell, the Covina Bowl was a 300.

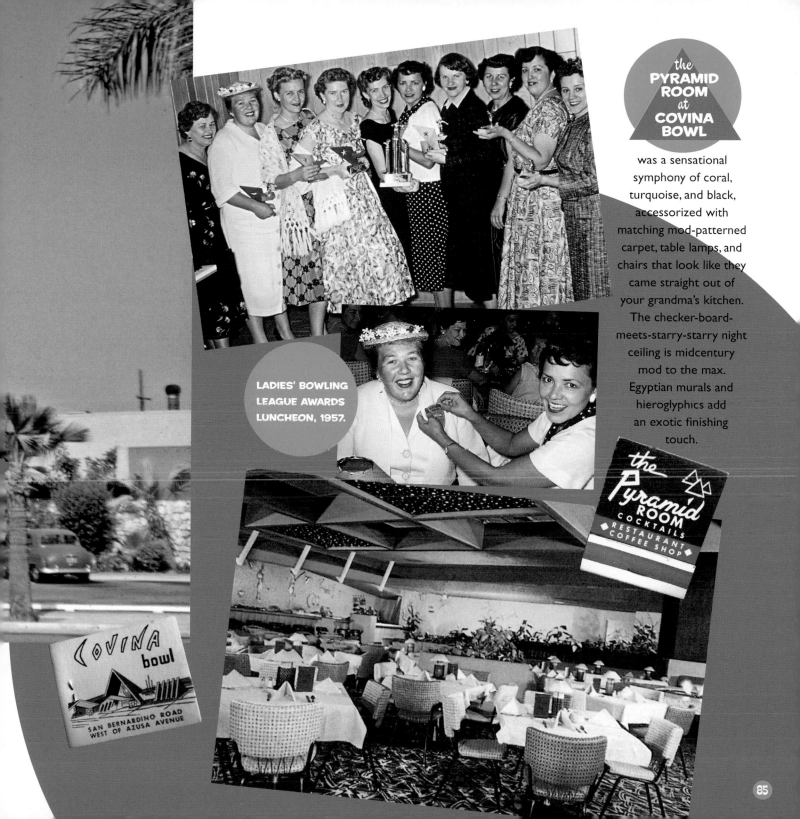

the PYRAMID ROOM at COVINA BOWL

was a sensational symphony of coral, turquoise, and black, accessorized with matching mod-patterned carpet, table lamps, and chairs that look like they came straight out of your grandma's kitchen. The checker-board-meets-starry-starry night ceiling is midcentury mod to the max. Egyptian murals and hieroglyphics add an exotic finishing touch.

LADIES' BOWLING LEAGUE AWARDS LUNCHEON, 1957.

the Pyramid ROOM COCKTAILS RESTAURANT COFFEE SHOP

COVINA bowl
SAN BERNARDINO ROAD
WEST OF AZUSA AVENUE

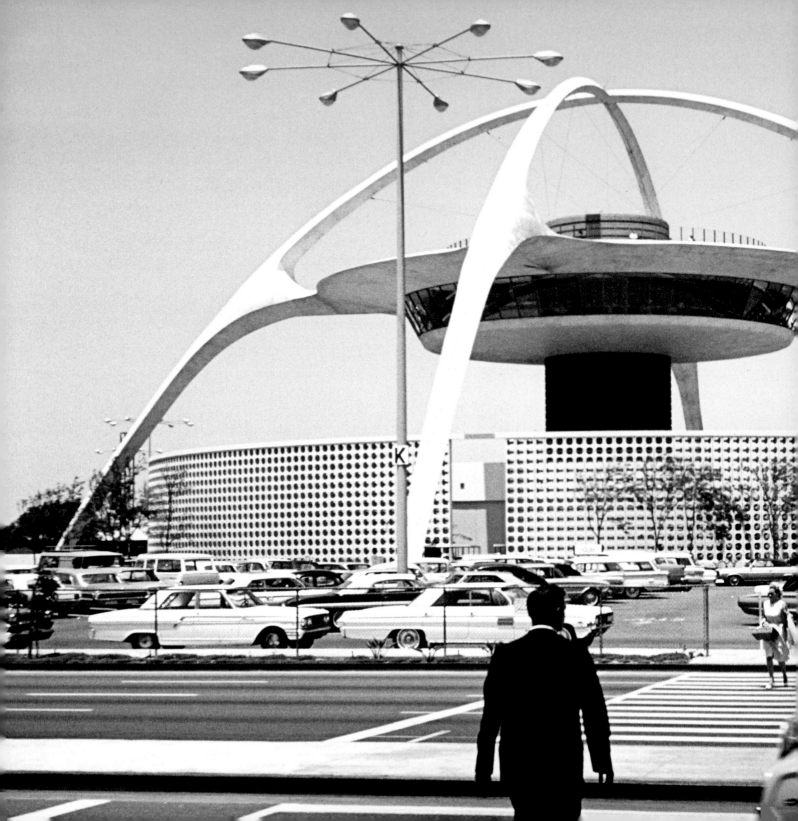

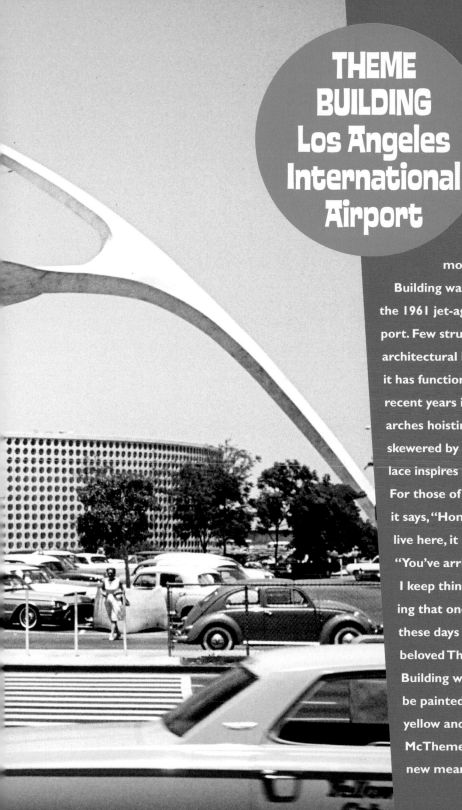

THEME BUILDING Los Angeles International Airport

IT IS THE AGE OF SPACE, THE YEAR IS 1965, AND WE HAVE JUST LANDED IN THE MOST MODERN METROPOLIS ON THE PLANET.

A '64 Ford yellow cab, a couple of crosswalkers, a lot full of cars, and a cocktail-pick-starburst-octopus light fixture are the picture-perfect accessories for one of the most stylish structures on the planet. The Theme Building was built as the centerpiece and crowning touch of the 1961 jet-age expansion of Los Angeles International Airport. Few structures in the world have achieved the status of architectural icon, and this is one of them. For most of its life, it has functioned as a restaurant and observation deck, but in recent years it's only there to admire. Those graceful, sweeping arches hoisting that see-through, soup-bowl-shaped restaurant skewered by a silo elevator tower and circling wall of concrete lace inspires a state of out-of-this-world architectural nirvana. For those of us who live in Southern California, when we land, it says, "Home sweet home." For those of you who don't live here, it says, "You've arrived." I keep thinking that one of these days our beloved Theme Building will be painted

yellow and morph into a McDonald's. They can call it the McTheme McDonald's and give the golden arches a whole new meaning. There's even room for a drive-thru!

1962 Seattle World's Fair

the SPACE NEEDLE

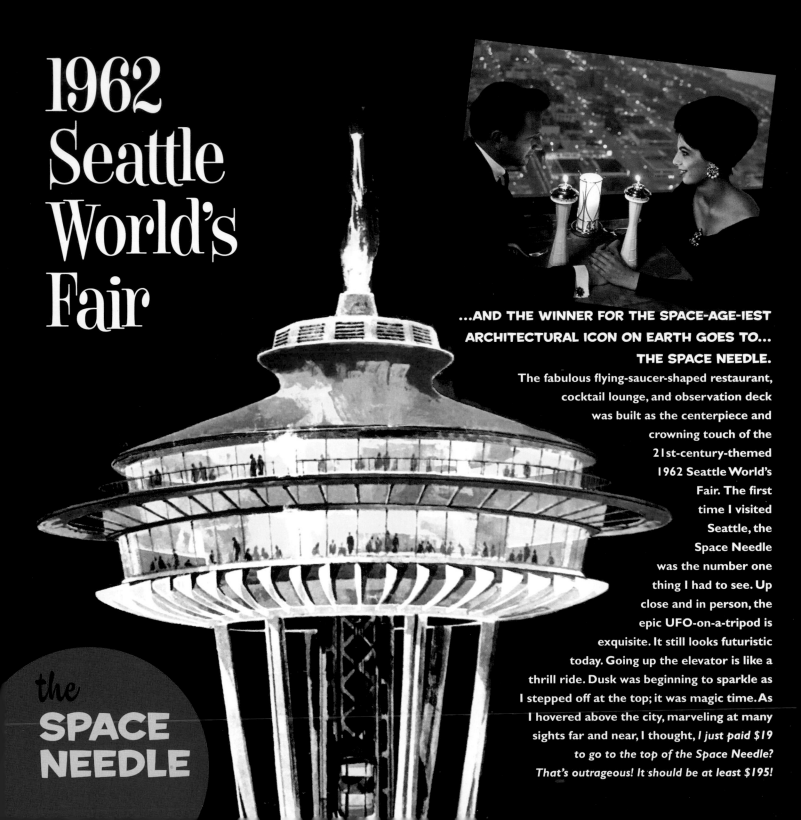

...AND THE WINNER FOR THE SPACE-AGE-IEST ARCHITECTURAL ICON ON EARTH GOES TO... THE SPACE NEEDLE.

The fabulous flying-saucer-shaped restaurant, cocktail lounge, and observation deck was built as the centerpiece and crowning touch of the 21st-century-themed 1962 Seattle World's Fair. The first time I visited Seattle, the Space Needle was the number one thing I had to see. Up close and in person, the epic UFO-on-a-tripod is exquisite. It still looks futuristic today. Going up the elevator is like a thrill ride. Dusk was beginning to sparkle as I stepped off at the top; it was magic time. As I hovered above the city, marveling at many sights far and near, I thought, *I just paid $19 to go to the top of the Space Needle? That's outrageous! It should be at least $195!*

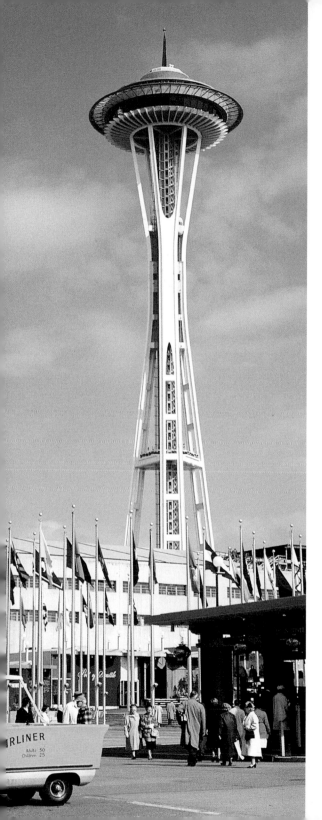

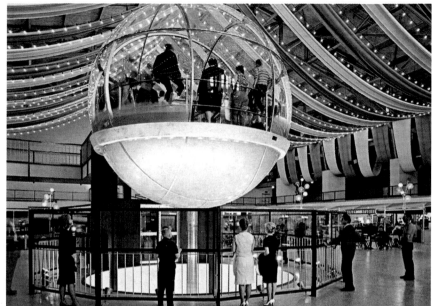

the BUBBLEATOR

THE WORLD'S ONLY BUBBLE-SHAPED ELEVATOR transported fairgoers for a memorable ride up and down one floor during the one-year run of the Seattle World's Fair, then remained in service until 1984. At some point, the big, beautiful bubble wound up in the front yard of a home in Des Plaines, just south of Seattle. When I heard that, I had to take a field trip to find it. Next thing you know, I'm asking locals, "Where's the Bubbleator?" They didn't have a clue. Finally, I spotted a crew of city workers; they always know everything. Sure enough, they knew where it was. I scribbled down their confusing directions, hopped in my rental car, and sped off like a thrill seeker. Somewhere along the way, however, I got lost. I found lots of front yards, but no Bubbleator. I stopped and asked a few more people, they didn't know either. No way was I giving up. I decided to go back to find those city workers and get clearer directions. As I turned a corner to head back, voilà, there it was. Drunk with pleasure, I marched myself right up to the front door and knocked, politely but with purpose. Next thing you know, I'm standing in the Bubbleator. If I were a hothouse flower, I would move right in!

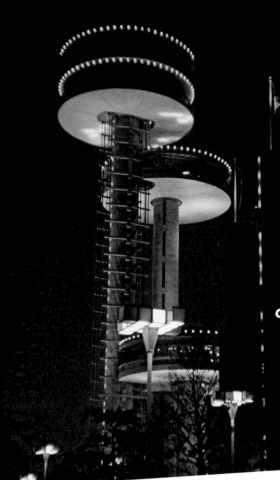

It's always a thrill to see the **NEW YORK STATE PAVILION OBSERVATION TOWERS,** among the very few fair structures that have survived. Long may they stand!

THE UNISPHERE

THE BIGGEST GLOBE ON THE GLOBE was built to be the icon, logo, and landmark of the 1964 New York World's Fair. Style-wise and otherwise, the 12-story stainless-steel sculpture is the very definition of exquisite classic design. Just about everything else built for the two-year-long corporate and cultural expo extravaganza, which defined the *Mad Men* era of American prosperity and opulence, has long been demolished. Thankfully, the Unisphere remains in place—you can't miss it gleaming as you travel between JFK and Manhattan. The next time you're in the neighborhood, I highly recommend hopping out of your train, bus, taxi, jitney, or fancy-pants limousine to experience this global masterpiece up close and in person. It may not spin, but it'll make your head spin. Afterward, step into the original 1939 New York Pavilion, now called the Queen's Museum, where memorabilia from both the 1939 and 1964 New York World's Fairs is on display.

1964-65 NEW YORK WORLD'S FAIR

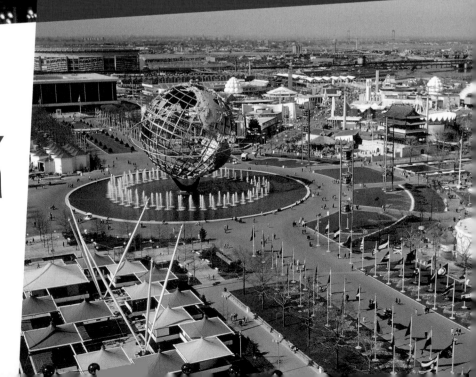

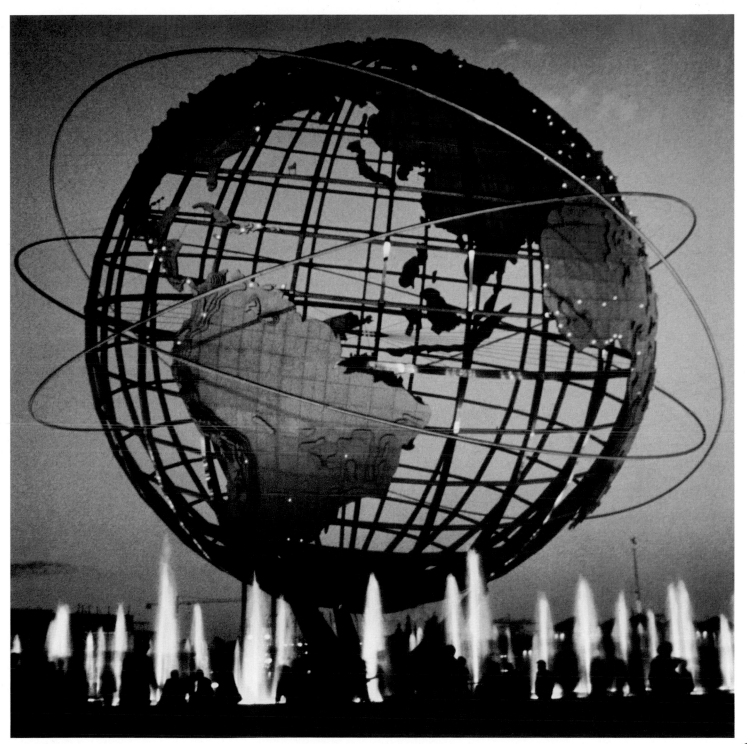

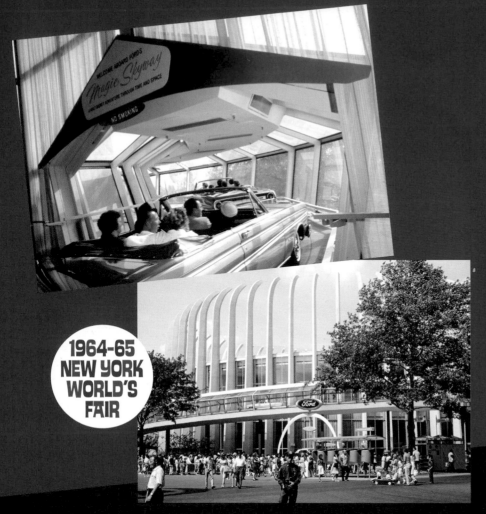

FAIRGOERS LINED UP FOR HOURS to board the most luxurious vehicles of any ride ever: brand-new 1964 Ford convertibles. "Welcome Aboard the Magic Skyway, Walt Disney's Adventure Through Time and Space"—I can hear it coming out of the car-radio speaker now. The attraction began in a see-through "magic skyway" tunnel which wrapped around the exterior of Ford's Wonder Rotunda, leading to Walt's epic version of the dawn of life on land, as well as his take on the far-out future. The journey through time was the most spectacular attraction at the Fair. Surprisingly, very few photos were taken of the ride's interior, leaving all but the dinosaurs a mystery. Because they survived. We've been enjoying them in Primeval World at Disneyland since 1966, every time we ride the train around the park. Yes, THOSE dinosaurs. Who knew they were leftovers from the World's Fair? Disney recycles, too. I wish I knew what happened to the far-out future.

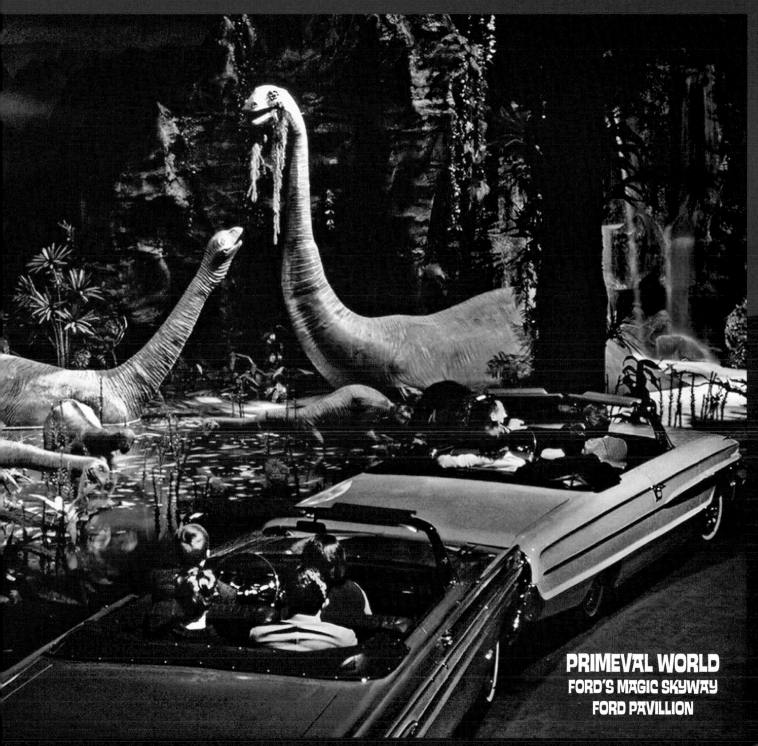

PRIMEVAL WORLD
FORD'S MAGIC SKYWAY
FORD PAVILLION

VEGAS VIC has been Las Vegas's official greeter since 1951. Other than seeing a chicken play the piano and a trapeze act at Circus Circus, Vegas Vic is the only thing I remember from my first trip to Las Vegas. I was four years old.

1950s showgirl slot machine hits the jackpot!

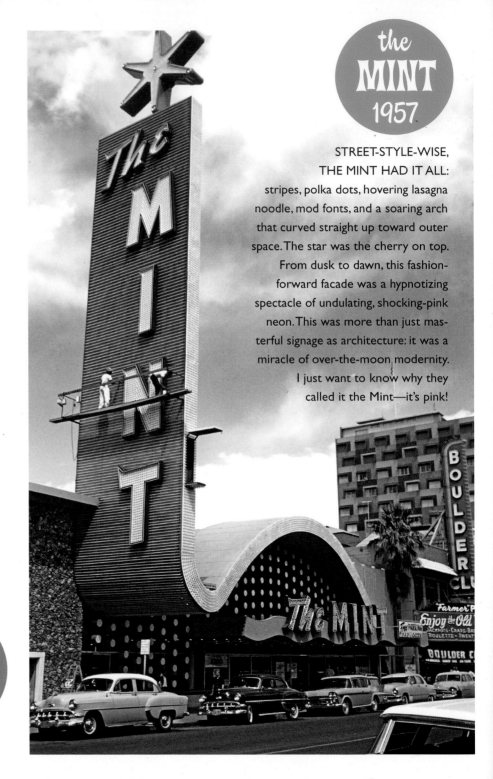

the MINT
1957

STREET-STYLE-WISE, THE MINT HAD IT ALL: stripes, polka dots, hovering lasagna noodle, mod fonts, and a soaring arch that curved straight up toward outer space. The star was the cherry on top. From dusk to dawn, this fashion-forward facade was a hypnotizing spectacle of undulating, shocking-pink neon. This was more than just masterful signage as architecture: it was a miracle of over-the-moon modernity. I just want to know why they called it the Mint—it's pink!

Las Vegas!

FREMONT STREET is the birthplace of Las Vegas. The first gambling license was issued there in 1931. By the late 1940s, it had become the most electrified and electrifying city block this side of Times Square.

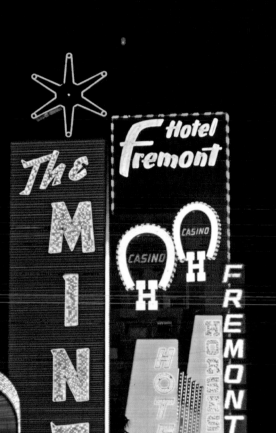

FREMONT STREET, 1964

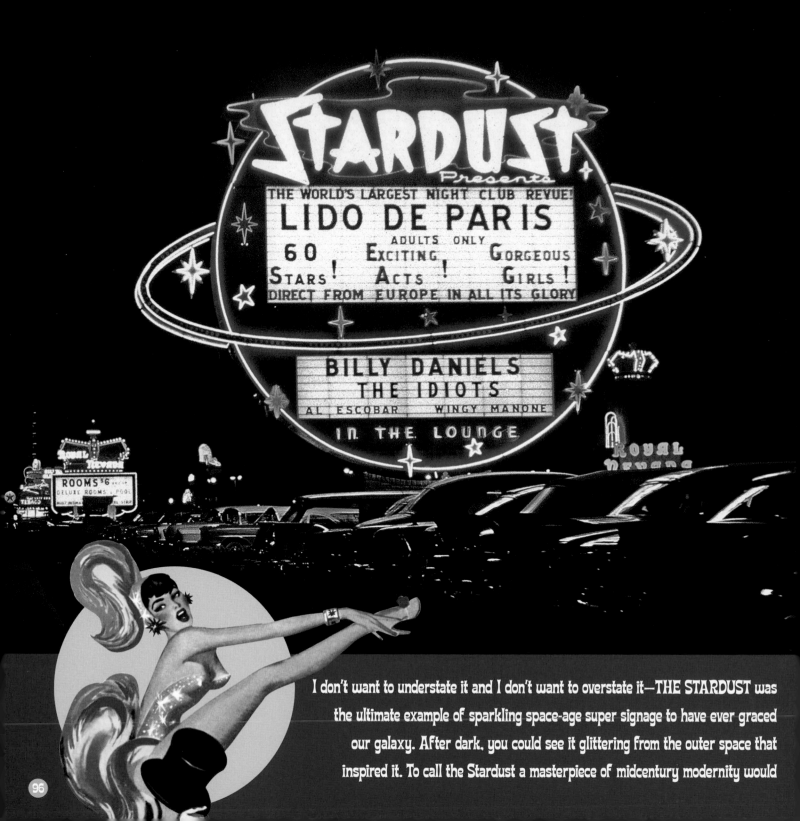

I don't want to understate it and I don't want to overstate it—THE STARDUST was the ultimate example of sparkling space-age super signage to have ever graced our galaxy. After dark, you could see it glittering from the outer space that inspired it. To call the Stardust a masterpiece of midcentury modernity would

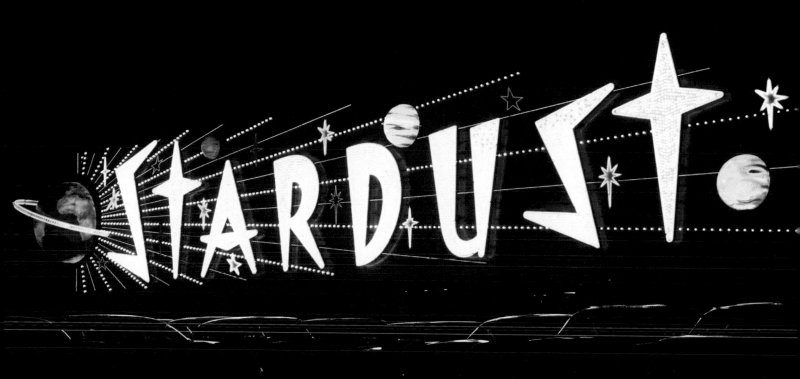

If you're looking for heart and soul in Las Vegas, THE NEON MUSEUM is where you'll find it.

be a gross understatement. The futuristic font set the standard by which all ultramodern fonts have since been measured. When this mega motel-casino combo landed on the Strip in 1958, the first to welcome the modern masses to Las Vegas, it was the largest resort on the planet.

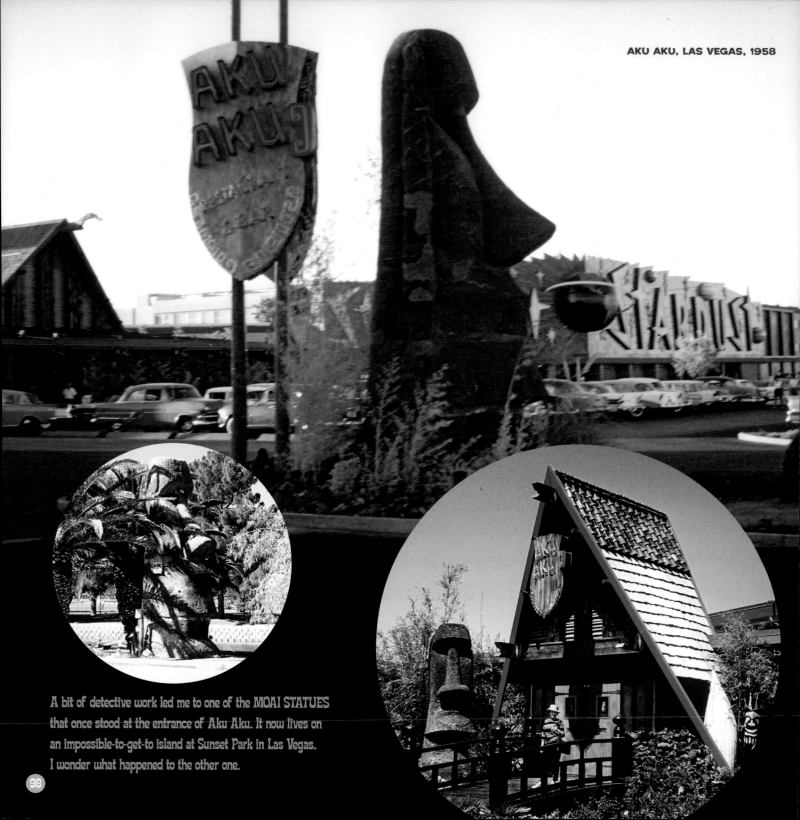

A bit of detective work led me to one of the MOAI STATUES
that once stood at the entrance of Aku Aku. It now lives on
an impossible-to-get-to island at Sunset Park in Las Vegas.
I wonder what happened to the other one.

AKU AKU

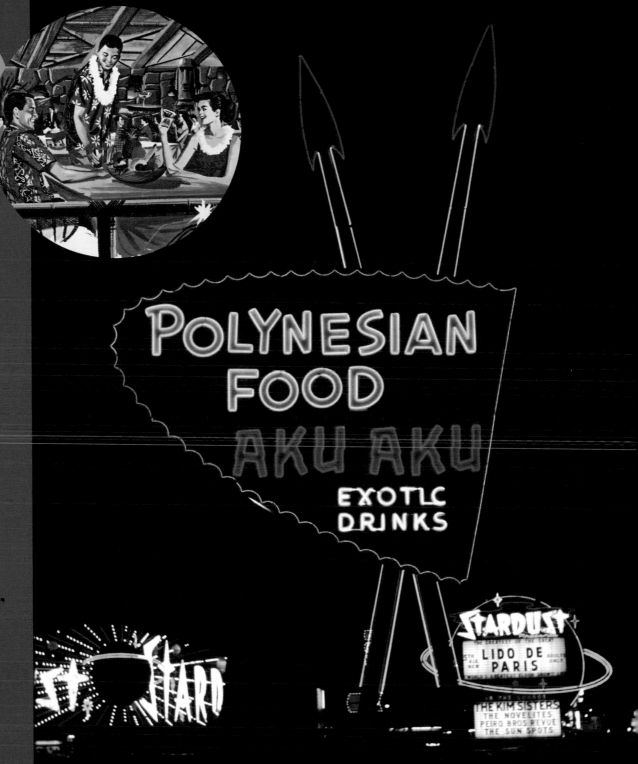

Tomorrowland wasn't the only flavor served up at the Stardust—there was also some Adventureland in the mix. An Easter Island tiki duo marked the entrance of the hotel's sweet-and-sour side dish, Aku Aku, the Strip's ultimate Polynesian dining experience.

POLYNESIAN FOOD

AKU AKU

EXOTIC DRINKS

STARDUST
THE GREATEST OF THE GREAT
5TH
ALL NEW LIDO DE
PARIS ADULTS ONLY
WORLD'S GREATEST STAGE SPECTACLE

IN THE LOUNGE
THE KIM SISTERS
THE NOVELITES
PEIRO BROS REVUE
THE SUN SPOTS

PANCAKES, hot dogs, hamburgers, fried chicken, barbecue, donuts, Jell-O, and ice cream are what's on the menu! Not only do I like to surround myself with Americana, I enjoy tasting it, too.

Breakfast, lunch, dinner, dessert, and snack time are far more nutritious and delicious when served up with a big helping of history. I'm not just feeding my body, I'm nourishing my heart and soul.

LET'S EAT!

Vintage restaurants, streamline diners, classic coffee shops, and fun fast food stands are my go-tos. The less updated the menu and decor, the better. I give extra points for vintage signage, especially big, splashy neon out front.

Everywhere I go, I ask, "What's the best local food?" On the road, time-honored regional favorites and traditional treats are what I seek. Seems like just about every town has something delicious that they're known for. In Palm Springs, it's the date shake. In St. Louis, it's deep-fried ravioli and sticky, gooey butter cake. In Pennsylvania, it's scrapple and shoo-fly pie. There's nothing I won't try, even the lamb fries, the specialty of the house at Cattlemen's Steakhouse in Oklahoma City since 1945. Turns out it's actually deep-fried sheep's testicles. YIKES! Well, everything tastes good fried.

It's not just the mom 'n pop places I'm looking for. It's also a feast for the senses to trace the history of the iconic chains, from visiting the world's oldest McDonald's to the very first Kentucky Fried Chicken.

I hope you're hungry, because it's time to eat!

Cheers to Foster's Freeze, serving it up since 1946 in Torrance, California.

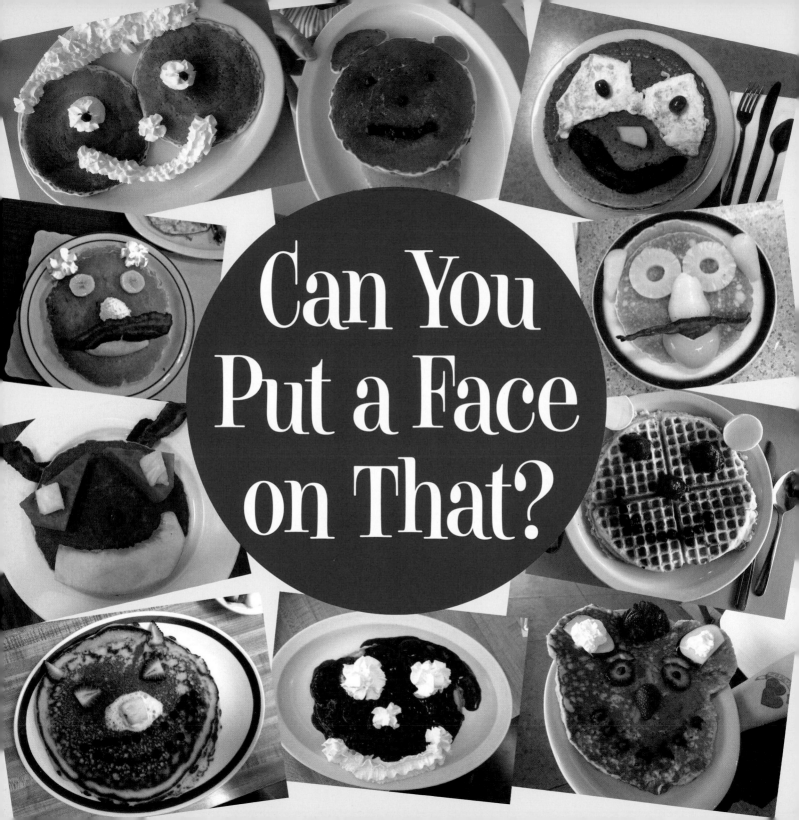

Can You Put a Face on That?

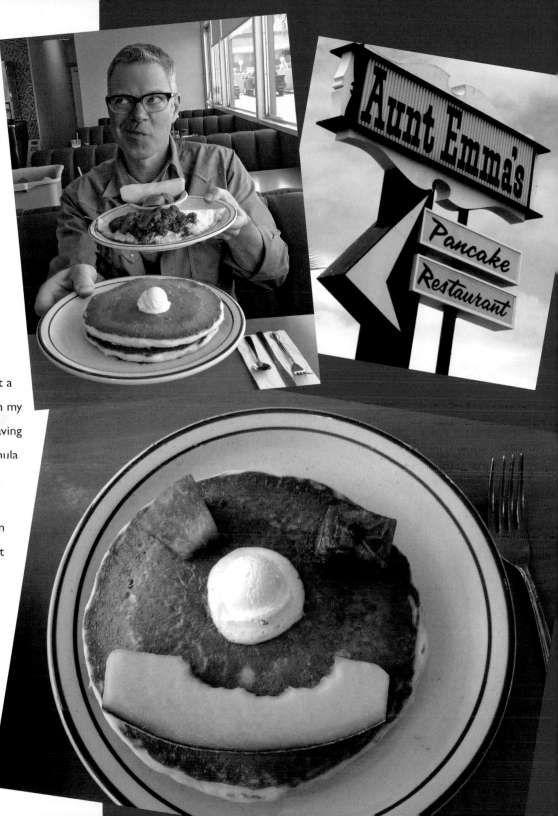

I'M ALWAYS IN SEARCH OF CLASSIC COFFEE SHOPS AND VINTAGE DINERS. AND THEY'RE OUT THERE.

When the mood strikes me, I like to have a little fun with the waitress—kinda like a social experiment. I order a stack of pancakes, and as she walks away, I ask, "Excuse me, can I please have a face on that?" The response is usually, "What?" So I repeat: "Can I please have a face...on the pancakes?" As the waitress walks away, without fail, I hear her mutter to herself, "Why would a grown man want a face on his pancakes?" Asking for a face on my pancakes started by chance when I was having breakfast at Aunt Emma's (est. 1959) in Chula Vista, California. Because I'm always trying to "cut down," I ordered fruit instead of potatoes with my Spanish omelet, but then defeated the purpose by asking for a short stack instead of toast. When the omelet was served, the "Spanish sauce" on it looked like...well, let's just say I lost my appetite. So during the time that I lost and regained my ability to eat, I amused myself by using my fruit to make a face on my pancakes. That was where the tradition of asking "Can I have a face on that?" first began.

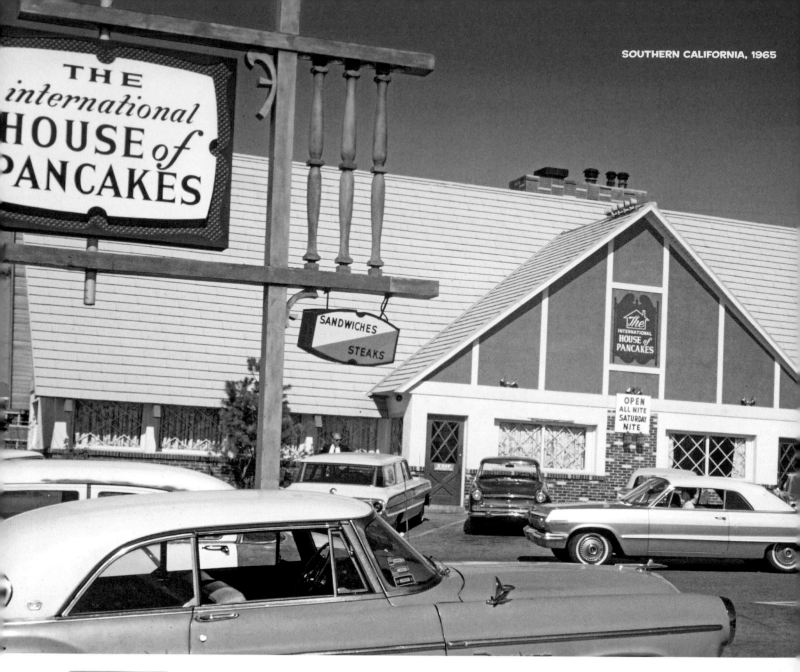

THE international HOUSE of PANCAKES

SANDWICHES STEAKS

OPEN ALL NITE SATURDAY NITE

The world got a little smaller in 1958 when the first INTERNATIONAL HOUSE OF PANCAKES opened in Burbank, California. It's a coffee shop with a clever gimmick: turning ordinary pancakes into around-the-world-taste sensations by ever so slightly altering the recipe. Top a short stack with lingonberries and they're Swedish; add pineapple and they're Hawaiian; throw in some shredded potatoes and they're German. Lighten up the batter and voilà—they're French! Who knew pancakes could be so worldly?

INTERNATIONAL HOUSE OF PANCAKES

The trademark super-sized A-frame structure is what I call SWISS MISS MOD. The big, maple-toned sign reminds me of the early-American-style furniture I grew up with.

Today, few IHOPs still operate in those iconic A-frames, but several of the original buildings still stand—mostly as independent mom 'n pop diners. I spotted one in Riverside, California. It was breakfast time, so I scampered in.

In awe of the A-frame, I started snapping pics. A waitress wandered over and asked, "Why are you taking so many pictures?"

"It's the architecture. A-frames are rare."

I sat down, and ordered a short stack of pancakes. As the waitress walked away, I added my usual, "Excuse me, can I please have a face on that?" When the pancakes arrived faceless, I graciously reminded her of my request. Right back they came with strawberry eyes and a sausage nose, and with a can of whipped cream, she applied a creamy smiley face. The pancakes were smiling, I was smiling, and she was smiling too.

The waitress asked, "Can you take my picture?" I said, "Sure—say 'cheese'!" Then she leaned over and whispered in my ear, "By the way, I'm single!"

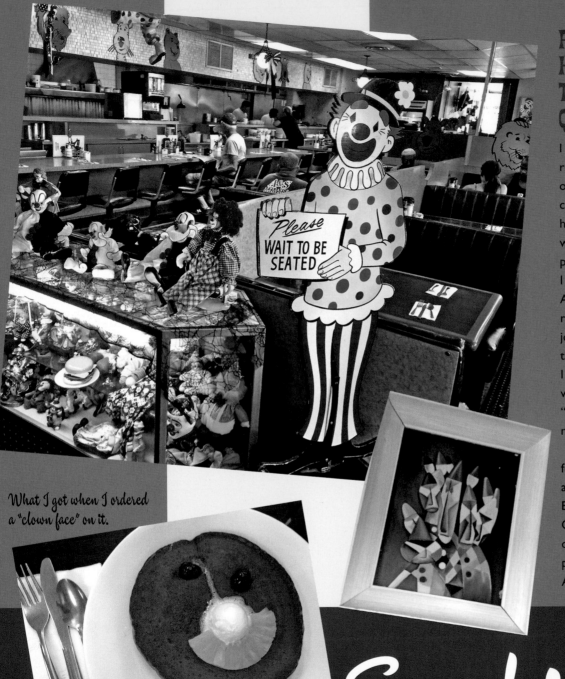

PANCAKE CIRCUS HAD BEEN ON MY TO-VISIT LIST FOR QUITE SOME TIME.

I finally got there! I'd heard rumors that a group of clowns occasionally dined at this Googie coffee shop, so naturally, I'd hoped that they'd be there when I came to partake in the pancakes. To increase the odds, I called up Sacramento's Klown Alley Club the day before I arrived in town and invited them to join me for breakfast. I said that if they showed up, I'd buy. They did, I did, and, of course, a great time was had by all! It gave the phrase "Send in the clowns" a whole new meaning.

Having breakfast with a table full of clowns *anywhere* would be a *Twilight Zone*-esque experience. But at PANCAKE CIRCUS?! Googie-clowny dreams really do come true! The icing on the pancake was that 1956 Nash Ambassador in shocking-pink.

What I got when I ordered a "clown face" on it.

Send in the

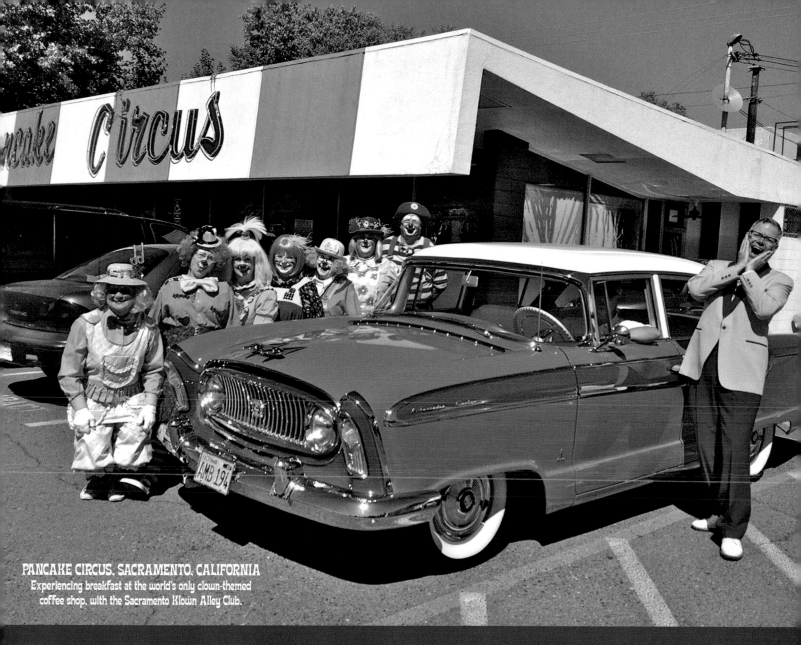

PANCAKE CIRCUS. SACRAMENTO. CALIFORNIA
Experiencing breakfast at the world's only clown-themed
coffee shop. with the Sacramento Klown Alley Club.

BREAKFAST CLOWNS!

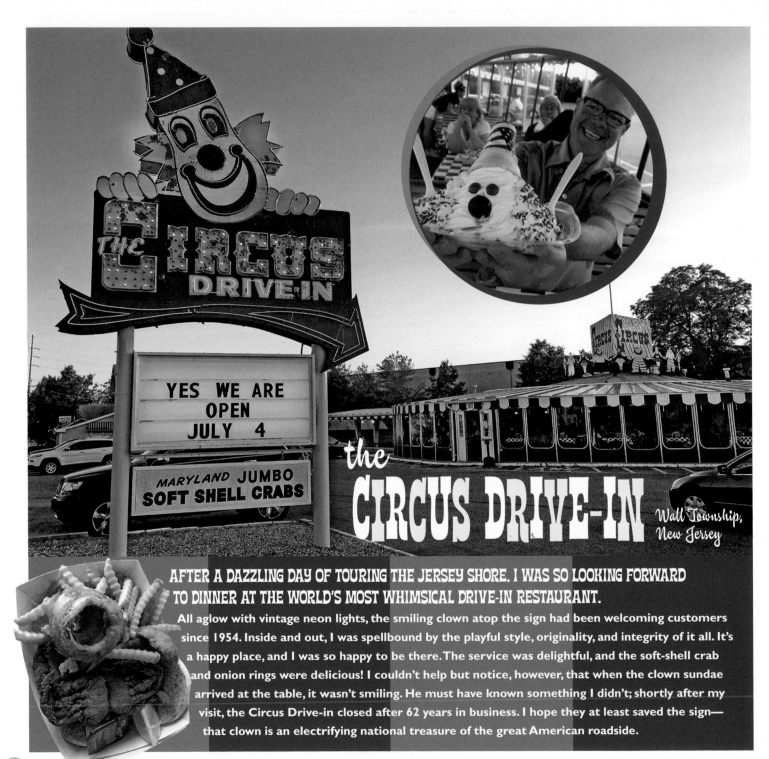

THE CIRCUS DRIVE-IN

YES WE ARE OPEN JULY 4

MARYLAND JUMBO SOFT SHELL CRABS

the CIRCUS DRIVE-IN

Wall Township, New Jersey

AFTER A DAZZLING DAY OF TOURING THE JERSEY SHORE, I WAS SO LOOKING FORWARD TO DINNER AT THE WORLD'S MOST WHIMSICAL DRIVE-IN RESTAURANT.

All aglow with vintage neon lights, the smiling clown atop the sign had been welcoming customers since 1954. Inside and out, I was spellbound by the playful style, originality, and integrity of it all. It's a happy place, and I was so happy to be there. The service was delightful, and the soft-shell crab and onion rings were delicious! I couldn't help but notice, however, that when the clown sundae arrived at the table, it wasn't smiling. He must have known something I didn't; shortly after my visit, the Circus Drive-in closed after 62 years in business. I hope they at least saved the sign— that clown is an electrifying national treasure of the great American roadside.

the Pizza Mobile!

That ferocious face would have caught my monster-loving eyes anywhere,

but to discover it on three pizza delivery vehicles in a vintage photo at Pina's Pizzeria in Downey, California? I had to get the full story! I asked the guy behind the counter at this homespun, circa-1959 pizza joint, "Do you by chance have one of those pizza monsters sitting in the back room or tucked away in a garage?" He answered, "I wish, but we don't."

Cut to a year later. While touring Dayton, Ohio, I'd stopped to eat at Cassano's, the town's oldest pizza-parlor chain, and I spotted an old picture of that same ferocious face. I had no idea there were more of those pizza-monster mobiles! I asked immediately if they'd saved it. When I got a "Yes" instead of a "No," I couldn't believe my ears. Before they could say, "It's on display at the Boonshoft Museum of Discovery," I was there. Life is full of surprises, and most of them are wonderful.

Pizza Mobile fleet at Pina's Pizzeria, Downey, California, 1965.

Cassano's Pizza Mobile now on display at Boonshoft Museum of Discovery, Dayton, Ohio.

Visiting Cassano's main office.

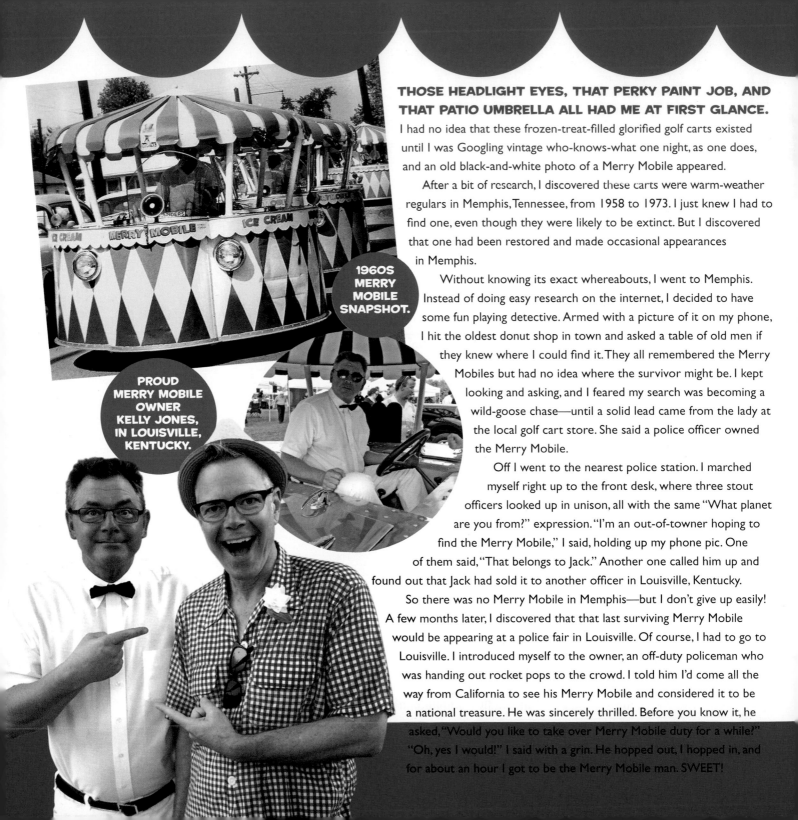

THOSE HEADLIGHT EYES, THAT PERKY PAINT JOB, AND THAT PATIO UMBRELLA ALL HAD ME AT FIRST GLANCE. I had no idea that these frozen-treat-filled glorified golf carts existed until I was Googling vintage who-knows-what one night, as one does, and an old black-and-white photo of a Merry Mobile appeared.

After a bit of research, I discovered these carts were warm-weather regulars in Memphis, Tennessee, from 1958 to 1973. I just knew I had to find one, even though they were likely to be extinct. But I discovered that one had been restored and made occasional appearances in Memphis.

Without knowing its exact whereabouts, I went to Memphis. Instead of doing easy research on the internet, I decided to have some fun playing detective. Armed with a picture of it on my phone, I hit the oldest donut shop in town and asked a table of old men if they knew where I could find it. They all remembered the Merry Mobiles but had no idea where the survivor might be. I kept looking and asking, and I feared my search was becoming a wild-goose chase—until a solid lead came from the lady at the local golf cart store. She said a police officer owned the Merry Mobile.

Off I went to the nearest police station. I marched myself right up to the front desk, where three stout officers looked up in unison, all with the same "What planet are you from?" expression. "I'm an out-of-towner hoping to find the Merry Mobile," I said, holding up my phone pic. One of them said, "That belongs to Jack." Another one called him up and found out that Jack had sold it to another officer in Louisville, Kentucky.

So there was no Merry Mobile in Memphis—but I don't give up easily! A few months later, I discovered that that last surviving Merry Mobile would be appearing at a police fair in Louisville. Of course, I had to go to Louisville. I introduced myself to the owner, an off-duty policeman who was handing out rocket pops to the crowd. I told him I'd come all the way from California to see his Merry Mobile and considered it to be a national treasure. He was sincerely thrilled. Before you know it, he asked, "Would you like to take over Merry Mobile duty for a while?" "Oh, yes I would!" I said with a grin. He hopped out, I hopped in, and for about an hour I got to be the Merry Mobile man. SWEET!

1960S MERRY MOBILE SNAPSHOT.

PROUD MERRY MOBILE OWNER KELLY JONES, IN LOUISVILLE, KENTUCKY.

the MERRY MOBILE!

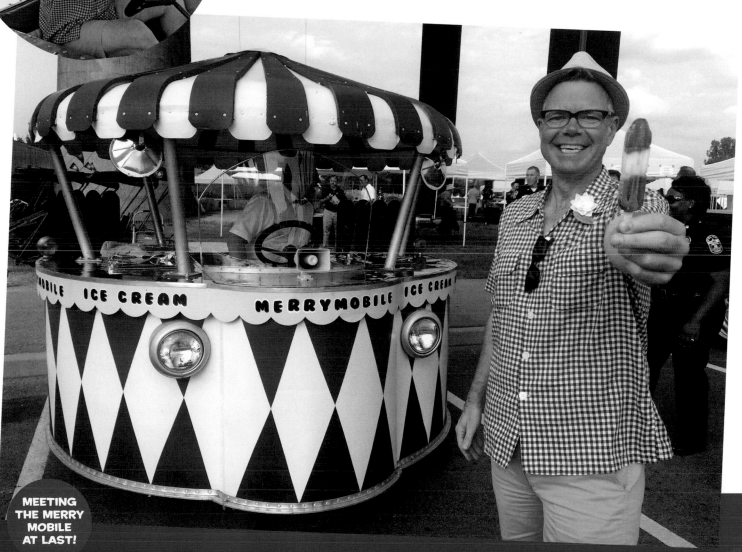

MERRYMOBILE ICE CREAM

MEETING THE MERRY MOBILE AT LAST!

The Wienermobile!

Taking a ride in the Wienermobile had always been a dream of mine. At last, the day came. The Wienermobile pulled up. I got in, and off we went. **The faux-painted clouds on its inside roof reminded me immediately of the ceiling at the Forum Shops at Caesar's Palace in Las Vegas.** We headed for Circus Liquor in North Hollywood. I got out, turned around, and saw the 1959 landmark neon clown standing "on" the Wienermobile. Let's just say it made for quite the Kodak moment—one that I'll never forget. When the ride was over, a miniature Wienermobile model was my surprise parting gift. Of course, it's now one of my most cherished possessions.

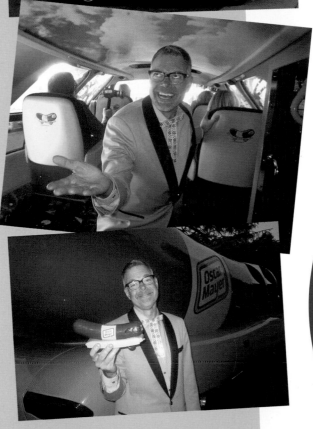

OSCAR MAYER began selling wurst in Chicago in 1883, and his first hot dog–shaped vehicle appeared in 1936. Between 1950 and 1954, five new Wienermobiles were built—and this is one of them! The huge custom-built weenie sits on a flattened 1950 Dodge.

Several generations of Wienermobiles followed. In 1991, the last surviving second-generation Wienermobile was restored and put on display at the Henry Ford Museum in Dearborn, Michigan. I've had the great honor of standing by it several times, each time having one of those wondrous "I'm SO proud to be American" moments!

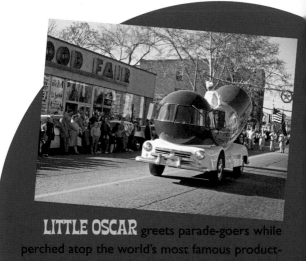

LITTLE OSCAR greets parade-goers while perched atop the world's most famous product-shaped vehicle. Dutifully dressed in his smart chef's uniform, the Oscar Mayer ambassador will sign autographs and hand out wiener whistles to the kids at the end of the parade.

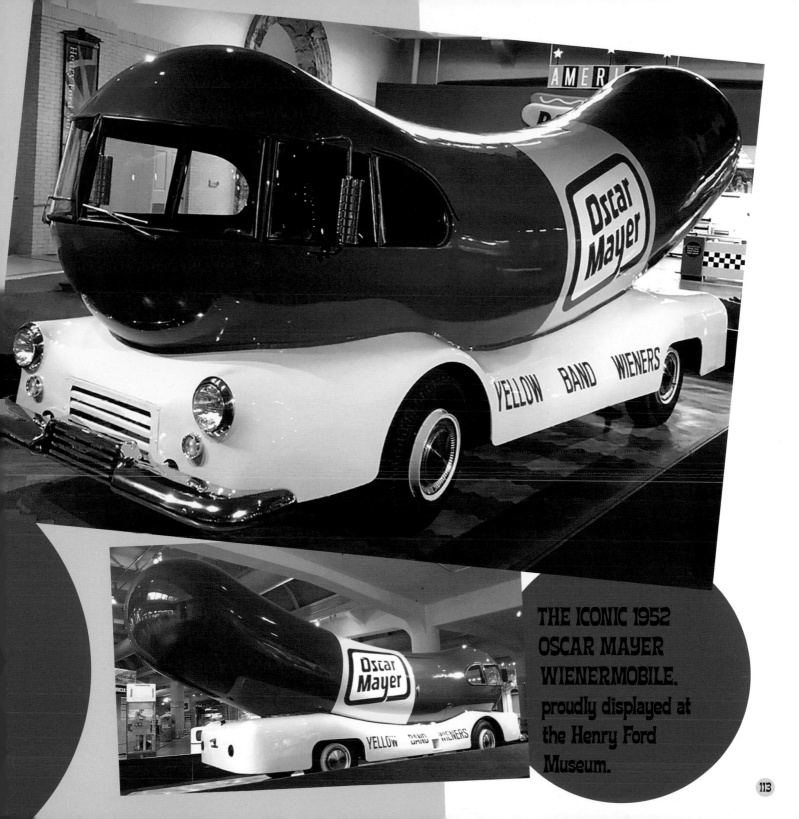

THE ICONIC 1952 OSCAR MAYER WIENERMOBILE, proudly displayed at the Henry Ford Museum.

PASS THE MUSTARD!

Clockwise from upper left:

COZY DOG DRIVE-IN
SPRINGFIELD, ILLINOIS
Serving them up since 1946.

GAY DOG
DOWNEY, CALIFORNIA
Once upon a time stood the Gay Dog—
right across the street from the Lesbian Cat!

QUICKIE DOG
BELL GARDENS,
CALIFORNIA
On the go since 1965.

THE TALE O' THE TAIL O' THE PUP

OPENED IN 1946, Tail o' the Pup was built in the novelty-architecture tradition in Southern California that also included buildings like the Brown Derby. In the mid-'80s, when the L.A. property it sat on (311 N. La Cienega) was slated for redevelopment, we almost lost this savory little gem. Thankfully, the owner found a new site nearby, where the dog sat until several years ago, when a hospital tower was built on the site. The Tail o' the Pup was no more.

Wondering what became of it, I did some sleuthing and found owner Eddie Blake's number. I called to ask if I could see it, and Eddie said yes, if I would pick him up and drive him to the storage facility in Torrance. So I did, and there it was in all of its hot doggy glory, resting under a big blue tarp. I snapped a few pics and said, "I'd like to take you to lunch at a nice steakhouse." He looked at me a little bemused and said, "Oh no, I don't eat steak for lunch." I asked, "Then what would you like for lunch?" Without skipping a beat he said, "Wienerschnitzel." So Wienerschnitzel it was!

After an uncertain future, the Tail o' the Pup found a new home at the Valley Relics Museum in Chatsworth, California. This is a "tail" with a happy ending!

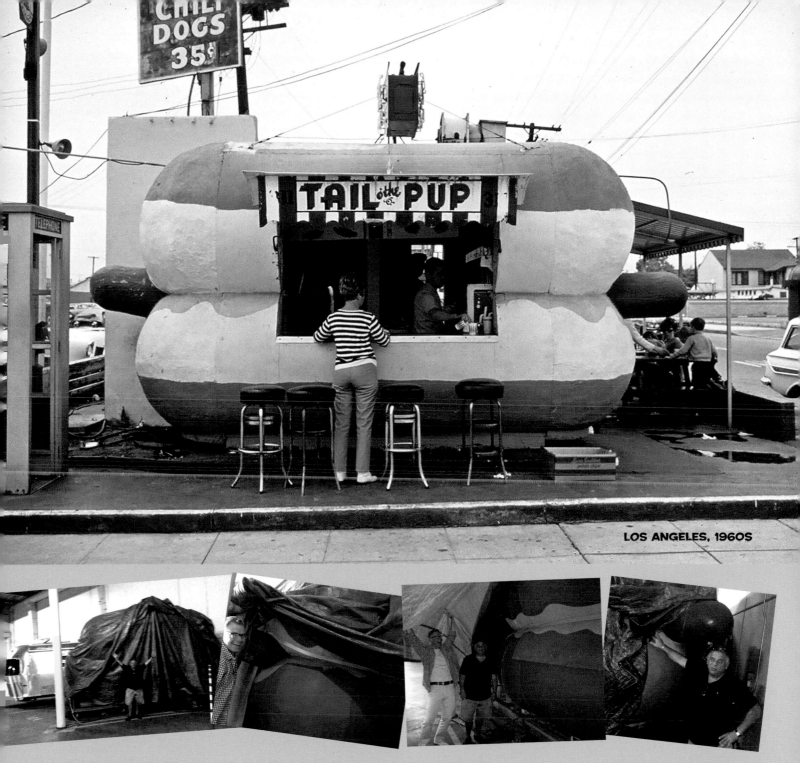

CHILI DOGS 35¢

TAIL o'the PUP

TELEPHONE

LOS ANGELES, 1960S

WHAT A TREAT TO SEE THE TAIL O' THE PUP WHILE IT WAS UNDER WRAPS IN STORAGE IN TORRANCE, CALIFORNIA.

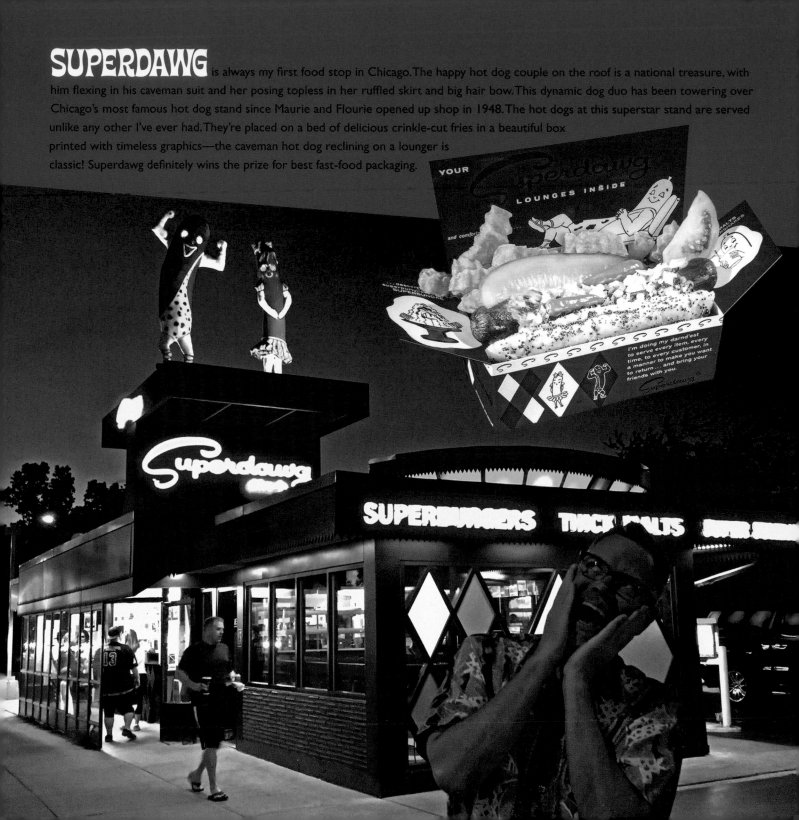

SUPERDAWG

is always my first food stop in Chicago. The happy hot dog couple on the roof is a national treasure, with him flexing in his caveman suit and her posing topless in her ruffled skirt and big hair bow. This dynamic dog duo has been towering over Chicago's most famous hot dog stand since Maurie and Flourie opened up shop in 1948. The hot dogs at this superstar stand are served unlike any other I've ever had. They're placed on a bed of delicious crinkle-cut fries in a beautiful box printed with timeless graphics—the caveman hot dog reclining on a lounger is classic! Superdawg definitely wins the prize for best fast-food packaging.

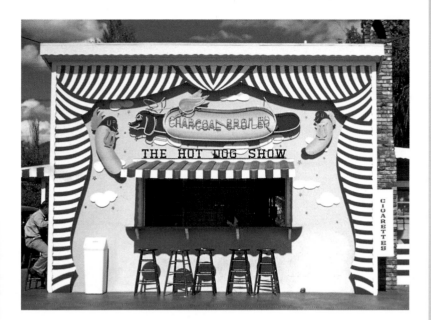

THE HOT DOG SHOW
ONTARIO, CALIFORNIA,
1954

Didn't the owners ever notice that those red-and-white-striped curtains looked like a rather large person squatting over the order window, thereby making those hot dogs with angel wings and halos seem quite unappetizing?

In the days before Interstate 10 extended through Ontario, Hollywood stars would stop for lunch at The Hot Dog Show when traveling between Los Angeles and Palm Springs. Norma Jones, the original owner, told me about the time that Joan Crawford pulled up in a big black limousine. Before she ordered a round of hot dogs for her chauffeur, nanny, the twins, and precious little Christina, she insisted upon inspecting the cleanliness of the kitchen. After it passed her test, she smoked a cigarette in the kitchen while her entourage ate their hot dogs on the patio. Sadly, The Hot Dog Show burned to the ground in 1960 after a grease fire in the kitchen.

I LOVE CUPID'S HOT DOGS, IN CANOGA PARK, CALIFORNIA.

DOG AND SUD'S, GRAYSLAKE, ILLINOIS.

IT'S SNOWING AT WOLFY'S, CHICAGO, ILLINOIS.

IN-N-OUT BURGER BALDWIN PARK, CALIFORNIA

The world's most honest-to-goodness hamburger chain has gifted us with a faithful replica of its iconic original 1948 drive-thru stand, virtually on the same site as the first one.

Everything about this replica is picture perfect. From the oh-so-classic neon sign to the matching candy-striped awnings and hand-painted menu board, every single detail seems authentic. There's even an old cigarette machine hanging from the signpost. Apparently, back in the day, you could stock up on cigs while waiting for your double-double burger.

It's like a mini–theme park, and your car is the ride vehicle—think Cars Land at Disney's California Adventure. Take the short but very sweet ride on the gleaming white (for now) rock driveway up to the stand, hop out, and say, "cheese...burger!" ALL fast-food chains should have replicas of their original stands.

If you actually want a burger (and you know you do!), you'll have to follow the three generations of signs and the signature crisscrossed pair of palms to a functioning In-N-Out on the other side of the freeway. History is the only thing on this In-N-Out menu.

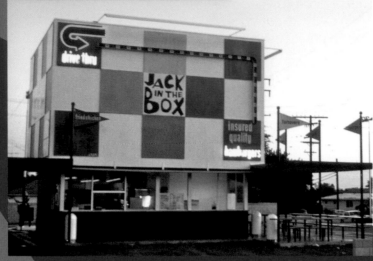

JACK IN THE BOX ALHAMBRA, CALIFORNIA, 1967

The colorful, clown-themed, "insured quality" drive-thru joint began in San Diego in 1951. The first of its memorable box-style stores was built as a clever solution to a local ordinance banning tall signs. Wrapping four billboards around the original building (thus creating a big box) not only worked well for the brand but also had a much stronger visual impact than the sign they had to remove from the front.

DRIVE-THRU

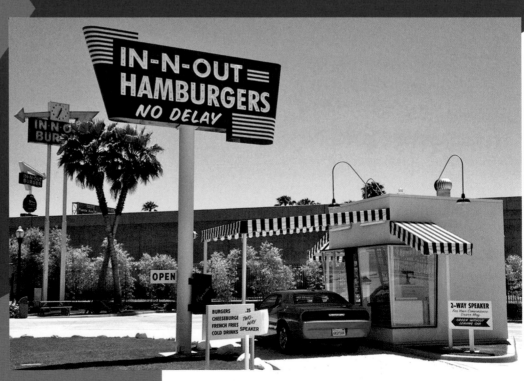

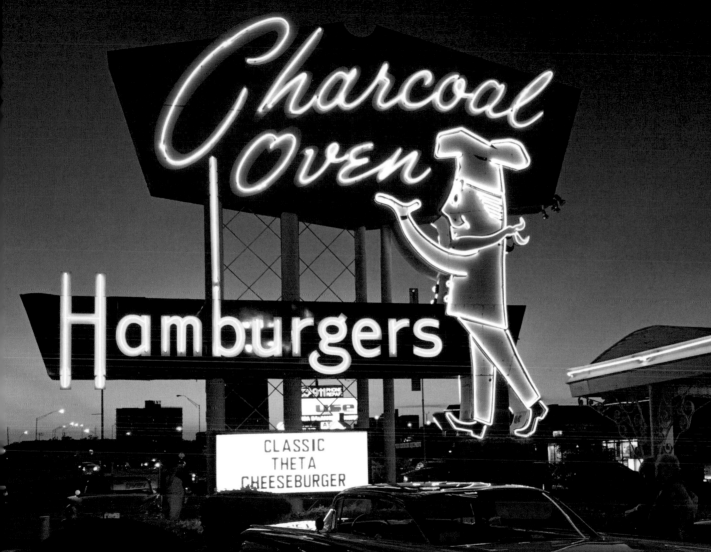

CLASSIC
THETA
CHEESEBURGER

CHARCOAL OVEN
OKLAHOMA CITY, 1958

That neon-dressed super-sized chef
stopped me in my tracks—as did the pretty-
in-pink lettering on that early-American-shaped
signboard, connected by a giraffe of a "b" to the sign listing
the stand's signature dish. This drive-thru served for 58 years until
closing in 2016. Not wanting this historic hamburger beacon to go down
without a fuss, I hosted a "Last Call–Cars with Fins Cruise-in Party" just before
it closed, only to be bulldozed to make way for a discount tire store. That's progress.

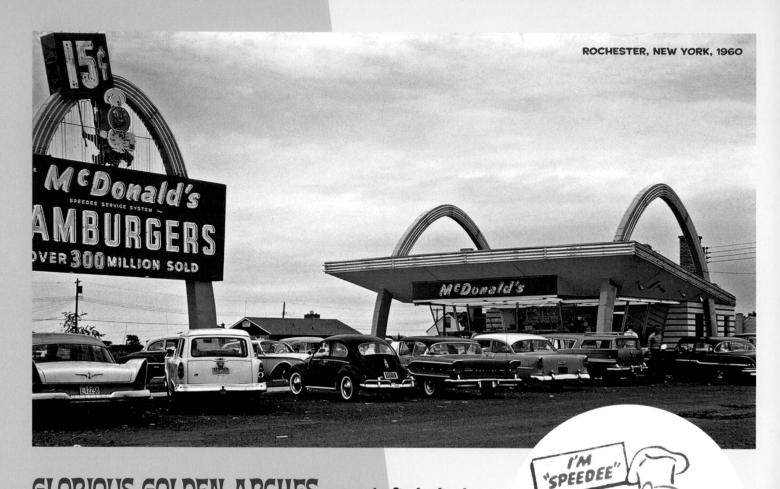

I'M "SPEEDEE"

GLORIOUS GOLDEN ARCHES suspend a finely sliced

roofline over three sides of slanted glass and gleaming candy-striped tile.

The matching sign is as decorative as it is informative, displaying the price,

the mascot, Speedee, and how many have been sold. The ketchup-and-mustard

color scheme is eye-catching and appetizing, and everything is aglow in neon.

It's a picture-perfect showcase for the revolutionary food service going on here, and it's the epitome of

1950s "form follows function" design. Together, the building and its companion signage are a midcentury-

modern masterpiece and an American classic.

DUELING McDONALD'S

I often meet people who seem to be confused about which historic McDonald's came first: Downey or Des Plaines.

The oldest McDonald's, in Downey, California, is not the first store ever built; it's actually the fourth. Neither is "Store #1," built in 1955 in Des Plaines, Illinois, the "first" (as McDonald's Corporation refers to it); it's actually the ninth. It is, however, the first one built by Ray Kroc, the milkshake salesman who pimped the franchise into a global superstar. Not only is Ray Kroc's first McDonald's not the real first McDonald's; it's also a 1985 replica of the original building that now functions as museum.

Long gone is the McDonald brothers' original stand, built in 1948 in San Bernardino, California. It was there that the McDonald brothers master-minded how to put the "fast" in "fast food" like nobody had done before, by streamlining the menu and meticulously organizing the food prep into an assembly line. The iconic golden-arches-style McDonald's didn't appear until 1952, in Phoenix, Arizona. That store is also long gone.

If you're looking for the most historic McDonald's, Downey is the place to go—golden arches, landmark super-sized "Speedee" sign, and all. Fast food doesn't get any more genuine or authentic than this!

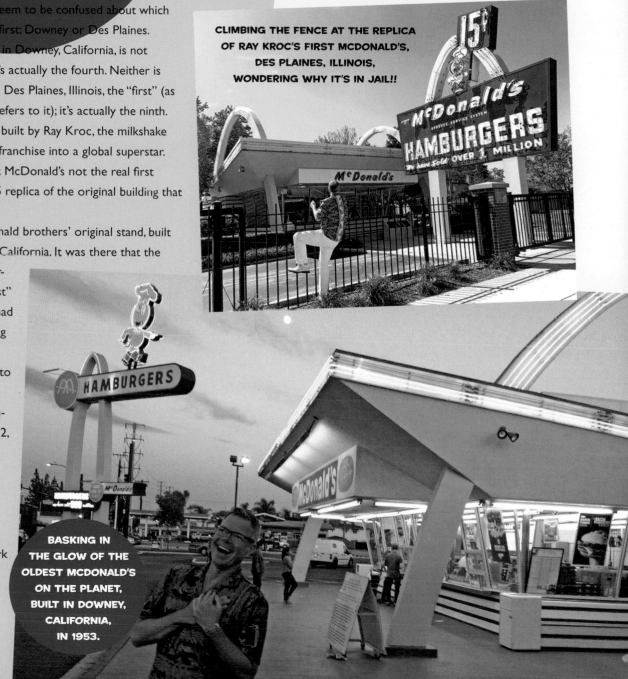

CLIMBING THE FENCE AT THE REPLICA OF RAY KROC'S FIRST MCDONALD'S, DES PLAINES, ILLINOIS, WONDERING WHY IT'S IN JAIL!!

BASKING IN THE GLOW OF THE OLDEST MCDONALD'S ON THE PLANET, BUILT IN DOWNEY, CALIFORNIA, IN 1953.

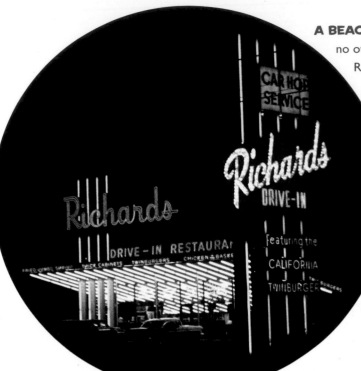

A BEACON OF LIGHT in the night like no other hamburger stand I've ever seen, RICHARDS was quite the electrifying eating experience, inside and out. It had several (now long gone) locations in Eastern and Mid-western states. Chances are the "California Twin Burger" was inspired by the triple-decker Big Boy at Bob's. Who needs a menu when it's spelled out in neon right in front of you?

BOB'S BIG BOY PASADENA, CALIFORNIA, 1956 A uniformed car hop, complete with march-ing-band-like pants and a matching cap, serves customers in their 1956 Dodge Custom Royal convertible.

Car Hops

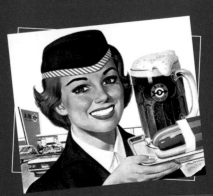

DON CARLOS BAR-BE-Q SALT LAKE CITY, 1955 Long gone is this towering car hop serving it up in red, white, and blue neon.

A&W ROOT BEER began in Lodi, California, in 1919. The legendary root beer stand was one of the first to offer car hop service.

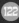

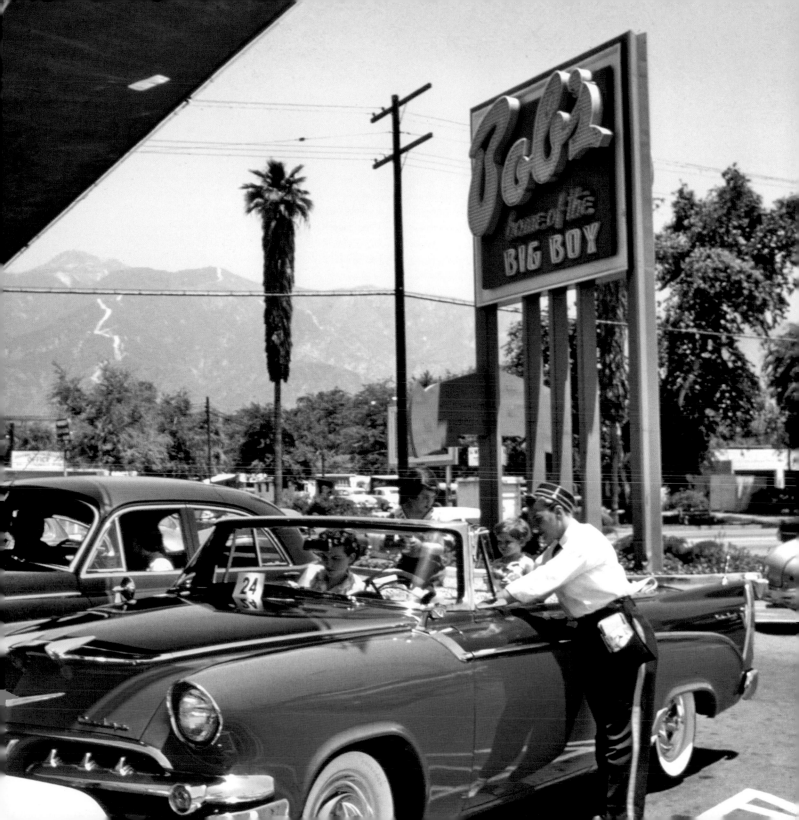

Fat Boy
Downey, California

the BOYS!

Like the Statue of Liberty holds the torch, Big Boy holds his namesake burger. The original triple-decker was first served in 1934 at Bob's Big Boy #1 in Glendale, California.

There've been many Big Boy wannabes, but few, if any, compare to Fat Boy, the mascot of Johnie's Broiler in Downey, California. He looks like Big Boy's blond cousin, although he was actually modeled on Beany from the TV show *Beany & Cecil*.

Ironically, Johnie's Broiler later became a Bob's Big Boy. Luckily for Fat Boy (and us), he still welcomes customers at the side street entrance, in all his glory.

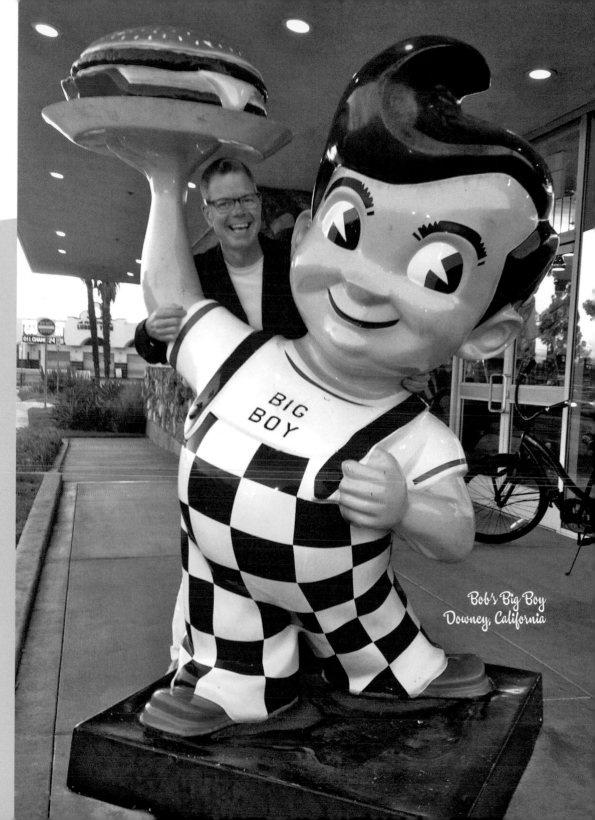

Bob's Big Boy
Downey, California

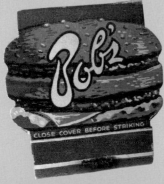

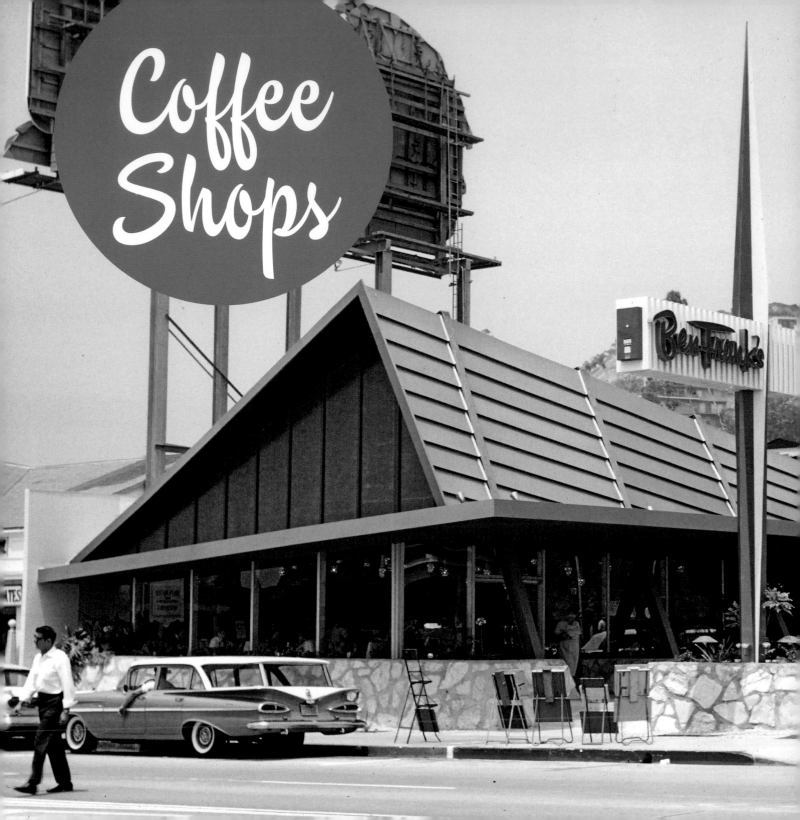

Coffee Shops

Ben Frank's, Hollywood, 1962

The sophisticated-yet-sassy harvest-gold-and-orange color scheme perfectly suits the relaxed A-frame—and just happens to match the 1959 Chevrolet station wagon parked out front. When I moved to Los Angeles in 1982, this was my Sunday dinner place of choice; liver and onions was my usual. Today, it's one of the few Southern Californian midcentury-Googie coffee shops still standing. It's a Mel's Diner now. I wonder if they have liver and onions on the menu?

PANN'S, LOS ANGELES

Owner Rena Poulos poses with her son, Jim, who now runs the place—and beautifully, I might add! Rena greeted customers daily well into her late 90s, just as she had since they opened the doors in 1958. She deserves to be crowned coffee shop queen.

SHIPS MENU, LOS ANGELES, 1970S

Among the many distinctive features of Ships (the epic sign, for starters) were the toasters on every table.

IN THE MID-'90S,

I painted several iconic Los Angeles Googie coffee shops, including Pann's (above) and Norm's La Cienega. Its animated neon pennant sign has been lighting up the night sky since 1957.

Pann's

LA CIENEGA AT LA TIJERA
LOS ANGELES

NORM'S

LA CIENEGA AT ROSEWOOD
LOS ANGELES

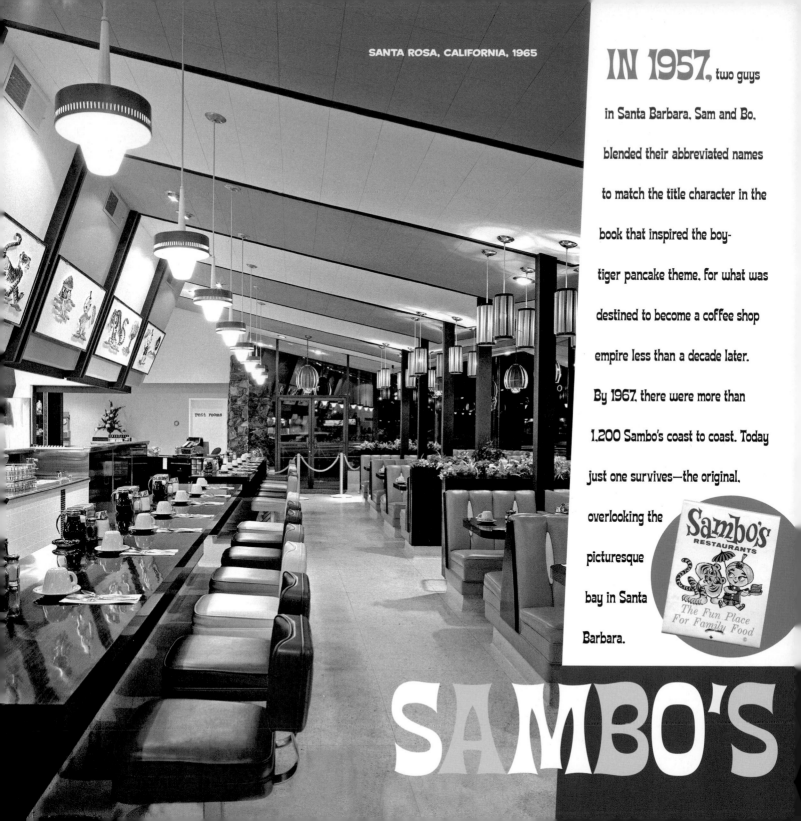

SANTA ROSA, CALIFORNIA, 1965

rest rooms

IN 1957, two guys in Santa Barbara, Sam and Bo, blended their abbreviated names to match the title character in the book that inspired the boy-tiger pancake theme, for what was destined to become a coffee shop empire less than a decade later. By 1967, there were more than 1,200 Sambo's coast to coast. Today just one survives—the original, overlooking the picturesque bay in Santa Barbara.

Sambo's
RESTAURANTS
The Fun Place
For Family Food

SAMBO'S

CUSTOMERS BASK IN THE GLORY OF ORANGE, YELLOW, BLUE, AND WHITE VINYL, WOOD PANELING, HANGING LAMPS, A SLANTED STRIPED CEILING, AND PLATE GLASS. AND IT'S ALL COLOR COORDINATED! BY ANY CREATIVE DESIGN STANDARDS, SAMBO'S INTERIOR DECOR IS AS PLAYFUL AND COLORFUL AS A SPACE-AGE TOYBOX.

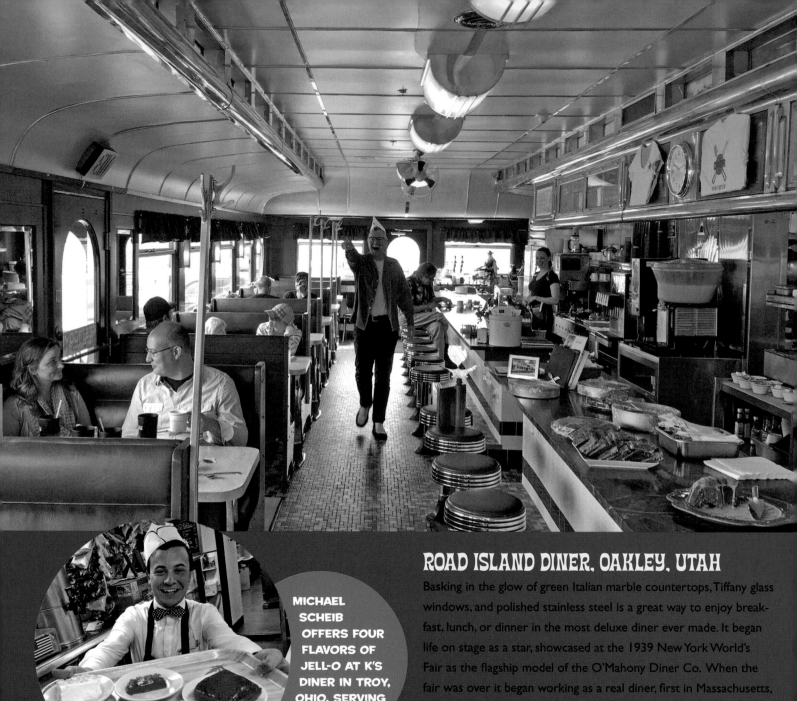

MICHAEL SCHEIB OFFERS FOUR FLAVORS OF JELL-O AT K'S DINER IN TROY, OHIO, SERVING SINCE 1935.

ROAD ISLAND DINER, OAKLEY, UTAH

Basking in the glow of green Italian marble countertops, Tiffany glass windows, and polished stainless steel is a great way to enjoy breakfast, lunch, or dinner in the most deluxe diner ever made. It began life on stage as a star, showcased at the 1939 New York World's Fair as the flagship model of the O'Mahony Diner Co. When the fair was over it began working as a real diner, first in Massachusetts, then in Rhode Island. In 2006, the not-so-shiny-anymore streamline art deco darling was carefully transported to its unlikely new home, restored and opened in Oakley. Once a star always a star—diners don't get any more polished than this!

BRICK, NEW JERSEY, 1961

Laurelton DINER

KING'S CHEF DINER CASTLE COLORADO SPRINGS

Greetings from the rarest of all the Valentine Diners, the pre-fab chain founded by Arthur Valentine in the 1930s. This too-cute castle is still open for business—and has been since 1956. With those six storybook turrets, it's the only pre-fab diner ever made that could do double duty in the middle of a miniature golf course. Too bad it was closed the day I was there. I'll be back!

DINNER in the DINER

DOT'S DINER BISBEE, ARIZONA

Streamlined styling stuns in silver and red at Dot's, a ten-stool, 1957 Valentine pre-fab diner. Originally Burger Boy #3, it served Los Angeles until 1983. In 1996, I happily discovered it at the sensational Shady Dell vintage trailer park in Bisbee.

FREE PARKING →
MICKEY'S DINING CAR
MICKEY'S DINER

MICKEY'S DINER ST. PAUL, MINNESOTA

Serving it up 24/7/365 since 1939.

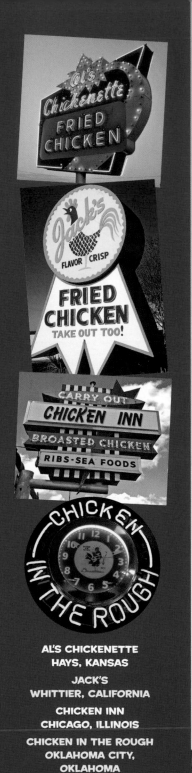

LA PALMA CHICKEN PIE SHOP
ANAHEIM, CALIFORNIA

This landmark neon sign had it all: color, style, shapes, stripes, fun fonts, and a perky, plump chicken. When the sign came down after 58 years in 2015, the chicken found a new roost at MONA, the Museum of Neon Art in Glendale, California.

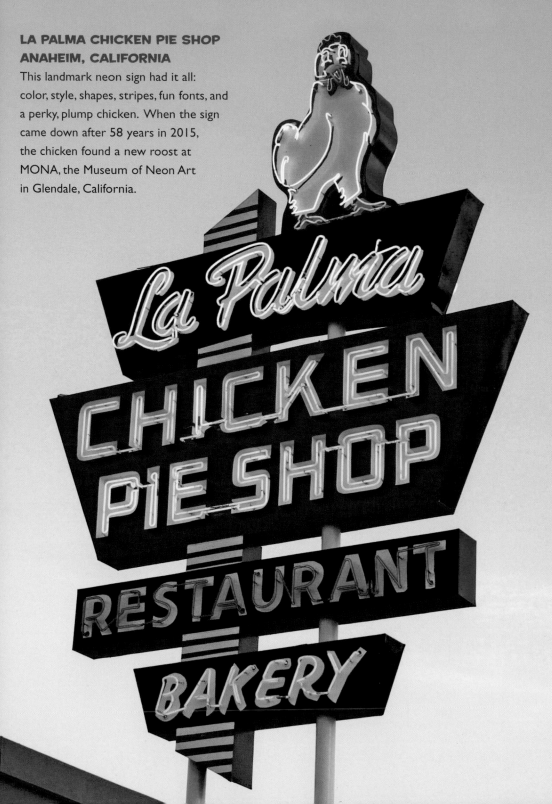

AL'S CHICKENETTE
HAYS, KANSAS

JACK'S
WHITTIER, CALIFORNIA

CHICKEN INN
CHICAGO, ILLINOIS

CHICKEN IN THE ROUGH
OKLAHOMA CITY,
OKLAHOMA

Fried, Pied, & Broasted

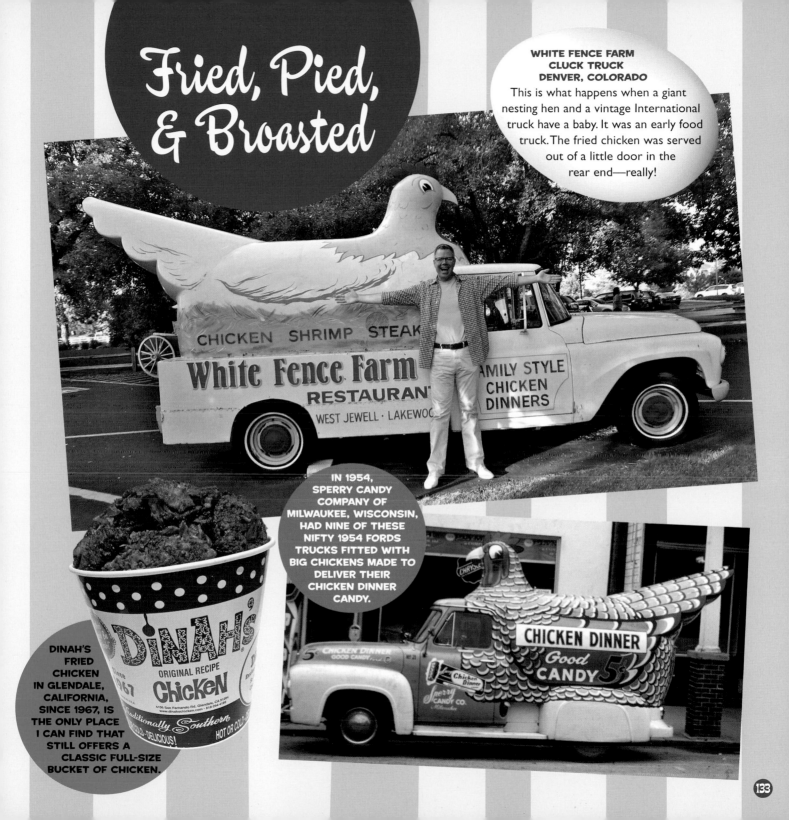

WHITE FENCE FARM CLUCK TRUCK DENVER, COLORADO
This is what happens when a giant nesting hen and a vintage International truck have a baby. It was an early food truck. The fried chicken was served out of a little door in the rear end—really!

CHICKEN SHRIMP STEAK

White Fence Farm RESTAURANT
WEST JEWELL · LAKEWOO

AMILY STYLE CHICKEN DINNERS

IN 1954, SPERRY CANDY COMPANY OF MILWAUKEE, WISCONSIN, HAD NINE OF THESE NIFTY 1954 FORDS TRUCKS FITTED WITH BIG CHICKENS MADE TO DELIVER THEIR CHICKEN DINNER CANDY.

DINAH'S FRIED CHICKEN IN GLENDALE, CALIFORNIA, SINCE 1967, IS THE ONLY PLACE I CAN FIND THAT STILL OFFERS A CLASSIC FULL-SIZE BUCKET OF CHICKEN.

DINAH'S
ORIGINAL RECIPE
ChicKeN
Traditionally Southern
HOT OR COLD

CHICKEN DINNER Good CANDY 53

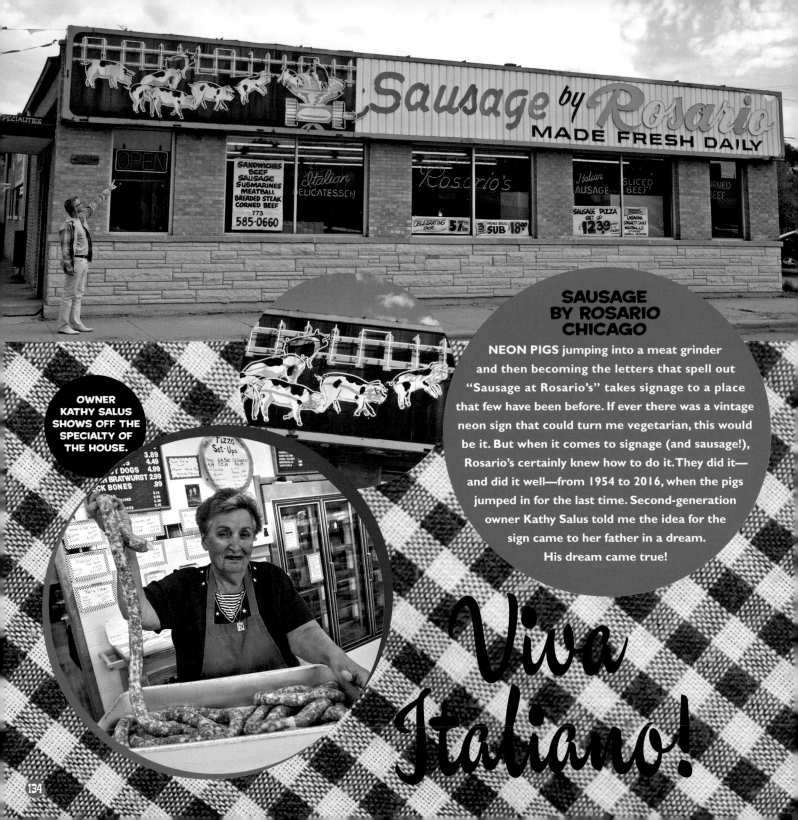

Sausage by Rosario

MADE FRESH DAILY

OPEN

SANDWICHES
BEEF
SAUSAGE
SUBMARINES
MEATBALL
BREADED STEAK
CORNED BEEF
773
585-0660

Italian
DELICATESSEN

Rosario's

Italian
SAUSAGE

SLICED
BEEF

CORNED
BEEF

CELEBRATING
OUR 57TH

FRENCH BREAD
SUB 18⁰⁰

SAUSAGE PIZZA
SET UP
12³⁹

LASAGNA
SPAGHETTI SAUCE
MEATBALLS
STUFFED
GREEN PEPPER

SAUSAGE BY ROSARIO CHICAGO

NEON PIGS jumping into a meat grinder and then becoming the letters that spell out "Sausage at Rosario's" takes signage to a place that few have been before. If ever there was a vintage neon sign that could turn me vegetarian, this would be it. But when it comes to signage (and sausage!), Rosario's certainly knew how to do it. They did it— and did it well—from 1954 to 2016, when the pigs jumped in for the last time. Second-generation owner Kathy Salus told me the idea for the sign came to her father in a dream. His dream came true!

OWNER KATHY SALUS SHOWS OFF THE SPECIALTY OF THE HOUSE.

Pizza Set-Ups

3.89
4.49
HOT DOGS 4.99
BRATWURST 2.99
CK BONES .99

Viva Italiano!

The World's
LARGEST
Spaghetti Restaurant

THE VINTAGE NEON SIGN, with its shapely green face, sassy stripes, and chasing arrow pointing customers to the front door, is the crowning touch of Vince's Spaghetti, which has been serving in my hometown of Ontario, California, since 1945. You can smell the simmering sauce wafting in the breeze before you even pull into the parking lot. When you walk in the door, you can feel the heart and soul. Talk about hometown pride!

My earliest memory of this oh-so-fine spaghetti shrine is my seventh birthday. We were in my aunt's bright turquoise 1959 Ford Galaxie 500, on our way to celebrate at Disneyland, when it started to rain. My mother turned around and said, "We're not going to Disneyland in the rain." Which immediately prompted a teary protest. "Where do you want to go instead?" she asked. Without skipping a beat, I stopped the sobbing and said, "Vince's Spaghetti." So Vince's it was, and a happy birthday was had after all!

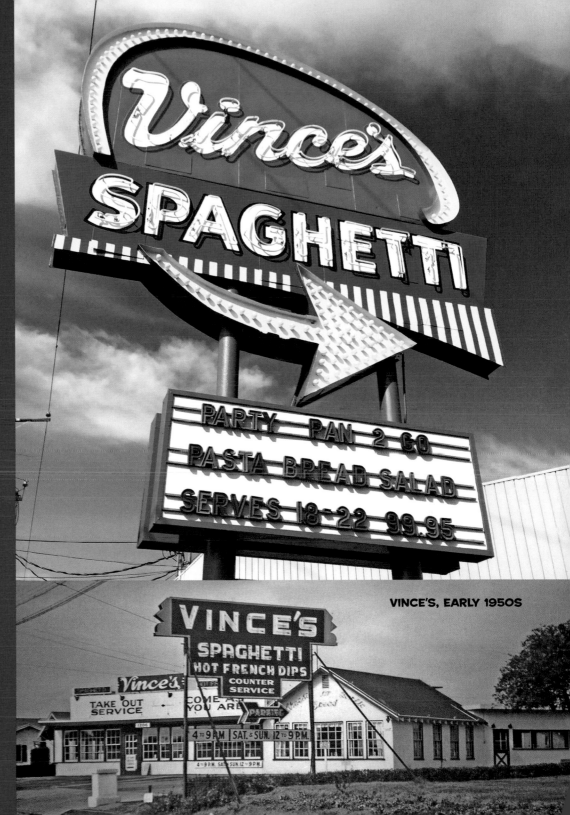

VINCE'S, EARLY 1950S

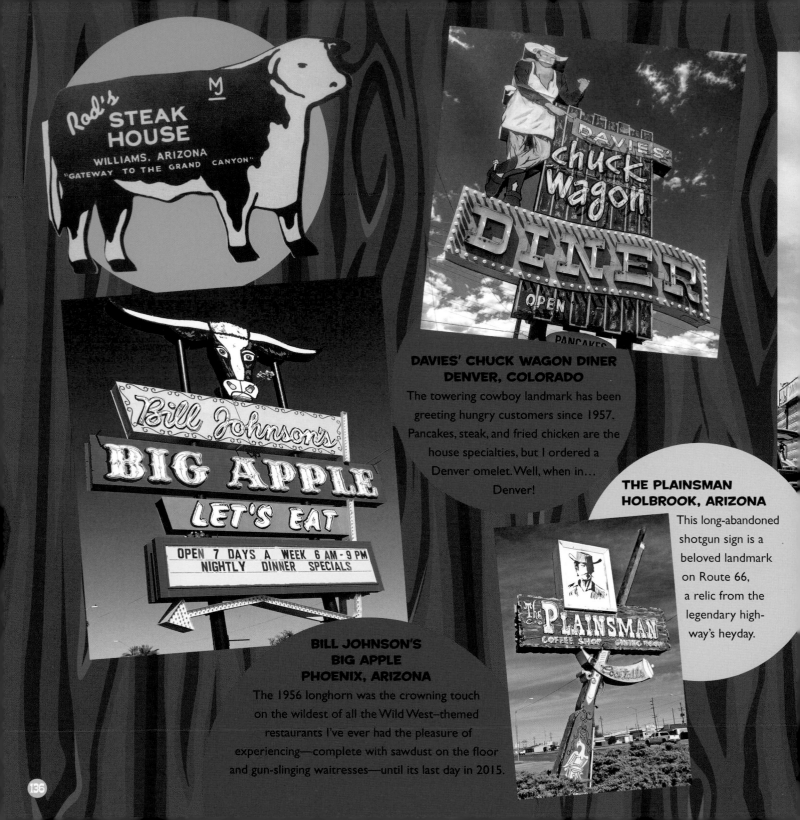

Rod's STEAK HOUSE
WILLIAMS, ARIZONA
"GATEWAY TO THE GRAND CANYON"

DAVIES' chuck wagon DINER
OPEN
PANCAKES

DAVIES' CHUCK WAGON DINER
DENVER, COLORADO

The towering cowboy landmark has been greeting hungry customers since 1957. Pancakes, steak, and fried chicken are the house specialties, but I ordered a Denver omelet. Well, when in… Denver!

Bill Johnson's
BIG APPLE
LET'S EAT
OPEN 7 DAYS A WEEK 6 AM - 9 PM
NIGHTLY DINNER SPECIALS

BILL JOHNSON'S
BIG APPLE
PHOENIX, ARIZONA

The 1956 longhorn was the crowning touch on the wildest of all the Wild West–themed restaurants I've ever had the pleasure of experiencing—complete with sawdust on the floor and gun-slinging waitresses—until its last day in 2015.

THE PLAINSMAN
HOLBROOK, ARIZONA

This long-abandoned shotgun sign is a beloved landmark on Route 66, a relic from the legendary highway's heyday.

The PLAINSMAN
COFFEE SHOP

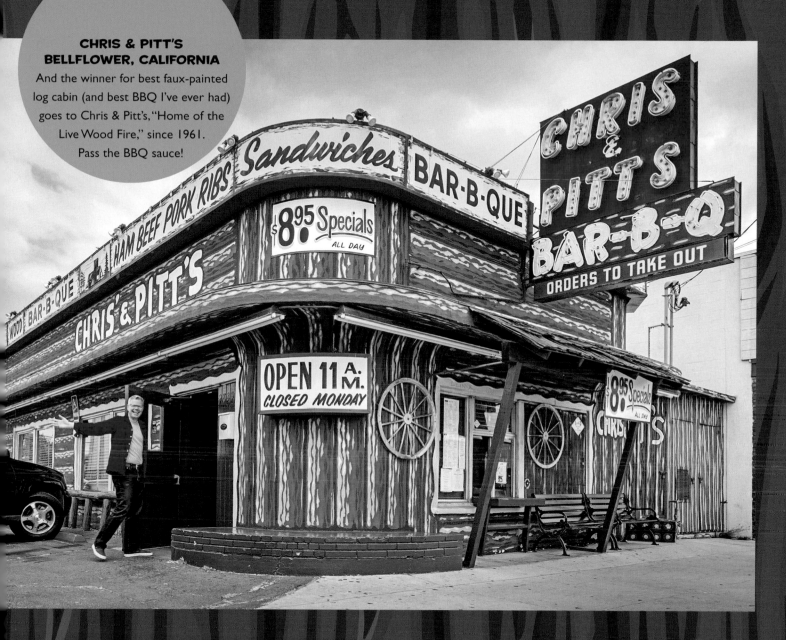

The Wild West!

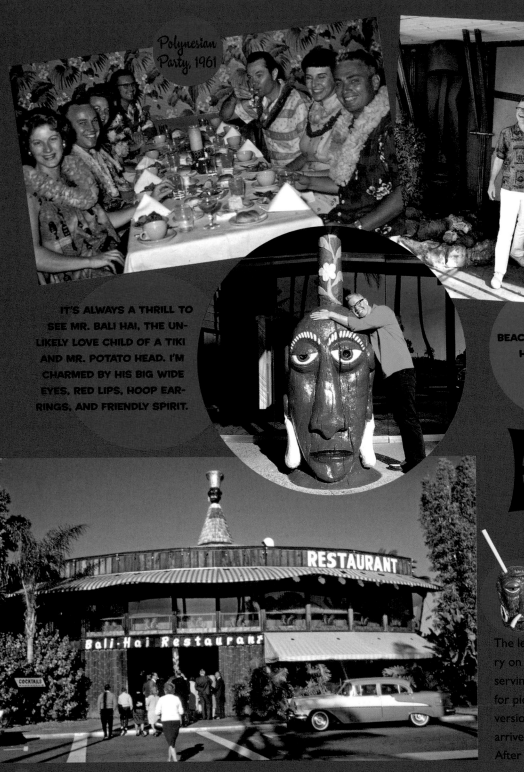

Polynesian Party, 1961

THE TONGA HUT, WHERE THEY'VE BEEN SERVING 'EM UP STRONG SINCE 1958. NORTH HOLLYWOOD, CALIFORNIA.

IT'S ALWAYS A THRILL TO SEE MR. BALI HAI, THE UNLIKELY LOVE CHILD OF A TIKI AND MR. POTATO HEAD. I'M CHARMED BY HIS BIG WIDE EYES, RED LIPS, HOOP EARRINGS, AND FRIENDLY SPIRIT.

DON THE BEACHCOMBER. HUNTINGTON BEACH, CALIFORNIA.

EXOTIC

BALI-HAI RESTAURANT SHELTER ISLAND, SAN DIEGO, 1963

The legendary "Goof" on the roof is the cherry on top of this world-class Polynesian palace, serving since 1954. At the entrance, guests pose for pictures with the mascot, Mr. Bali Hai, a giant version of its famous souvenir tiki mug. You may arrive by car or by boat, as it does have a dock. After all, it is on an "island!"

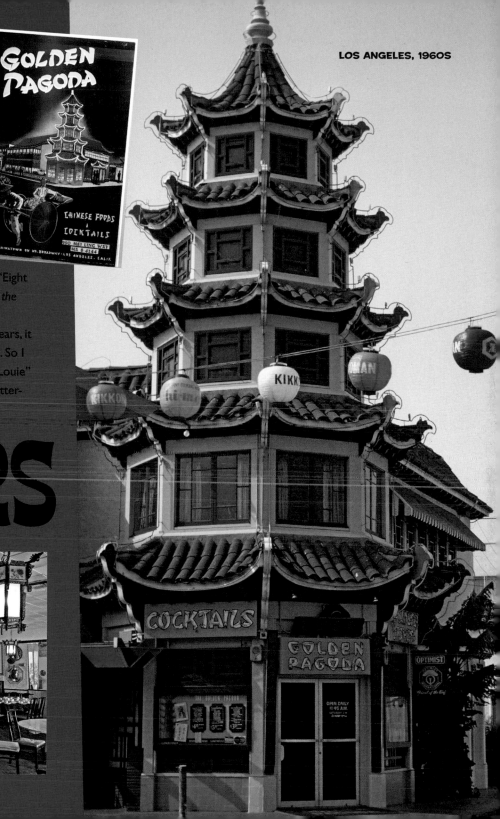

HOP LOUIE, originally the

GOLDEN PAGODA, was and forever shall be my favorite Chinese restaurant on the planet. When it opened in L.A. in 1941, the yellow-neon-trimmed pagoda became an instant landmark and the centerpiece of Chinatown. The exotic dining room is a rare and spectacular example of midcentury Chinese modern. The best table in the house is the only one that's actually inside the pagoda. I once asked the hostess, "How many does the booth in the pagoda seat?" She looked me up and down and said, "Eight heavy-set people." I thought to myself, *No seconds of the sweet-and-sour pork for me tonight!*

In 2016, the night the restaurant closed after 75 years, it couldn't go without a proper goodbye and thank-you. So I put the word out and hosted a "Last Supper at Hop Louie" dinner. The place was packed! But that night, it was bitter-sweet-and-sour pork.

FLAVORS

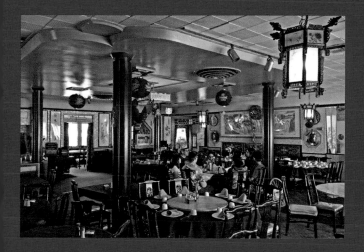

The Joy of GIANT DONUTS!

THE DONUT HOLE, LA PUENTE, CALIFORNIA

The donuts aren't the only thing deep-fried here—maneuvering your motor vehicle in one side and out the other of the world's only drive-thru donut shop will deep-fry your brain, too. No trip to the south side of the San Gabriel Valley is complete without experiencing the glory of this classic car-culture curiosity, where they've been serving the motoring masses since 1968. It's a tight squeeze, but once inside you simply point to the donuts you want, then stop to pay the cashier. Life brings many drive-thru experiences, but none compare to driving through the hole of an enormous chocolate donut. Where else can you drive through a giant version of what you're about to eat?

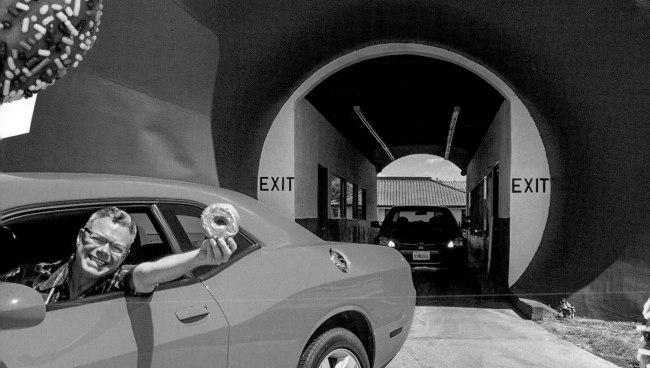

THE DONUT HOLE

"IT'S THE QUALITY"

EXIT EXIT

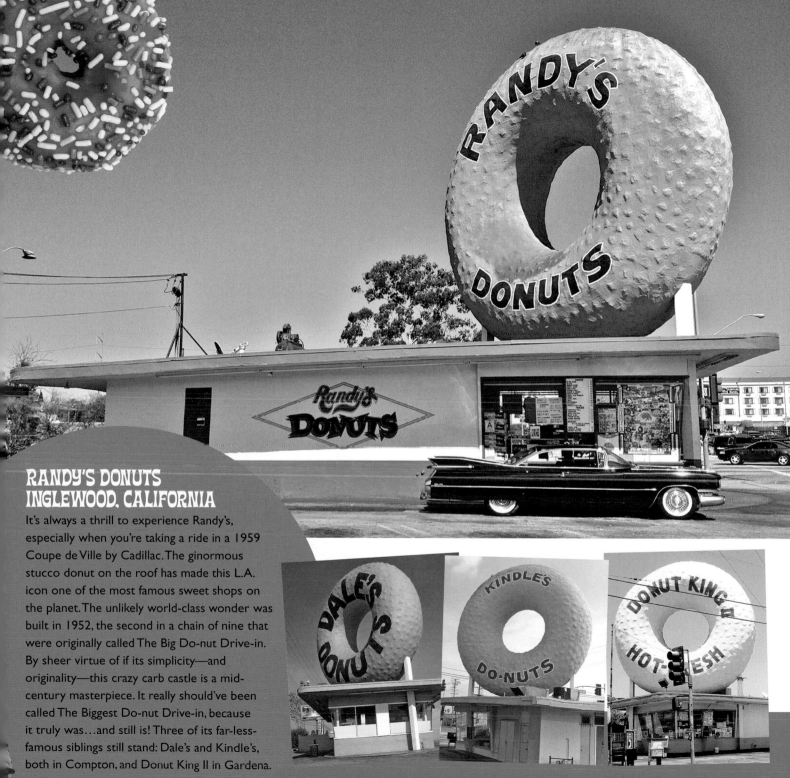

RANDY'S DONUTS
INGLEWOOD, CALIFORNIA

It's always a thrill to experience Randy's, especially when you're taking a ride in a 1959 Coupe de Ville by Cadillac. The ginormous stucco donut on the roof has made this L.A. icon one of the most famous sweet shops on the planet. The unlikely world-class wonder was built in 1952, the second in a chain of nine that were originally called The Big Do-nut Drive-in. By sheer virtue of if its simplicity—and originality—this crazy carb castle is a mid-century masterpiece. It really should've been called The Biggest Do-nut Drive-in, because it truly was…and still is! Three of its far-less-famous siblings still stand: Dale's and Kindle's, both in Compton, and Donut King II in Gardena.

ICE CREAM! ICE CREAM! ICE CREAM!

GUNTHER'S ICE CREAM SACRAMENTO

The animated ice cream scooper has been a local land-mark for decades. It wins the prize for best vintage neon ice cream shop sign on the planet!

CLASSIC ICE CREAM CLOWNS AT FOSSELMAN'S IN ALHAMBRA, CALIFORNIA.

TWINS, ICE CREAM, AND COWHIDE UPHOLSTERY. BUFFALO, NEW YORK, 1957.

BARREL OF FUN ICE CREAM LOUISVILLE, KENTUCKY

To dip or not to dip?

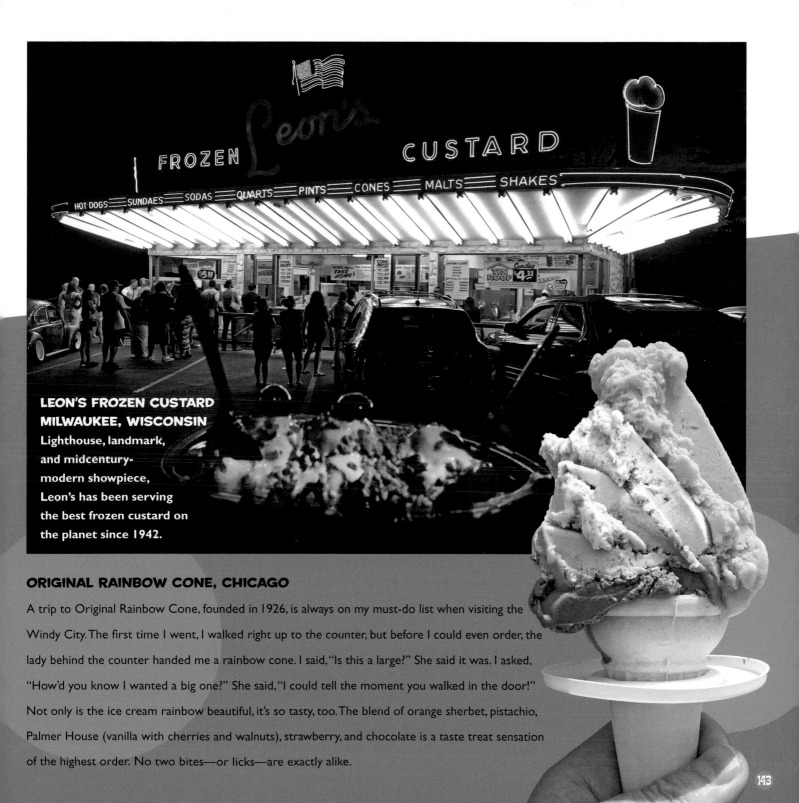

LEON'S FROZEN CUSTARD
MILWAUKEE, WISCONSIN

Lighthouse, landmark, and midcentury-modern showpiece, Leon's has been serving the best frozen custard on the planet since 1942.

ORIGINAL RAINBOW CONE, CHICAGO

A trip to Original Rainbow Cone, founded in 1926, is always on my must-do list when visiting the Windy City. The first time I went, I walked right up to the counter, but before I could even order, the lady behind the counter handed me a rainbow cone. I said, "Is this a large?" She said it was. I asked, "How'd you know I wanted a big one?" She said, "I could tell the moment you walked in the door!" Not only is the ice cream rainbow beautiful, it's so tasty, too. The blend of orange sherbet, pistachio, Palmer House (vanilla with cherries and walnuts), strawberry, and chocolate is a taste treat sensation of the highest order. No two bites—or licks—are exactly alike.

I LOVE FUTURISTIC FLAIR. Space-age cars, dream mobiles, streamlined trains, midcentury monorails, and wannabe rocket ships are my preferred mode of transportation. I don't want to just go places; I want to travel in hyper style.

America's race for space reflected itself in many ways, but nowhere more extravagantly than in the realm of transportation. By the mid-'50s, automakers were super-styling their ever-evolving parade of products into the most ornate and out-of-this-world cars ever mass produced. Tail fins reached their zenith in 1959.

One-of-a-kind prototype cars were the darlings of the auto-show circuit. But after they did their tour of duty, most of them were carelessly cast aside and crushed. Thankfully, a few escaped the scrap heap.

Monorails were predicted to revolutionize the future of mass transit. But ultimately the notion was short lived, and most have vanished.

These are the vehicles I'm constantly on the lookout for. I've been known to fly across the country just to see a one-of-a-kind "show car of the future" from the past. Playing detective to find retired monorail cars or ice cream mobiles is my definition of bliss. Sneaking a ride on a playground or parade rocket sends me to the moon.

It's not just the astronauts who are going to the moon—we all are. We all want to feel like we can fly! And with these space-age vehicles, we almost can. So sit back, relax, and enjoy this voyage into the stratosphere of the ultimate era of optimistic transportation!

5-4-3-2-1... BLAST-OFF!

THE APOLLO COMMAND
MODULE AT THE COLUMBIA
MEMORIAL SPACE CENTER IN
DOWNEY, CALIFORNIA, THE SITE
WHERE ALL SIX COMMAND
MODULES THAT CARRIED MAN
TO AND FROM THE MOON WERE
DESIGNED AND BUILT.

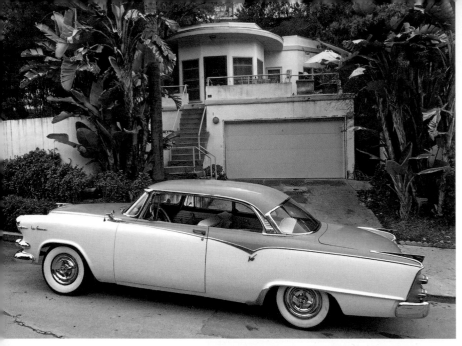

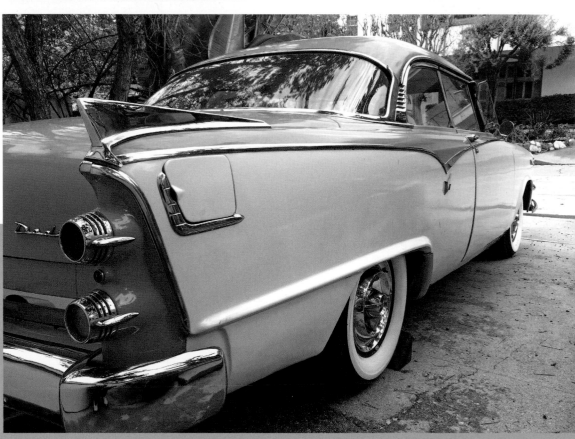

BRIAN COTTON SEARCHED FOR YEARS TO FIND THIS SUPER-RARE LA FEMME— AND EVEN LONGER FOR THE ALMOST-IMPOSSIBLE-TO-FIND MATCHING PURSE. HE PAINTED HIS 1937 STREAMLINE MODERNE HOME IN LOS ANGELES TO MATCH THE CAR.

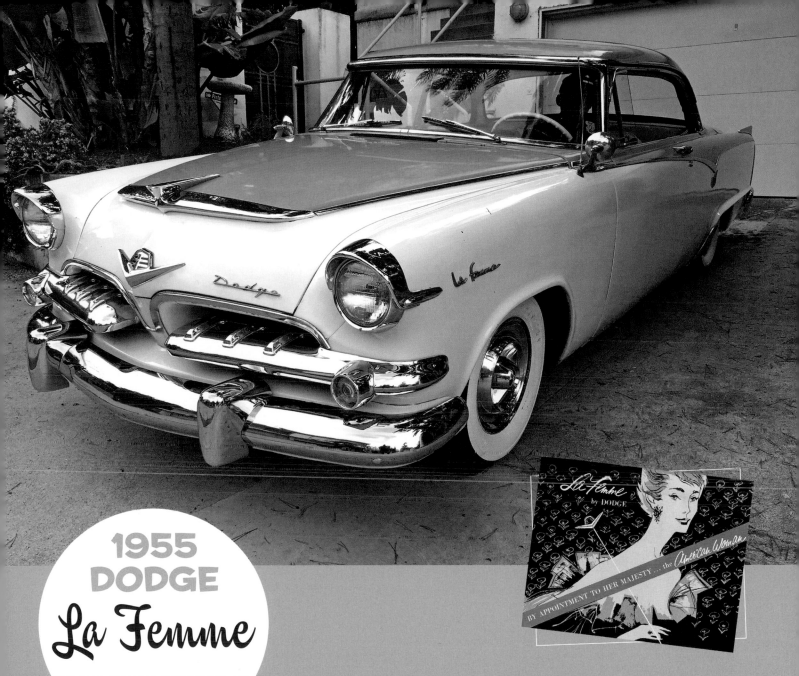

1955 DODGE
La Femme

FOR $143 MORE THAN DODGE'S TOP-OF-THE-LINE CUSTOM ROYAL LANCER, the La Femme package included gold "La Femme" front fender scripts, pretty-in-pink-and-white paint, and a coordinating pink "rosebud" cloth-and-vinyl interior. As if that weren't enough to line up lady drivers, the dressy deal was sweetened with a matching umbrella, raincoat, purse, and cigarette case. Dodge discontinued the La Femme after the 1956 model year. In all my years of chasing classic cars, this is only the second 1955 La Femme I've had the pleasure of experiencing in person.

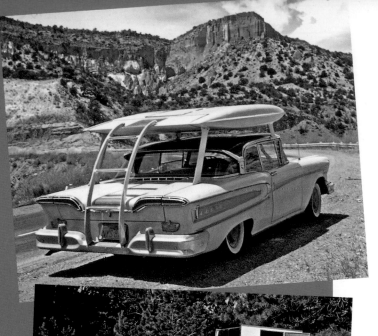

EDSEL'S DOUBLE-DECKER HORSE-COLLAR GRILL MADE IT THE MOST RIDICULED CAR OF ALL TIME.

That's just one of the reasons it's always been one of my favorite cars. In 1957, the granddaddy of American automobile companies, Ford, introduced its ballyhooed Edsel, not as a new model but as a new marque, an entirely new line. There were coupes, convertibles, sedans, and station wagons to fit every budget, in a dizzying array of two-toned and tri-toned paint schemes. Among Edsel's "modern motoring" features was a pushbutton transmission in the hub of the steering wheel.

Despite all this, the line was not well received. A famous automotive journalist declared, "It looks like an Oldsmobile sucking a lemon." The public seemed to agree, because in 1960, after just three years of production, Ford discontinued the Edsel. That double-decker, deep-dish horse-collar grill and all-around "Queen from Outer Space"-age styling were perhaps more than we mere earthlings could comprehend in the late '50s. But now that six decades have passed, we see it a bit differently. We might as well just get it out in the open: every surviving Edsel is an American classic and national treasure!

It's a beautiful day in the neighborhood when one of these mid-century marvels motors by.

the Aero Cabana!

A 1958 EDSEL CITATION models this clever camping contraption...SO *Popular Mechanics*! We've all slept in a car, but have you ever slept over a car? The smart, sci-fi-style upstairs addition was called the Aero Cabana. Such a great name! It was a fancy '50s way of explaining exactly what it was: a clamp-on airplane wingette with a pop-up travel tent tucked inside. Just think—you could have a sleepover in your sleep over!

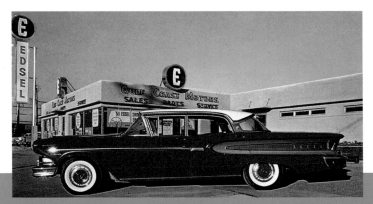

1958 EDSEL

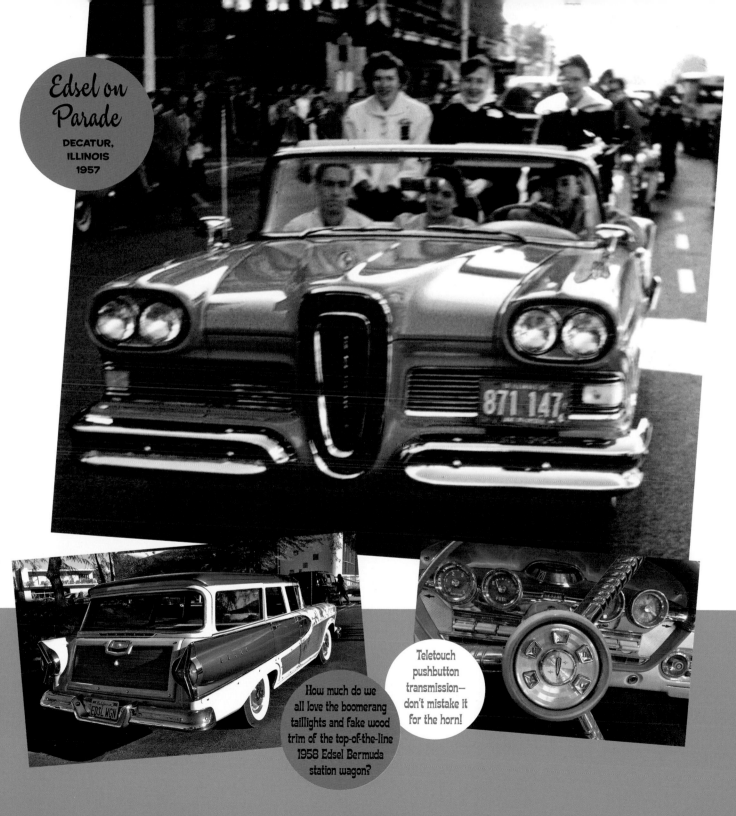

871 147

EDSL WGN

How much do we all love the boomerang taillights and fake wood trim of the top-of-the-line 1958 Edsel Bermuda station wagon?

Teletouch pushbutton transmission—don't mistake it for the horn!

149

CURLY & His Cadillac

SACRAMENTO, CALIFORNIA, 2013

AS A WHIRLWIND FIELD-TRIP EXTRAVAGANZA exploring California's capital city came to an end, I had just enough time to grab a quick lunch before my flight. A snap decision guided me to Sam's Hofbrau, a Sacramento landmark serving since 1959. As I pulled into the parking lot, my eyes bugged out of my head. A super-rare 1956 Cadillac Eldorado Seville was parked right in front. The depth of the color and iridescence of the metallic blue were otherworldly. Drunk with pleasure, I staggered around it, ogling and wondering who might own this beauty. Hunger finally pulled me away from the Caddy and into the wonderfully time-warpy saloon-meets-hofbrau restaurant. Even at 3 p.m., the place was crowded.

Sitting down with my hand-carved brisket sandwich, served by chefs wearing paper hats (so old school—I love it!), I noticed the most stunning big blond cowboy hat I've ever seen. It was perfectly perched atop a dignified old man seated with a younger lady in a booth directly across from me. He was also sporting striking red cowboy boots. Wanting to say hello, I approached him as he got up to leave.

Just as I caught up with him and reached out to shake his hand, I realized that the Cadillac had to be his. Before I could introduce myself and ask, "Is that your Cadillac?" he said, "Yes it is. My name is Curly Bunfill, and I'm 100 years old."

Curly, you are an inspiration to us all! Sporting the picture-perfect cowboy look and runnin' 'round Sacramento in your classic Caddy at 100! The people you meet at Sam's Hofbrau!

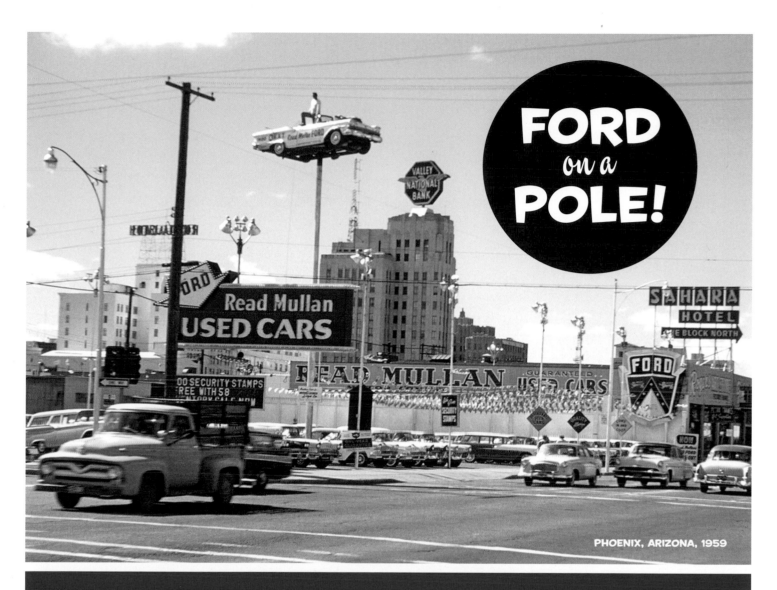

FORD
on a
POLE!

Read Mullan
USED CARS

SAHARA
HOTEL
E BLOCK NORTH

FORD

PHOENIX, ARIZONA, 1959

A 1955 FORD PICKUP CROSSES THE INTERSECTION in front of a colorful corner lot full of future classic cars. The art deco Valley National Bank in the background wears its sky-high sign like a cherry on top of an ice cream sundae. Bold signage tells us the cars are "USED." I can just hear those plastic pennants flapping in the breeze. And that land-of-the-giants-scale FORD emblem is so effectively rendered, it looks 3-D. Normally that sign would be the crowning touch to this intoxicating city scene—but it's upstaged by a man standing in the sky in a 1959 Ford Sunliner convertible on a pole.

In 1959, Read Mullen Ford in downtown Phoenix teamed up with local DJ Lonesome Long John Roller for a publicity stunt. After spending 244 days in the Arizona sky living and working (he did his daily shift on KHAT Radio from the Ford on the pole), even recording a single up there, he broke the world's flagpole-sitting record. I hope they gave him the car!

I FIRST HEARD ABOUT "MISS BELVEDERE," THE 1957 PLYMOUTH BURIED BRAND NEW IN A TIME CAPSULE IN TULSA, OKLAHOMA, WHILE READING A CLASSIC-CAR MAGAZINE ON A FLIGHT TO HONG KONG IN 1989. The car was to be exhumed 50 years later and awarded to the person who guessed the population of Tulsa in 2007. The 1957 Plymouth is one of my all-time favorite cars, so I promised myself I would be there for the epic unveiling.

After 18 years of anticipation, the day came, and of course I was there with hundreds of other spectators. Against all odds, we hoped the car would be in pristine condition. But as fate would have it, the car had been drowning for decades in a watery grave. It wasn't a pretty sight. Tulsa's mayor and many others were in tears.

The contest winner had died in 1979, so his 93-year-old sister won the rusty remains. Miss Belvedere then found her way into the hands of a "de-ruster," who said the car was beyond hope. After the city of Tulsa and the Smithsonian both passed on displaying the now-legendary Plymouth, its whereabouts became a mystery. In 2016 I heard that an auto museum in Illinois had purchased the car, but as of this writing it has not been put on display. I look forward to the day we meet again!

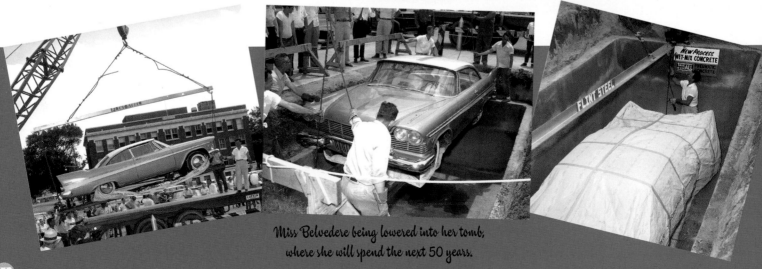

Miss Belvedere being lowered into her tomb, where she will spend the next 50 years.

Miss Belvedere

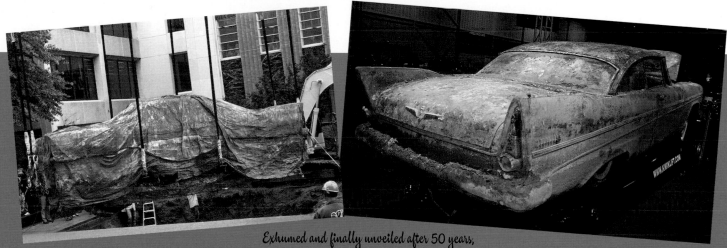

Exhumed and finally unveiled after 50 years,
Miss Belvedere looks like she's been battered and deep-fried like a piece of chicken!

1956
ASTRA-GNOME

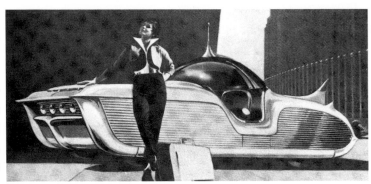

I STUMBLED UPON A VINTAGE SLIDE (below) of an amazing 1950s space-age show car. Much to my frustration, I had no idea what it was and couldn't quite read the nameplate on the hood. In all the car books and magazines I'd ever read, I'd never seen this dream car of the future. But I knew that someday, some way, I would solve the mystery.

Finally, during Palm Springs Modernism Week, I attended a slide-show lecture about midcentury show cars. Halfway into the presentation, this car appeared on the screen—pictured on the September 3, 1956, cover of *Newsweek*, no less. I recognized it instantly and was delighted to finally learn that the striking bubble-topped, quad-headlamped space-age show car is the Astra-Gnome. Mystery solved! Knowing the vast majority of midcentury-era dream cars were made only for show and then destroyed, I almost fell out of my chair when he said it was on display at the Metropolitan Pit Stop in North Hollywood, California.

The adorable Astra-Gnome was built on a Metropolitan chassis and displayed just one time, at the 1956 New York Auto Show. Later, the Astra-Gnome was discovered in New York. It was restored in 1980 and is now fully functional but far too precious to roll onto the reckless streets of Los Angeles.

Crazed with curiosity, I went to see it right away. There it was, gleaming in all its out-of-this-world glory and spellbinding me into an out-of-body retro-religious experience of the highest order. So the Astra-Gnome stays indoors, virtually undiscovered except by those who trek from all over the world to the Metropolitan Pit Stop to seek parts for their Metropolitans. Perhaps if you ask very nicely, the people there might turn on all four headlights and raise and lower the bubble top with the push of a button. But fair warning—you might pass out from joy!

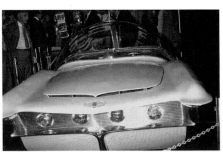

ABOVE: ARTIST'S RENDERING SHOWS MATCHING LUGGAGE.

VINTAGE SLIDE OF THE ASTRA-GNOME ON DISPLAY AT THE 1956 NEW YORK AUTO SHOW.

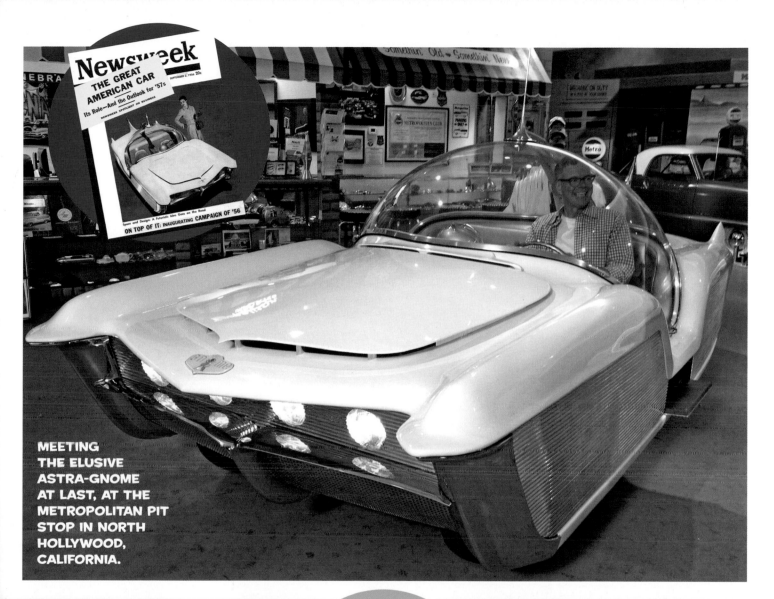

MEETING
THE ELUSIVE
ASTRA-GNOME
AT LAST, AT THE
METROPOLITAN PIT
STOP IN NORTH
HOLLYWOOD,
CALIFORNIA.

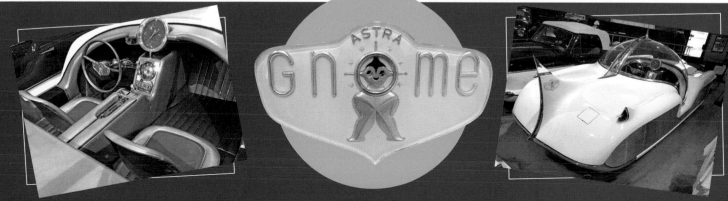

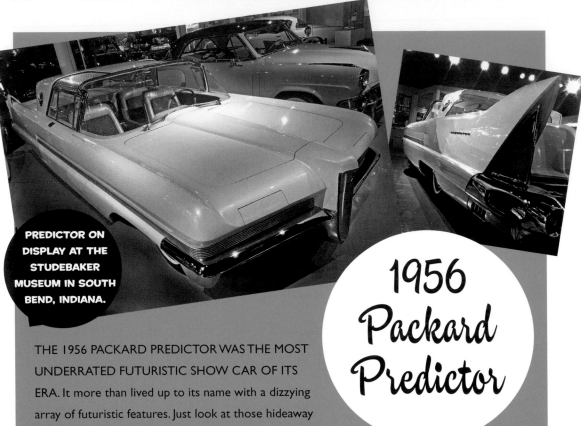

PREDICTOR ON DISPLAY AT THE STUDEBAKER MUSEUM IN SOUTH BEND, INDIANA.

1956 Packard Predictor

THE 1956 PACKARD PREDICTOR WAS THE MOST UNDERRATED FUTURISTIC SHOW CAR OF ITS ERA. It more than lived up to its name with a dizzying array of futuristic features. Just look at those hideaway headlights, that wrap-around-and-over windshield, the aluminum tambour-door T-tops, the swivel bucket seats with reversible cushions, and the reverse rear window that goes up and down with the flip of a switch. As if that wasn't enough, the twin-antenna-topped fins are see-through. And let's not forget the irresistible porthole windows! Simply put, the Predictor is a spellbinding space-age spectacular from every angle. Too bad it never went into production—Packard went out of business in 1958.

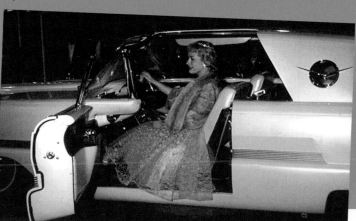

ONE-OF-A-KIND PREDICTOR STUNS AT THE 1956 NEW YORK AUTO SHOW.

I THOUGHT I HAD DIED AND GONE TO CAR-SHOW HEAVEN, but no, I really was standing beside this one-of-a-kind bubble-topped beauty. By any standards before or since, this stratospheric symphony of glass, steel, chrome, and lipstick red is not only a masterpiece of mid-century-modern motoring, it's a miracle survivor, too. The Centurion is one of the very few of General Motors' legendary Motorama show cars that has lived far beyond the future it predicted. And survive it has, in jaw-droppingly pristine condition, proudly on display at the Sloan Museum in Flint, Michigan. Next time I'm going to ask if they'll let me take it for a joyride!

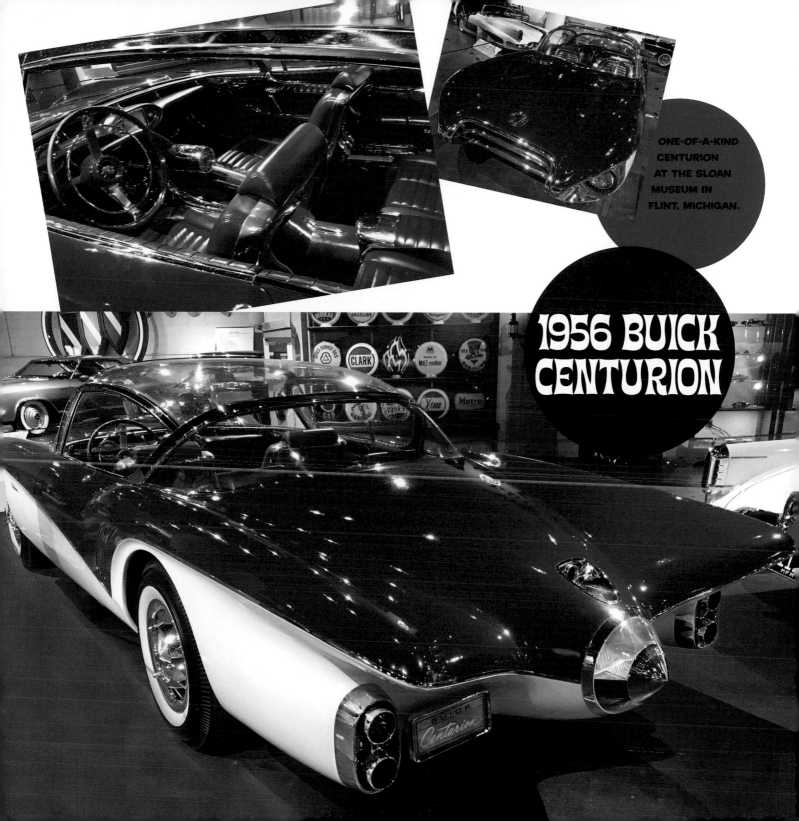

ONE-OF-A-KIND CENTURION AT THE SLOAN MUSEUM IN FLINT, MICHIGAN.

1956 BUICK CENTURION

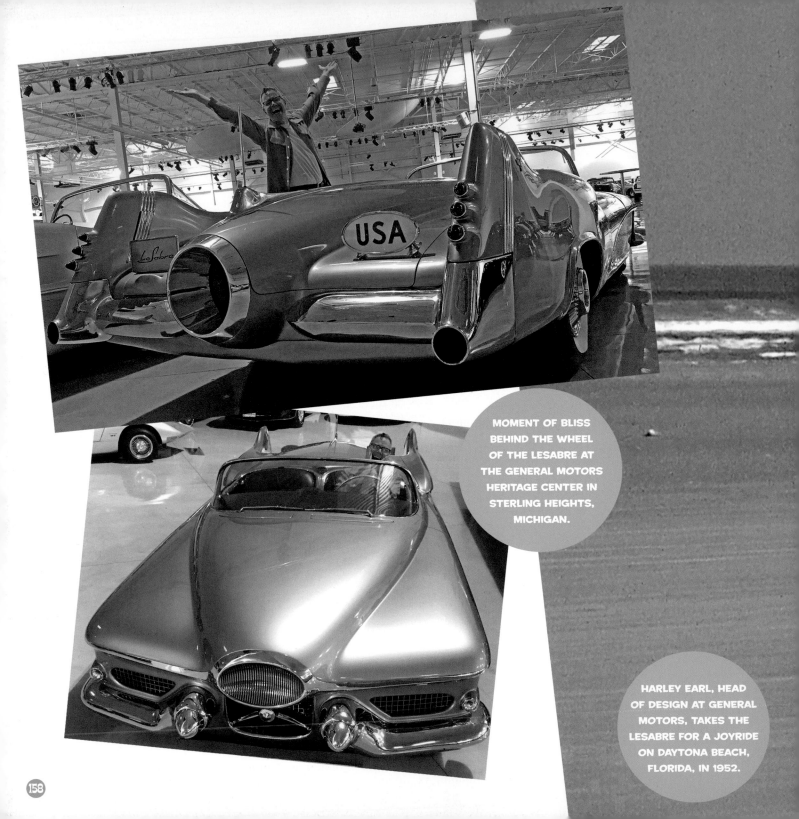

MOMENT OF BLISS
BEHIND THE WHEEL
OF THE LESABRE AT
THE GENERAL MOTORS
HERITAGE CENTER IN
STERLING HEIGHTS,
MICHIGAN.

HARLEY EARL, HEAD
OF DESIGN AT GENERAL
MOTORS, TAKES THE
LESABRE FOR A JOYRIDE
ON DAYTONA BEACH,
FLORIDA, IN 1952.

1951 General Motors LeSabre

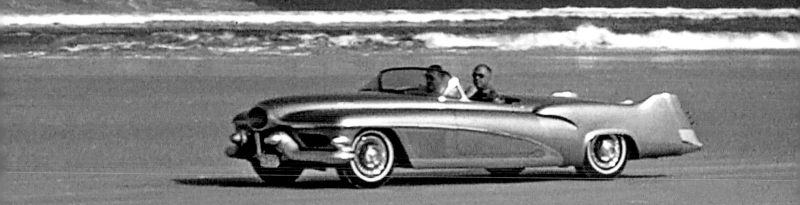

A Dream-car Dream Come True!

After touring GM's private car collection at the GM Heritage Center in Warren, Michigan, I was more than a bit intoxicated. The dizzying display of GM gems is a mesmerizing sampler of 100 years of dream cars, one-off prototypes, first-off-the-assembly-line cars, low-mileage originals, rarities, oddities, and my favorite car of all time, the one I'd wanted to see more than any other—the iconic 1951 LeSabre. I'd never seen it in person. This was the prototype that set the style guide for GM's unequaled 1950s flamboyance and ushered in the era of space-age automotive design that exploded into a cultural juggernaut.

I was screaming inside, but I did my very best to maintain my composure. When the tour was over, I graciously thanked the kind curator, then properly marched straight for the exit far across the other side of the warehouse. Just before I got to the door, the curator called, "Wait, we're not done yet! You haven't sat in your favorite car!" I'm like, what? "You can't leave until you sit in the LeSabre," he said. I made a beeline for the car, he opened the door, and as gingerly as possible, I slid behind the wheel. It was a perfect fit. My imagination was inspired, my spirit soared. I felt like I could have flown it to the moon.

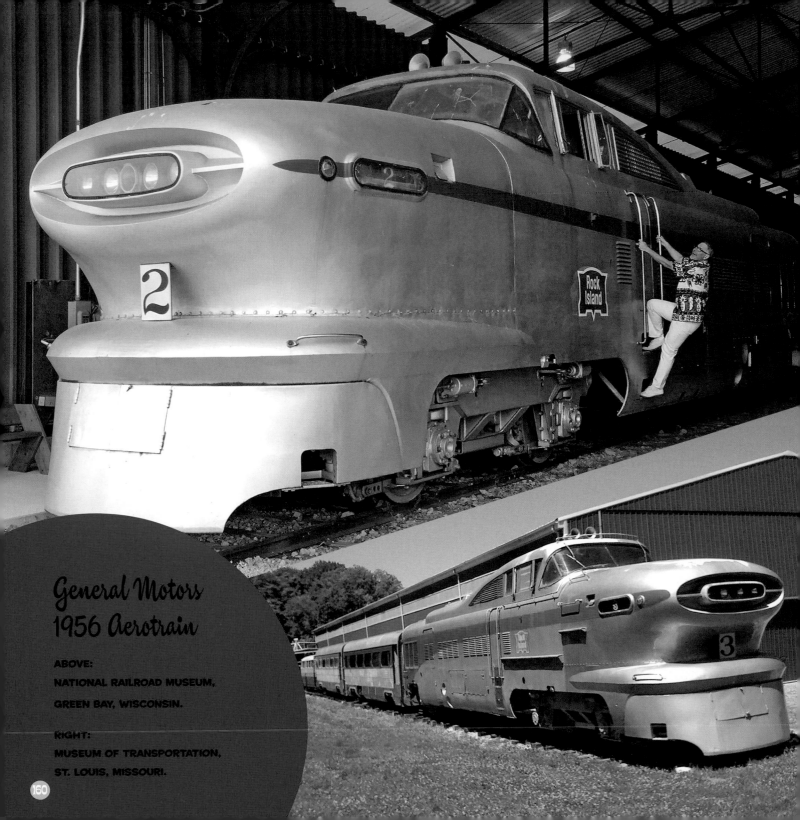

General Motors 1956 Aerotrain

ABOVE:
NATIONAL RAILROAD MUSEUM,
GREEN BAY, WISCONSIN.

RIGHT:
MUSEUM OF TRANSPORTATION,
ST. LOUIS, MISSOURI.

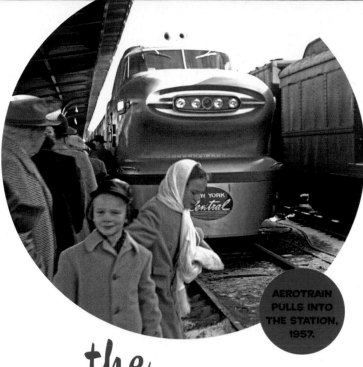

AEROTRAIN PULLS INTO THE STATION, 1957.

the Aerotrain

ALL ABOARD! In 1956, General Motors built these two identical prototypes "to save rail travel by offering ultramodern styling."

With its oval grill and wraparound windshield and wipers, it looks like a '56 Oldsmobile and a locomotive had a baby. The passenger cars were glorified buses. After a yearlong promotional tour, including summer service between Los Angeles and Las Vegas, the public response was lukewarm at best. In 1957 both Aerotrains were sold to the Rock Island Railroad for Chicago commuter service. Nine years later, the railroad retired the Aerotrains. One was donated to the National Railroad Museum in Green Bay, Wisconsin, and the other to the Museum of Transportation in St. Louis, Missouri. I've seen them both, and they're magnificent midcentury-modern machines. I'm sorry to say that they're sitting there slowing deteriorating. I say let's fix 'em up, fire 'em up, and take 'em on a tour of the USA!

ZOOLINER
OREGON ZOO, PORTLAND

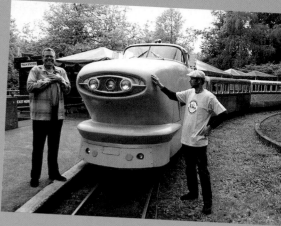

What, a mini-me Aerotrain?! Yep! In 1958, the two prototypes had a baby. It's been carrying animal-loving passengers through the north woods of the Oregon Zoo ever since.

The first time I went to Portland, the Zooliner was on the top of my list, but by the time I got to the zoo, it was almost closing time. So my guide, Jeff Kunkle of Vintage Roadside, and I bolted to the Zooliner station, only to be told it had been put away for the day. Before I could finish explaining how far I'd come to ride it, they'd fired it back up just for us! Every moment of that two-mile ride through the forest was Zooliner bliss.

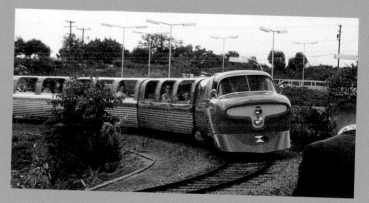

VIEWLINER
DISNEYLAND, ANAHEIM

With its Oldsmobile windshield, doors, and dashboard, Disneyland's adorable Viewliner also resembled GM's Aerotrain. Two trains (one orange, one blue) transported guests between Tomorrowland and Fantasyland in 1957 and '58. They were prototypes for the monorail that replaced the Viewliner in 1959.

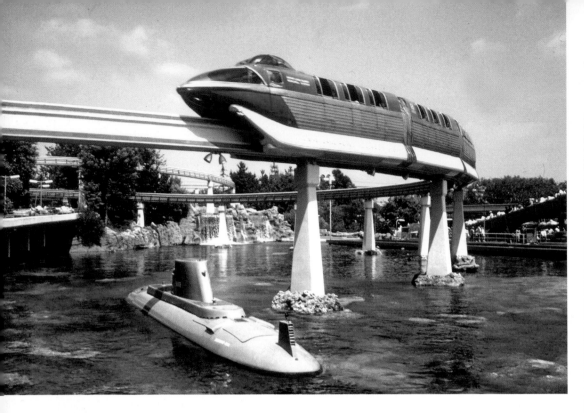

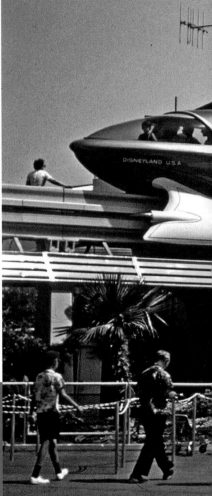

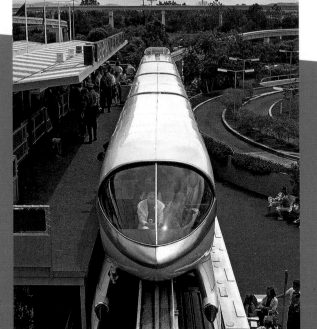

DISNEYLAND-ALWEG MONORAIL ANAHEIM 1960s

WHOOSHING BY ON THE HIGHWAY IN THE SKY,

passengers travel in supreme space-age style between the Disneyland Hotel and Tomorrowland. Of all the great experiences at Disneyland, riding the monorail has always been one of my favorites. Never have green tinted glass, ribbed stainless-steel panels, and primary colors looked so great together. The design is so brilliant that it's still fashion-forward nearly 60 years later.

The earliest concept sketches of Tomorrowland included a monorail, but Walt

MONORAILS

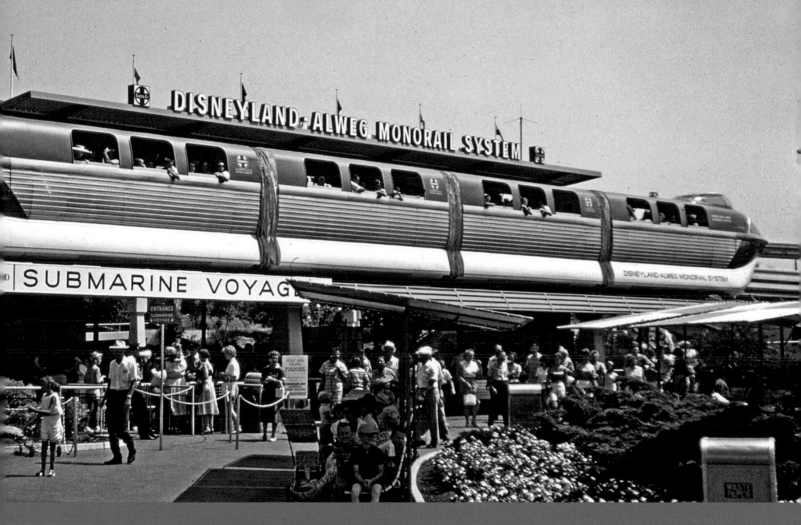

Disney had neither the technology nor the money to build his futuristic vision of mass transportation. Then, while visiting Europe in 1958, he saw a prototype being developed by Alweg, a German engineering company. Within a year he had married Alweg's technology with a flamboyant futuristic vision by legendary Disney designer Bob Gurr.

In the days leading up to the ribbon cutting and "first ride" ceremony, the monorail caught on fire every time the engineers did a test run. Dedication day came, and Tomorrowland was packed with reporters and visitors eager to see the monorail and its first official passengers, Vice President Nixon and his family. They and a nervous Walt Disney boarded the space-age train in the sky, and much to the relief of Walt and the engineers, it made it all they way around the track without catching on fire!

the TRAIL OF the TRAILBLAZER
Texas State Fair

THE TRAILBLAZER BEGAN ITS LIFE IN HOUSTON IN 1956 AS A PROTOTYPE FOR MASS TRANSIT. After six months of test runs, city officials nixed it and moved it to the fairgrounds, where it ran until 1963. Perhaps it would've had a longer life if Oscar Mayer had painted it to look like a big wiener and called it the Oscar Mayer Wienermonorail!

When I showed this slide (on the right) during a show in Dallas, a woman in the audience blurted out, "It still exists!" I was shocked and asked where it was. "Somewhere in a little farm town about an hour east

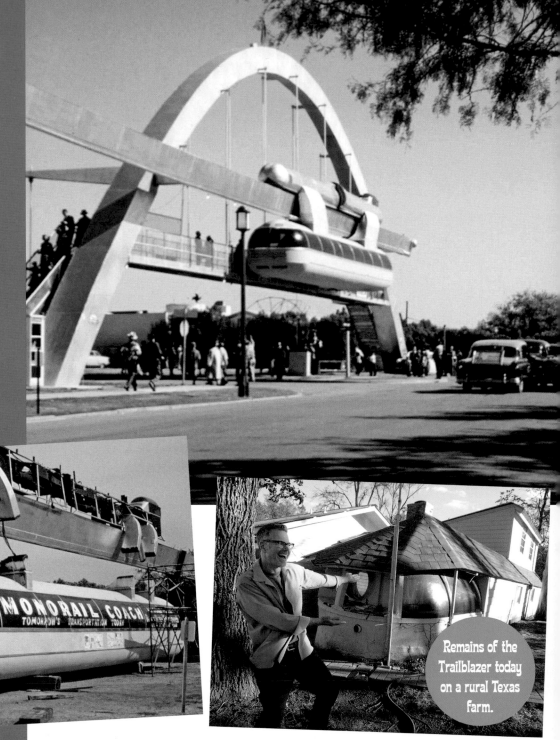

Trailblazer deinstallation in Houston, Texas, 1956.

I AM THE Skyway **MONORAIL COACH**
TOMORROW'S TRANSPORTATION TODAY
Trailblazer

Remains of the Trailblazer today on a rural Texas farm.

of here," she said. Naturally, I had to go there the very next day. Wanting to play detective as usual, I stopped first at the old pharmacy in the heart of town. Showing a picture of the Trailblazer on my phone, I asked just about everyone in the place if they knew where it was. Finally two little old ladies said they'd heard it was nearby but didn't know where. They suggested I go to the barbecue stand next door, and the man there might know. Well, he didn't—but he insisted I stay for lunch, and his ribs and peach cobbler hit the spot. He sent me to the "Little Lady," as he called her, who worked at a real estate office. She didn't know, but she called an agent who did. It was on a farm outside of town. YAY!

I wrote down the confusing directions and, against all odds, found the farm. Standing at the locked gate, I saw what I thought was the remains of the Trailblazer in the distance. As loudly as I could, I called out, "Is anybody home?" several times before deciding that nobody was except the four big barking dogs that came running up to greet me. I didn't come all this way not to get a good look at it. So I asked the dogs not to eat me, and I climbed over the gate and ran what seemed a mile to where it was. I took my picture and got the hell out of there. The remains of the Trailblazer monorail are looking more farmy than futuristic these days, but at least it's still here!

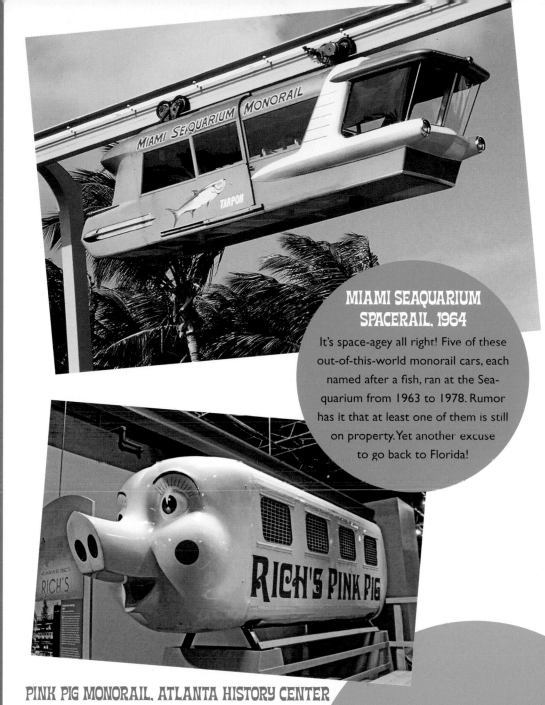

MIAMI SEAQUARIUM SPACERAIL, 1964

It's space-agey all right! Five of these out-of-this-world monorail cars, each named after a fish, ran at the Seaquarium from 1963 to 1978. Rumor has it that at least one of them is still on property. Yet another excuse to go back to Florida!

PINK PIG MONORAIL, ATLANTA HISTORY CENTER

I first spotted this precious pink pig in the window of the former Rich's Department Store, where it had run in the toy department for decades. When I went back two years later, it was gone. Glad to now know it's found a good home at the History Center. Next trip to Atlanta, it's the first thing I want to see!

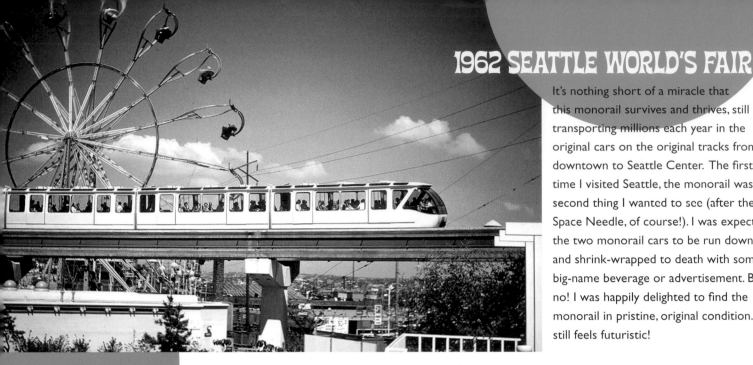

1962 SEATTLE WORLD'S FAIR

It's nothing short of a miracle that this monorail survives and thrives, still transporting millions each year in the original cars on the original tracks from downtown to Seattle Center. The first time I visited Seattle, the monorail was the second thing I wanted to see (after the Space Needle, of course!). I was expecting the two monorail cars to be run down and shrink-wrapped to death with some big-name beverage or advertisement. But no! I was happily delighted to find the monorail in pristine, original condition. It still feels futuristic!

I grew up going to the Los Angeles County Fair, and I remember these sci-fi-style monorail cars very well. On opening day in 1962, Richard Nixon was the first official passenger. Everything was fine—except they forgot to put air conditioning in the cars, and it gets very hot in Pomona in September. The windows didn't open either. So Nixon and all the other riders that first season roasted until done while taking in the mile-long, bird's-eye view of the fair's festivities below. Fourteen of these cars roamed the fair until 1990, then vanished without a trace.

LOS ANGELES COUNTY FAIR POMONA

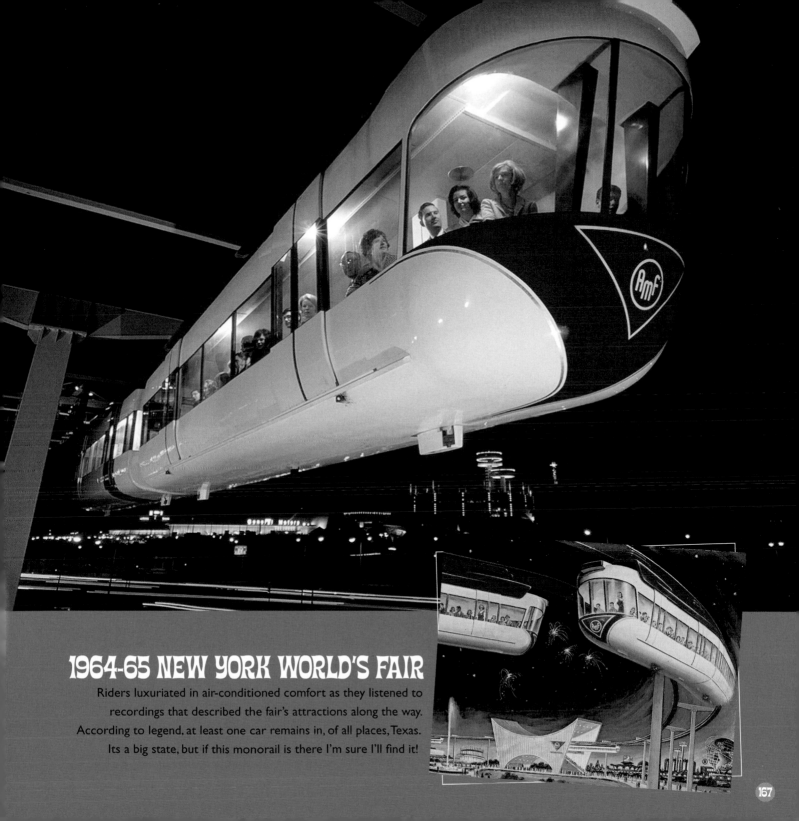

1964-65 NEW YORK WORLD'S FAIR

Riders luxuriated in air-conditioned comfort as they listened to
recordings that described the fair's attractions along the way.
According to legend, at least one car remains in, of all places, Texas.
Its a big state, but if this monorail is there I'm sure I'll find it!

FLYING HIGH INSIDE THE CABIN, WITH ITS UNEXPECTED GREEN-AND-GOLD COLOR SCHEME, FAKE WOOD PANEL-ING, AND MOD SILKSCREENED MAP OF THE WORLD.

Welcome Aboard!
TWA

DRESSED UP IN A VINTAGE PILOT'S UNIFORM, READY TO HOST A RETRO SLIDE SHOW AT THE AIRLINE HISTORY MUSEUM.

the (TWA) Constellation

BEFORE TWA BEGAN JET PASSENGER SERVICE IN 1959, the Constellation was the most luxurious and fastest way to fly. It began commercial passenger service in 1946, and in 1955, its bigger, flashier sibling, the Super-G Constellation, became the first plane to fly nonstop from California to Europe. TWA's last Constellation passenger flight was in 1967.

THE BEST-PRESERVED CONSTELLATION ON THE PLANET AT THE AIRLINE HISTORY MUSEUM IN KANSAS CITY, MISSOURI.

THE ORIGINAL TWA MOONLINER,
DISNEYLAND, 1957.

the TWA MOONLINER

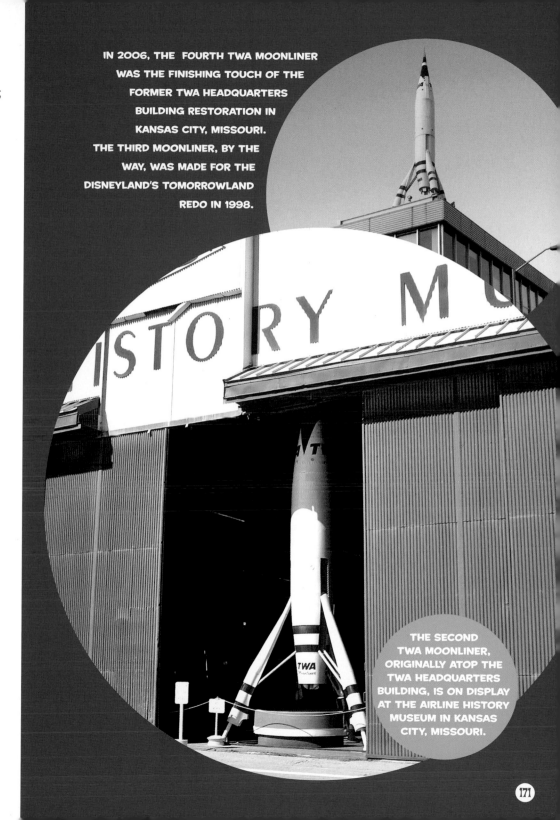

THE TWA MOONLINER WAS THE CROWNING TOUCH OF DISNEYLAND'S ORIGINAL 1955 TOMORROWLAND.

In 1956, TWA's big bad boy, Howard Hughes, ordered a replica of Tomorrowland's TWA-sponsored rocket and displayed it prominently atop the TWA headquarters in Kansas City, Missouri. It stood there until 1962, when TWA ended its Disneyland sponsorship. I heard that when the rocket was removed, it wound up in rural Missouri as the unlikely centerpiece for an RV manufacturing company, appropriately called Spacecraft.

Disneyland had scrapped their Moonliner decades earlier, so when I heard there was another one in Missouri, I immediately thought, *I will find that rocket ship!*

I finally got to Kansas City and before dashing out to the hinterlands, where I thought the elusive Moonliner was, I took a quick detour to the Airline History Museum. I wanted to see the 1955 TWA Super Constellation. The sight of this magnificent modern flying machine was mesmerizing.

I had no idea my search for the Moonliner was over before it even started. After touring the epic Constellation, I walked around to the other side of the hangar, turned a corner, and there it was, the TWA Moonliner! As I stood there not believing what I was seeing, I asked the docent, "Where'd you get this?!" She said, "Oh, it came from an RV factory!"

IN 2006, THE FOURTH TWA MOONLINER WAS THE FINISHING TOUCH OF THE FORMER TWA HEADQUARTERS BUILDING RESTORATION IN KANSAS CITY, MISSOURI. THE THIRD MOONLINER, BY THE WAY, WAS MADE FOR THE DISNEYLAND'S TOMORROWLAND REDO IN 1998.

THE SECOND TWA MOONLINER, ORIGINALLY ATOP THE TWA HEADQUARTERS BUILDING, IS ON DISPLAY AT THE AIRLINE HISTORY MUSEUM IN KANSAS CITY, MISSOURI.

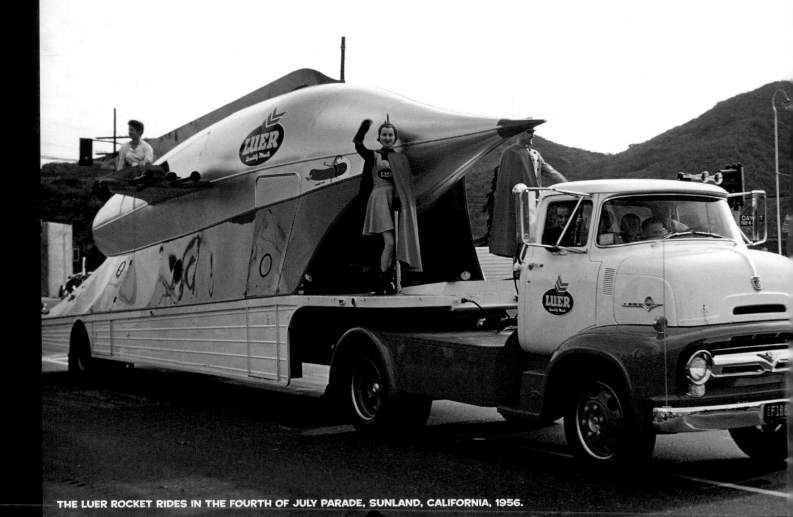

Fly Me to the

THE LUER ROCKET RIDES IN THE FOURTH OF JULY PARADE, SUNLAND, CALIFORNIA, 1956.

Moon!

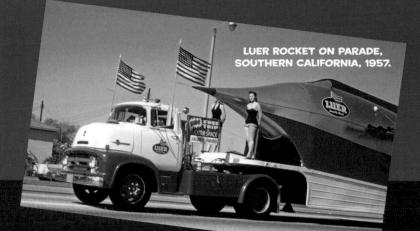

THE LUER "QUALITY MEAT" ROCKET

Until I stumbled upon this glorious slide (on the left), I had no idea that the Luer Rocket existed. This 1950s-era rocket ship was to Luer what the Wienermobile was to Oscar Mayer. It made appearances in local parades and at supermarket grand openings to promote the company's "quality meat" products. You could actually go inside of it.

Its history is a bit foggy, but I do know that Luer was a meatpacking house that started in downtown Los Angeles in 1885. Surprisingly, 60-plus years later, the rocket still exists. After it decayed for decades in a boneyard in Prescott, Arizona, space-age rocket collectors John Kleeman and his son Peter rescued it in 2007. They have it stored in a barn, where it awaits restoration. I look forward to seeing the wonderous rocket, no matter what condition it's in. And when they do restore it, I'll be first in line to fly it to the moon!

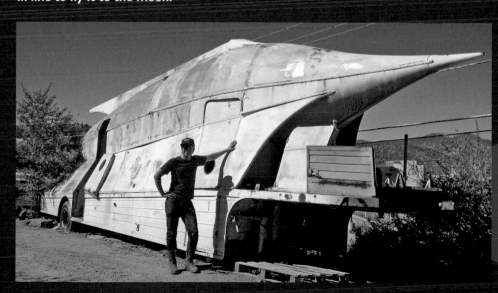

COLLECTOR PETER KLEEMAN DISCOVERS THE ROCKET IN PRESCOTT, ARIZONA, 2007.

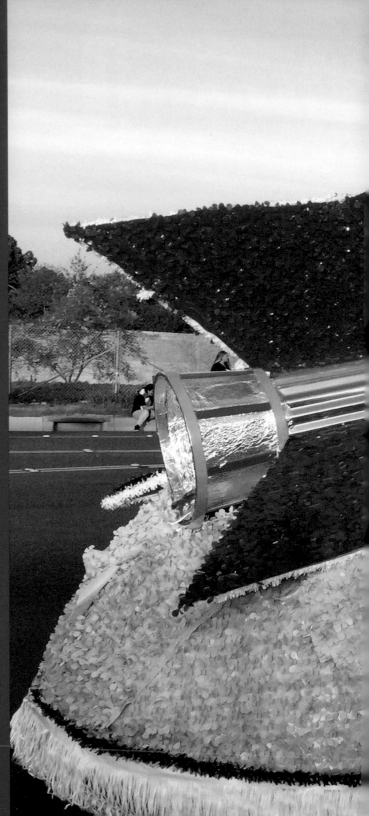

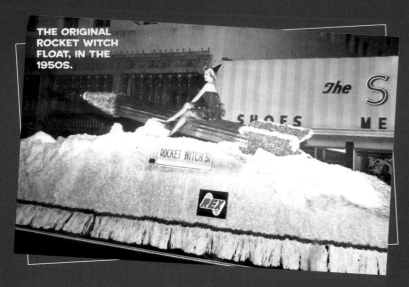

THE ORIGINAL ROCKET WITCH FLOAT, IN THE 1950S.

ROCKET WITCH 51

WHAT A THRILL to climb aboard this rocket for a quickie before-the-parade pose. As soon as I hopped off, the witch hopped on, in all of her wicked finery, and the parade began.

Originally built in 1951 for the Anaheim Halloween Parade, which began in 1924, the Rocket Witch float was faithfully re-created in all its retro glory a few years ago, and once again appears every year in the parade.

THE UTAH HERITAGE FOUNDATION SAID IT HAD A SPECIAL SURPRISE CAKE FOR ME...BUT I NEVER EXPECTED THIS. LIFE IS FULL OF SURPRISES, AND MOST OF THEM ARE WONDERFUL!

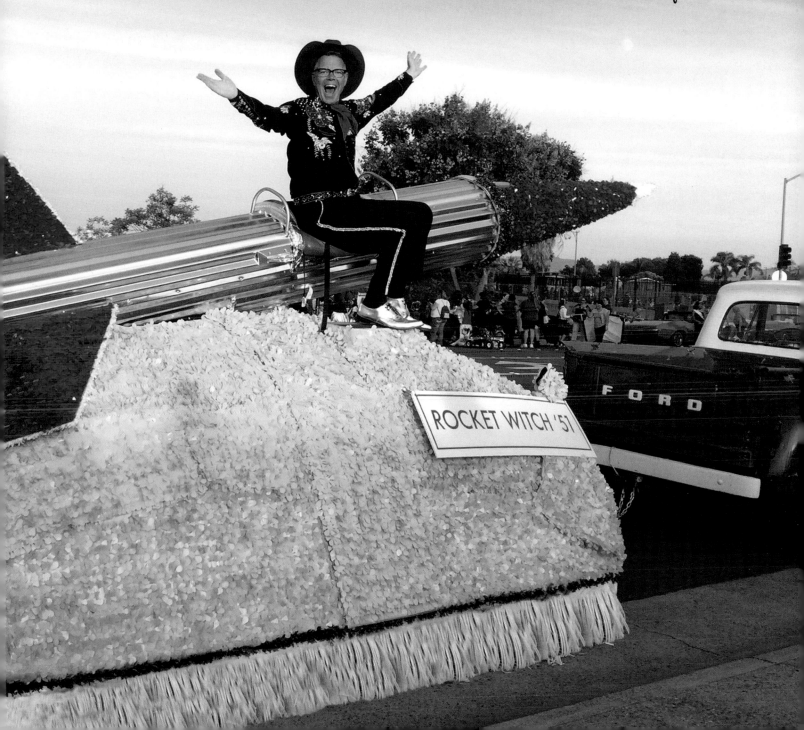

"ROCKET WITCH" FLOAT
Anaheim Halloween Parade, Anaheim, California

THANKYOULAND

A super-duper extra special thank you to creative director and designer extraordinaire, Kathy Kikkert, who graciously and gallantly guided this colorful book every step of the way, and without whom, it would've never happened.

A very special thank you to extraordinary publisher Colleen Dunn Bates; supermanager Scott Marcus; incredible "slibrarian" Teresa Kennedy; and my dear mother, Donna Givens, who taught me that I could do anything I wanted.

Thank you to these fine folks whose kind gestures and generosities also contribute to this book: Dorie Bailey, Tony Baxter, Adrienne Biondo, Eric Brockman, Molly Brown, Curly Bunfill, Brian Cotton, Jody Daily, Ben Dickow, Caitlin Ek, Jeff Freeman, Lynn Graves, Jennifer Greenburg, Bob Gurr, Dolores Heinsong, Paul Hettick, Kirk Huffacre, Nancy Jacobs, Kelly Jones, Norma Jones, Kevin Kidney, Pete Kim, John Kleeman, Peter Kleeman, Jeff Kunkle, Beth Lennon, Vickie Lewis, Phyllis Madonna, Robbie Mack, Marsha Mardock, Kelly Ann Martin, Chris Merritt, Jane Newell, Chris Nichols, Phil Noyes, Joe Peterbuilt, George Redfox, Boyd Rice, Larry Rodkey, Paul Ruebens, Kathy Salus, Jaime Samson, Stephen Schafer, Michael Scheib, Susan Skarsgard, Bill Stewart, Casey Stockdon, Roger Tofte, Robert Townsend, June Valentine, Joe Ventura, and Allee Willis.

Thanks also to these wonderful institutions: Boonshoft Museum of Discovery, GM Heritage Center, Henry Ford Museum, National Railroad Museum, Museum of Transportation, Sloan Museum, and Studebaker National Museum.

And thank you to those who have attended my retro slides shows, events and tours, as well as everyone that has connected on social media. Cheers to Americana and you!

Photo credits:
Anaheim Public Library (174, upper left)
Atlanta History Center (165, bottom)
John Eng (153, lower right)
Jim Jordan Collection (159)
Teresa Kennedy (57 lower right, 131, bottom)
Bob Greenspan (38, 44, 76 top right and left, 101, 137, 140)
Ron Groeper (12, lower right)
Chris Haston (7)
Chuck Kelley Collection (64, 107)
Gary Krueger (40 top right, 75 upper left and bottom, 115)
Eric Lynxwyler (65)

Stephanie Pashkowsky (9, lower right)
Mark Peacock (75, center right)
Timothy P. Putz (128-9)
Scott's Photography (36, top left)
David Sprague (11, right center)
Sean Teegarden (70)
Maurice Terrall (123)
Tulsa Historical Society (152 lower left)
Rebecca, Usnik (107, 155)
Utah Heritage Foundation (83, left)
John Zimmerman (93, 167)

All other images are from the Charles Phoenix Collection.

All photographs are owned by the author or used by the author with permission.

Published by Prospect Park Books
2359 Lincoln Ave.
Altadena, CA 91001
www.prospectparkbooks.com

Distributed by Consortium
www.cbsd.com

Library of Congress Cataloging in Publication Data is on file with the Library of Congress.
The following is for reference only:

Names: Phoenix, Charles, author
Titles: Addicted to Americana (2017)
Identifiers: ISBN 978-1-945551-19-2 (hardback)
Subjects: Americana; Travel: American;
References: Curiosities & Wonders

CREATIVE DIRECTION & DESIGN BY KATHY KIKKERT

PRINTED IN KOREA

I KNOW!

Visit CHARLESPHOENIX.COM for retro slide show, special event dates, and much more!

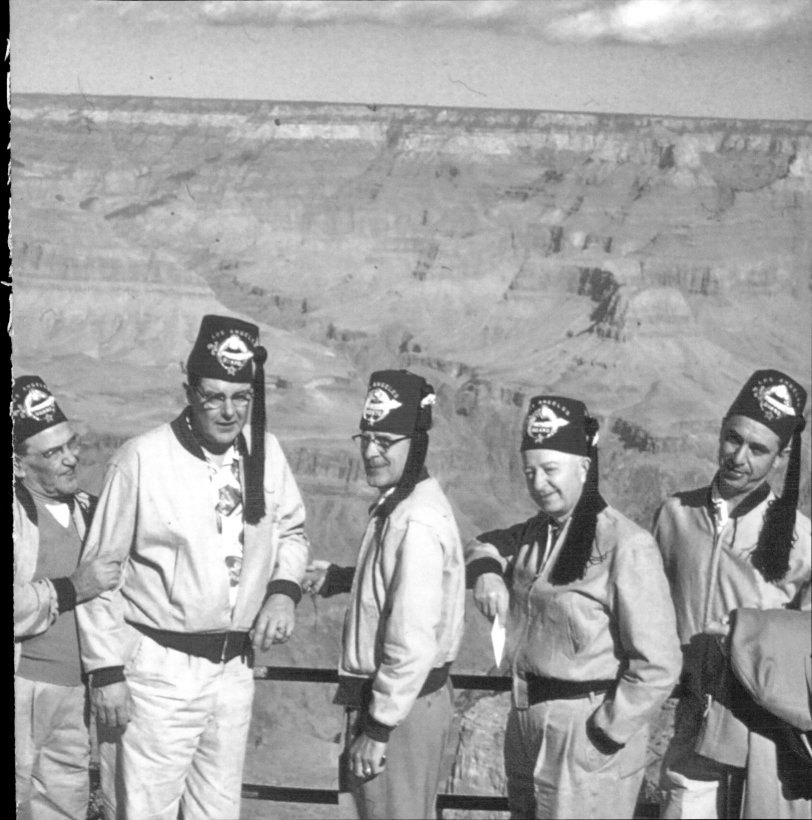